THE THEATRICAL WORLD OF
ANGUS McBEAN

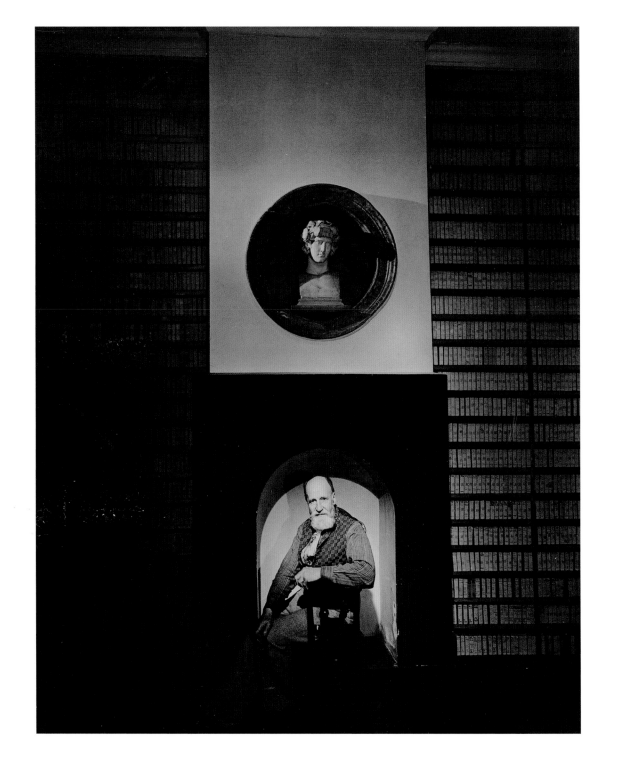

THE THEATRICAL WORLD OF
ANGUS McBEAN

PHOTOGRAPHS FROM THE
HARVARD THEATRE COLLECTION

FREDRIC WOODBRIDGE WILSON

with an essay by RICHARD TRAUBNER

AN IMAGO MUNDI BOOK
DAVID R. GODINE · PUBLISHER
BOSTON

This is an Imago Mundi Book
Published in 2009 by
DAVID R. GODINE · *Publisher*
Post Office Box 450
Jaffrey, New Hampshire 03452
www.godine.com

LIBRARY OF CONGRESS CATALOGING-IN-PUBLICATION DATA

Wilson, Fredric Woodbridge.
The theatrical world of Angus McBean : photographs from the Harvard
Theatre Collection / Fredric Woodbridge Wilson ; with an essay by Richard
Traubner. — 1st ed.
p. cm.
Accompanies a centenary exhibition at the Harvard Library.
"This is an Imago Mundi Book."
Includes bibliographical references and indexes.
ISBN 978-1-56792-360-5
1. Stage photography—Exhibitions. 2. Portrait photography—Exhibitions.
3. McBean, Angus, 1904–1990—Exhibitions. 4. Harvard University. Library—
Photograph collections—Exhibitions. I. Traubner, Richard. II. Title.
TR817.W55 2009
779—dc22
2008046930

FIRST EDITION
Printed in Korea

HARVARD
COLLEGE
LIBRARY

This is a companion book to the centenary exhibition
Photographs by Angus McBean (1904–1990) in the Harvard
Theatre Collection, Houghton Library, Harvard College Library.
The exhibition was organized by Fredric Woodbridge Wilson,
Curator of the Harvard Theatre Collection.

This publication was supported in part by the Barry Bingham, Sr.,
Fund for Publications in the Harvard Theatre Collection.

The Harvard Theatre Collection is the owner of the archive of
Angus McBean's original negatives and proofs, and holds copyrights
to the photographs of Angus McBean. For information concerning
the publication or use of photographs by Angus McBean,
please contact the Harvard Theatre Collection, Houghton Library,
Harvard University, Cambridge, Massachusetts 02138.

FRONTISPIECE:
Angus McBean at home at 50 Colebrooke Row, Islington, where he
also kept his studio, sitting before his library of glass plate negatives, 1968.
This photograph was taken in 1968 by McBean's assistant Jake Wallis,
using McBean's photographic equipment. Since 1970, Angus McBean's
archive, including the plates reproduced in this book, has formed a part
of the Harvard Theatre Collection.

CONTENTS

———

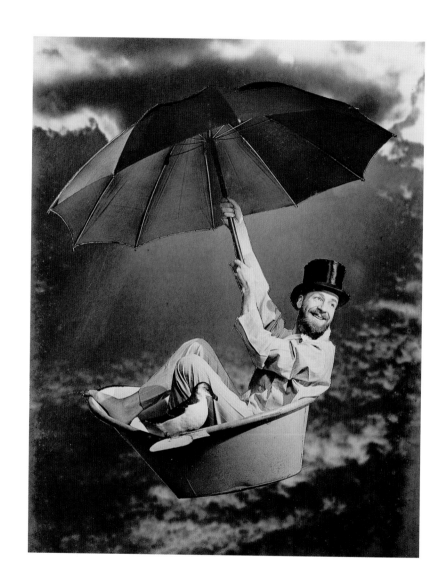

INTRODUCTION

FREDRIC WOODBRIDGE WILSON

Curator of the Harvard Theatre Collection

THE PHOTOGRAPHY OF ANGUS MCBEAN (pronounced McBain) records and represents a period of British theater of more than three full decades, beginning in 1936. His work from those years – brilliant years in the annals of British theater – includes most of the memorable productions of what is now the Royal Shakespeare Company and what was the Old Vic Company; many opera productions at Glyndebourne and the Royal Opera House, Covent Garden; ballet and operetta productions at Sadler's Wells; and West End productions of plays and musicals both old and new. For example, McBean captured (and, as the following demonstrates, preserved, in visual terms) the first productions of Benjamin Britten's *Peter Grimes*, *The Rape of Lucretia*, *Albert Herring*, *A Midsummer Night's Dream*, and other of that composer's operatic works, not to mention hundreds of other landmarks of that great era of theater and music.

McBean was in nearly every sense a conservative. His square-cut beard and tweedy dress were redolent of an earlier century. He traveled by train and by bicycle. In a photographic age that came to embrace the strobe light, the light meter, and the hand-held, small-format film camera, he employed cumbersome floodlights and a view camera that relied upon six-by-four-inch glass plates. He gauged his exposures by eye. In the theater, McBean worked from a photo call, a special session in which all of the cast members re-created the key moments from the play, as re-lit and re-arranged by the photographer, rather than passively shooting scenes under stage lighting during rehearsals or performances. He retained his negatives and owned his copyrights, and he provided custom reprints on demand. He painstakingly retouched his negatives as well as his prints; he avoided color film in part because it could not be easily retouched.

McBean's taste in theater was also conservative: not for him the "kitchen sink" drama of John Osborne or progressive trends represented by Pinter or Beckett; rather, his tastes ran to the more genteel works of Ivor Novello and Noël Coward. McBean liked to have a good time in the theater. He enjoyed larger-than-life on-stage acting and off-stage personality, as well as themes of romance and fantasy. He reveled heartily in the physical acting style, just as he adored the heavy greasepaint makeup of the stage actors of his day, and he brought out these attributes in his pictures, a very real sense of the theatrical experience.

McBean's photography was characterized by rich contrasts and an impressive range of dark tones. The large-format plate gave his photographs some thirty times the detail of the ordinary thirty-five-millimeter negative. This was ideal for enlargements, especially for display outside the theater, which in his day were the principal means and medium of theatrical advertisement.

Perhaps McBean was the last of the theatrical great photographers to have used these techniques as a matter of course: before the end of his career, Kodak abandoned the manufacture of glass photographic plates.

Although McBean's specialty was theatrical work, his studio was very active, and among his patrons were not only actors, singers, and dancers, but also playwrights, producers, composers, artists, writers, and other outstanding personalities of the period.

Early in his career, McBean made a mark with the public in a series of so-called "surreal" photographs that were published in the popular magazine *The Sketch*. Here his name was prominently connected to his work, unlike his work for the theater, which tended to be all but anonymous as far as the public was concerned. As examples of surrealism, these compositions now seem tame and repetitive (sand, driftwood, clouds, and disembodied heads figure in all too many of them), but they led to the establishment of a signature style. Later, having played out the surrealist theme, McBean created another series of novel photographs, using montage and multiple exposure, this time publishing them in *The Tatler*. The surreal and montage compositions, and McBean's whimsical self-portrait fantasy montages, which he sent out as Christmas greetings, are among the best-remembered of his images, but they represent only a small portion of his work, which was mostly devoted to the sympathetic representation of portrait sitters and stage productions.

ANGUS McBEAN

RICHARD TRAUBNER

"MY KIND OF THEATRE concerns itself with kings and queens, princesses sleeping or otherwise in ivory towers, or in enchanted castles with satins, furs,and cloths of gold. . . . There must be huge splashes of colour, wild music, beautiful people, monstrous Calibans; magic, imagination, illusion, fairies, oceans of blood and wine, and always happy endings. . . ."

So wrote Angus McBean of the theater for which he was the court photographer for nearly thirty years, the London stage from the 1930s to the 1960s that encompassed legendary productions of Shakespeare, Congreve, Shaw, Wilde, and Coward, the fading British musical and the burgeoning Broadway musical, the operas of Benjamin Britten, and the beginnings of the Royal Ballet and the Royal National Theater.

His style was nurtured through the stage-magazine photographs of the 1920s, the glossiness of the silent screen still, the mannered charm of the Society portrait, and the then-new and fashionable Surrealism. He synthesized these elements into a super-theatrical style which was distinctly his own. Poring through copies of *Theatre World* and *The Sketch*, and theatrical biographies when I was young, McBean's photography said to me, unmistakably, this is the London Theatre.

Angus McBean was born in 1904 near Newport, in South Wales. He had a Scottish name, but came of Welsh stock. His father was a mine surveyor; his mother, the artistic one in the family, would eventually make a living buying up houses, redecorating and then reselling them. Angus, interested, was steered toward architecture as a profession. He preferred watching the glittering stars of the silent screen at a local cinema.

It was then decided that he should go into banking, which he called "a disastrous idea," and ended up at the far-out Bryn Mawr branch where bank managers were sent to "die of drink or despair," as he succinctly stated.

As a boy, however, he had developed a keen interest in photography. He bought a camera, a 2½-by-3½-inch autographic Kodak. He also bought a bicycle, in order to ride through the English countryside to take pictures. And he had an interest in making masks, beginning by crafting impressions of his and his friends' faces.

After the death of Angus's father in 1924, his mother relocated to Acton, West London with her family. Angus began working as a restorer in the antiques department at Liberty's, the famous store that was just at that time moving into its Elizabethan-styled premises in Regent Street. The job would last for seven years, during which time Angus was also making masks and photographing at home.

Doubtlessly influenced by the arts-and-crafts aestheticism of

Liberty's, McBean began the eccentric dressing that was to characterize him for a lifetime. He liked a pair of Dutch workmen's velvet trousers so much, with their side creases and wide bottoms, that he had them copied for everything he wore, even his dress suit. Laurence Olivier, one his oldest friends, remembered that McBean's clothes in the 1920s and '30s were so "far out" that "no one could afford to be seen with" him, but that by the 1960s, they were so old-fashioned that "no one would want to."

At this time, he married, briefly, "got out with surprisingly little pain," and left Liberty's. An exhibition of his masks and photographs was held at a London tea shop called The Pirates' Den. His received a commission to do the masks for a spectacle called *The Golden Toy* at the Coliseum, designed by the famous Berlin stage designer Ernst Stern.

His photographs attracted the attention of Hugh Cecil, the prominent Society photographer. Cecil took him on as an assistant at his silver-and-black studio in Hay, designed by the interior decorator Basil Ionides (whose work can still be seen today in London's restored Savoy Theatre).

It was Cecil who taught McBean the advanced art of photographic portraiture. Using a large reflex camera with a soft-focus lens and half-plate negatives which could be drawn on with a pencil, and employing gauzed indirect lighting, Cecil's portraits set the standard for the Bond Street look his famous clients desired. For nearly a year, McBean actually took the portraits which went out under the Cecil imprimatur, while Cecil himself was trying to perfect a color-photograph machine. During his year at Cecil's atelier, McBean "didn't . . . see photography as 'art.' It is only a means of reproducing what the camera sees. . . . But put the camera into the hands of an artist and a very different kind of photography will emerge."

McBean parted company with Cecil and set up his own studio in Belgrave Road, Victoria. By this time he had acquired a half-plate Soho Tropical reflex camera. He would use this camera, with Zeiss lenses and Kodak Panchromatic black-and-white plates, for the next twenty years. His masks and theatrical

props, however, remained his main source of income.

He created some of the medieval furnishings for *Richard of Bordeaux* in 1933 at the New Theatre, the play that catapulted John Gielgud to fame, and in 1936 his masks for a stage adaptation of Clemence Dane's *The Happy Hypocrite* at His Majesty's Theatre got him his first job as a theater photographer. Its star, Ivor Novello, asked McBean to take the publicity photos.

McBean's startlingly chiaroscuro, intensely black, dramatic prints were utterly unlike the flat photographs taken by the Stage Photo Company, which then photographed nearly every West End show. These were put in front of the theater, and submitted to the magazines of the day, such as *The Sketch*, *Theatre World*, and *The Play Pictorial*. McBean remembered polishing the glass every morning on the exterior theater frames, to make the photos seem even more lustrous.

Novello had McBean do the photos for his next project, the Drury Lane musical *Careless Rapture* (1937), for which a Chinese mask was also made for the star. He began to take on other theater jobs, including the Old Vic Theatre's 1936–1937 season, by claiming he had been commissioned to take photos for *The Sketch*: this was not true, strictly speaking, but the magazine invariably used his prints anyway. McBean's acclaimed career as a Shakespearean chronicler had begun.

It is to McBean that we turn to conjure up the brilliance of the of the late 1930s at the Old Vic, which saw Laurence Olivier's earliest *Macbeth*, *Hamlet*, and *Henry V*. The photographer wisely concentrated on the faces: the outlays for the physical productions at the Vic were laughably meager. McBean remembered that the entire budget for the *Hamlet*, designed by Martin Battersby, was £10, and that the robes for *Macbeth* were concocted from blue flooring felt, with necklaces made from 30-ampere rubber cable.

In 1936–1937 he also started two happy traditions. One was photographing Vivien Leigh – who had a part in *The Happy Hypocrite*. She would become his favorite model and lifelong muse. The other was sending out his famously surreal Christmas cards. These, in which the photographer or any of his famous

models were placed into increasingly bizarre settings and scissors-created contortions, became something McBean's increasingly wide circle of stage and society friends looked forward to annually with high anticipation. Influenced by the artists Man Ray, Dalí, De Chirico, and others, McBean became Britain's most famous photo-surrealist as well as its most celebrated stage photographer.

The association with Leigh was to prove propitious for the actress. One of the earliest photos taken by McBean, in which Leigh, in the character of Serena Blandish, wore a big hat under a bower of blossoms, was sent by her press agent to David Selznick, then preparing to cast the role of Scarlett O'Hara in his film of *Gone With the Wind*. It was at about this time that both Leigh and Charles Laughton were filming *St. Martin's Lane*, for which McBean was asked to take publicity photographs. The film, about street entertainers working in front of the London theaters of the day, was called *Sidewalks of London* on its American release. Curiously, McBean does not seem to have continued doing publicity stills for the cinema.

Until the war, *The Sketch* ran a weekly series of portraits of personalities – many from the stage – that also flirted with surrealism. Vivien Leigh, Dorothy Dickson, Penelope Dudley Ward, aviatrixes, tennis players, debutantes, and U.S. Ambassador Joseph Kennedy's daughter were among the sitters. A yard of sand that had been delivered by lorry to McBean's studio, and was not easy to move away, accounted for the preponderance of vaguely nautical or beach settings in the surreal works. Special studio backdrops were meticulously painted by his friend, the artist L. Roy Hobbel, while McBean's assistant John Vickers helped with the many props and drapes in the setting-up for each shot.

While doing these surrealist magazine portraits, McBean refused to do the kind of society photographs that had made his mentor Hugh Cecil famous. "The highborn, the wealthy, the titled expect their photography for nothing!" he complained; this was "a Bond Street game I never played." McBean continued his association with both the Old Vic and its sister to the northeast,

Sadler's Wells. He had ingratiated himself with their directress, the eccentric Lillian Bayliss, after she had first pronounced: "*The Sketch? The Sketch!?* We don't want those people here!" McBean began working for H. M. Tennent and many of the other West End producers in the late 1930s. His photos adorned the theater façades as well as the photo-spreads in *The Sketch* and other magazines like *The Tatler* and *The Bystander*.

The usual procedure for McBean and his assistants was to see the play in its tryout engagement or final rehearsals, where he would take notes on certain attractive scenes or portrait opportunities. The photo-call itself would invariably last a half-day; McBean was known as a fabulously fast shot and never used a light-meter. The average amount of time devoted to each pose was six minutes. Often, the show's director was called upon during the photo call to compose the shot, in an approximation of a moment in the play.

Part of the fascination of McBean's art was that the highly theatrical shots did not rely on the existing stage lighting. The harsh spotlights, footlights, and hanging light battens would have resulted in washed-out faces and a loss of detail in the scenery and furniture behind the actors.

The fabulously dark blacks, Velázquez-like in their density, and the dramatic chiaroscuro effects were McBean's hallmarks. Not for him the wispy, deadening soft-focus lens so admired by Hugh Cecil, or the flat, curiously undramatic shots taken by the staff photographers of the Stage Photo Company. For McBean, the romantic, comic or melodramatic quality of the drama at hand had to be conveyed through the portrait of the actor or actors. He shared with Cecil Beaton an admiration for the affected studio setting, but McBean looked ahead to the Surrealists while Beaton looked back to the Edwardians. (At one time, Beaton called McBean the best photographer in England.)

If "one-shot" McBean's theater photographs each took an average of six minutes, speed was also of the essence in having the 8-by-10-inch prints ready for the producer, the press agent, the magazine picture editor. There were no contact sheets – each shot

was taken on individual, by-then-outmoded glass plates using a heavy, boxy camera that had to be transported to the theater along with a battery of auxiliary lights. (Even these fixtures would become old-fashioned in time, but McBean had wisely bought out a supply of the discontinued light bulbs and used this equipment for years.)

Then, in the studio, the process of retouching and reworking began. At one point in his successful career, McBean employed two retouchers full-time, who were called "finishers." They were responsible for erasing the awkward wig joins, the forehead lines, the unglamorous wrinkles and unattractive facial marks. On average, it took McBean and his workers ten seconds to print each glossy, two hours to handle fifty glass negatives.

The cost of the photo call for Ivor Novello's *Careless Rapture* in 1937, without the photographer's fee, was £250, a large sum in those days. McBean recalled later in his career that in the 1930s many producers would cut the photo call altogether, to save expenses. McBean would then have to impress upon the wary producer "how soon a good display of photographs outside the theatre" would "pay for itself in money directly into the box office."

Although these McBean pictures have become precious, glorious documents of theater history, they were hardly thought of this way when they were taken. The producers and managers wanted them for entirely commercial purposes, to lure people walking outside the theaters into the box offices, and to coax readers of magazines to also visit (or telephone) the box offices, or ticket agencies.

The theater's press agent was McBean's principal conduit to the stars, and the producer's key instrument in choosing which photos would be used. But his or her decision was hardly the last word. In between the proofs and the theater fronts or magazine pages lay a dangerous minefield of other highly opinionated souls: the producer, the actor in question (and his or her agent), the magazine's picture editor, and McBean himself. It was invariably the actor who caused the most trouble.

Edith Evans, among many monarchs of the stage whose career McBean documented, had utter confidence in his work, because he made her as beautiful in his photographs as she magically gave the illusion of being on the stage. Sagging eyelids and extra chins were corrected cosmetically by retouching, and McBean confessed that the soft-focus lens had been "designed" for Dame Edith.

His first work for *The Sketch* was of Evans as Lady Fidget in *The Country Wife*, at the Old Vic Theatre in 1936, designed by Oliver Messel. When she played the part of Rosalind in *As You Like It* for the Old Vic on her fiftieth birthday, in 1938, she refused to be photographed, using the excuse that her wig wasn't right. On hearing which photographer had been assigned, she exclaimed: "Oh, why didn't you tell me it was dear Mr. McBean? He will retouch us all out of recognition."

Vivien Leigh always hated her own hair, and had a large selection of wigs at her disposal. When Ivor Novello asked McBean to photograph him in 1936, he was aware that he was in danger of losing his famous matinée-idol looks. "I am forty-four, and the profile won't last forever," he candidly mused to his photographer. McBean and his photo-finishers made sure that the actor's good looks lasted until the day of his death, in 1951, after a performance of his romantic operetta *King's Rhapsody* at the Palace Theatre.

A factor of McBean's penchant for the surreal involved his use of montage – several photos cut up and arranged in a novel way. One of the most famous before the war was the "design" he dreamed up for the H. M. Tennent production of Noël Coward's *Design for Living* in 1939. Three shots of the stars, Diana Wynyard, Rex Harrison and Anton Walbrook, were used for one image, the design conveyed by a T-square surmounted on an architectural drawing in the background. It so artfully hinted at the licentious theme of the comedy that the image was used for the show's poster. (Tennent in fact had three photographers working on this production, but McBean's shots were obviously the most successful.) A later montage image was used for the poster for the famous John Gielgud wartime revival of Wilde's *The Importance of Being Earnest*.

The Second World War caused logistical as well as personal problems for McBean. With the temporary shutting-down of London's theaters after the declaration of war in September, 1939, work for the West End came to a halt. There were still touring productions, but McBean's volume of theater work declined. As the Blitz began, the studio in Belgrave Road was closed. McBean moved as many of the glass negatives as possible to an uncle's home in Bath in a "three-ton lorry with faulty brakes." Some were damaged, and the bombings inflicted casualties on several of the plates left in the Victoria studio, among them the shots of Ivor Novello in his *Happy Hypocrite* and *Careless Rapture*.

The series of portraits continued only for a while in *The Sketch*. The more lowbrow *Picture Post* (a British counterpart to the American *Life* magazine) used a McBean portrait of the actress Diana Churchill that showed only her disembodied head, under a kitchen chair. The picture was taken up by German propaganda, which mistakenly thought she was the Prime Minister's daughter, and McBean was denounced by the *British Journal of Photography* as a surrealist charlatan. (The journal later apologized, after a barrage of angry letters from its readers.)

The war meant that even the provincial theaters were at risk from the Luftwaffe. Beatrice Lillie appeared in a theater in Bristol in a tour of Noël Coward's *Tonight at 8.30*, which McBean photographed for *The Sketch*. One week later, the theater was bombed.

Then came a wartime prison sentence for two-and-a-half years. In the prison camp in Lincolnshire, he took photos of his bunkmates and produced and designed plays.

McBean resumed his career after the war with photos for the Shakespeare Memorial Theatre in Stratford; these were also used in *The Tatler*. He set up a new studio near Covent Garden, in Endell Street, and began to reassociate himself with the West End managements. American musicals like Rodgers and Hammerstein's *Oklahoma!* and *Carousel* were seen at Drury Lane, and other American entertainment personalities followed. Mae West was photographed alongside the doll McBean had made of her in the 1930s. Katherine Hepburn appeared in Shaw's *The Million-airess* at the New Theatre wearing a spectacularly beaded Balmain gown, immortalized glowingly, and flowingly, by McBean.

Some work for commercial West End productions after the war proved typically troublesome because of the temperamental stars, or else caused much comment because of their wild compositions. But the actors and actresses continued to adore "dear Angus," knowing full well that he would bring out their best and most attractive points.

When McBean was asked to photograph revue favorites Hermione Baddeley and Hermione Gingold in a revival of Noël Coward's *Fallen Angels* at the Ambassadors' Theatre (1949), the two Hermiones were not on speaking terms. Their dressing rooms, it was said, had been created from the star dressing room sawn in half and divided by a brick wall. The resulting photos – which were cleverly put into a montage that was used for the poster – were so ebulliently good and fair-minded that the ladies kissed and made up.

In one of McBean's most inspired (and theatrical) gestures, he had the full-size producer Hugh Beaumont (of the firm of H. M. Tennent) manipulating tiny cardboard cut-outs of Emlyn Williams and Angela Baddeley on a Pollock's toy theater for his mounting of Terence Rattigan's *The Winslow Boy* at the Lyric Theatre (1946). This montage caused much comment and was used once again for publicity.

Actresses could always be counted on to comment on his work. Diana Wynyard told the photographer on one occasion that a particular proof was "very good," but that that it gave her that "I don't think I ought to have another cocktail" expression. The results of the photo call for *Duel of Angels* (Christopher Fry's version of Jean Giraudoux's last play) at the Apollo Theatre in April 1958 would result in anguish for McBean and the producers. Of the seventy shots taken by McBean and then refinished by his staff, only twenty-five were approved by the two stars. Claire Bloom had vetoed all the photos in which Vivien Leigh looked more beautiful, and vice-versa.

The association with Vivien Leigh and Laurence Olivier thrived

for many years. McBean had photographed Leigh in a popular wartime revival of Shaw's *The Doctor's Dilemma*. After the war, for the London production of Tennessee Williams's *A Streetcar Named Desire*, McBean was sent up to Birmingham for the try-out. There was a fight scene between Leigh and Bonar Colleano (playing the part that Marlon Brando had originated in New York). During the scene, McBean's assistant Kurt Hutton took a picture from between McBean's legs. Vivien Leigh hated the shot, but it wound up on the cover of *The Picture Post*.

The usual time for a McBean photo call, during the out-of-town tryout or the London preview or dress rehearsal, was from about 10 A.M. to a late lunch. After the war, there came the new American fashion for photographing the play directly after the curtain had come down, at night. The Drury Lane production of *Oklahoma!* had to be done on two successive nights, for the total four hours permitted by American Actors Equity, which legally oversaw the American cast. For the production a decade later of *West Side Story*, which tried out at the Opera House, Manchester, *Life* magazine took up two hours in a photo session, leaving McBean only two hours to work. He claimed to have been helped in that brief time by the Oliver Smith sets, which could be changed swiftly.

One famous musical – also with set designs by Oliver Smith – that McBean did not get to photograph on its London premiere was *My Fair Lady*, which opened at Drury Lane in 1958. The reason was that the costume designer of the show, Cecil Beaton, managed to convince H. M. Tennent that he himself would do the stage photographs. McBean did do photos of the Drury Lane with a replacement cast: it is interesting to contrast the styles of Beaton and McBean with the same physical production.

By this time, McBean was employing up to ten assistants to arrange the theater shoots and to photograph and retouch the pictures. In his Endell Street studio, the succession of portraits continued, some in color. *The Illustrated London News* wanted a portrait of the Hollywood producer Sam Goldwyn. E. M. I. records commissioned McBean to do portraits of its artists that could be used for record covers.

He photographed the Beatles just as they were becoming famous, for the record cover for their E. M. I. album *Please Please Me*, in color, and then again a few years later in the same location for a series of Beatles compilations. He had wanted to shoot the four boys besieged by a horde of screaming girls, but E. M. I. vetoed that idea when it was realized that they would have to obtain a written permission from each girl in the picture.

By the 1960s McBean had abandoned his cumbersome half-plate camera in favor of a 4-by-5-inch Sinar Monorail. For the color shots, he switched from hard to soft lenses. However, he disliked using color film because it was impossible to retouch the negatives.

McBean never photographed Queen Elizabeth II, stating that he would have been "shaking in fear," afraid he would call her not "Ma'am" but "Ducks." He also avoided ballet photography, because he disliked the idea of having to use high-speed exposures. But he did many portraits of famous dancers in his studio: Martha Graham, Tamara Toumanova, Ram Gopal, and others.

In the 1950s, McBean's knack for interior design (so obvious from the settings in his photographs) found a new, real outlet. He redid rooms in his house in Islington's Gibson Square, and redesigned the interior of the Academy Cinema in Oxford Street, using the strange theatrical touches for which he had become well-known. McBean had a house in Bedingfield, Sussex, East Anglia (near Sir Frederick Ashton), "with Elizabethan additions," which he also decorated.

His mastery of Shakespearean and classical-theater photography continued for the Old Vic Theatre in London, the Shakespeare Memorial Theatre at Stratford, and the new National Theatre, which began at the Old Vic. One of his seventeen last assignments was the *Othello* with Laurence Olivier at the National, which produced some memorable images of a legendary, dangerously brave performance.

As the British theater moved inexorably in the direction of harsh realism of the seedy bed-sitter – John Osborne's *Look Back in Anger*, at the Royal Court Theatre in 1957, is usually given as

the offending beginning of this trend – the theater of glamour, illusion and beauty which McBean had so wonderfully captured began to fade. And McBean, as the official Royal Court photographer, was loathe to emulate the scrappy, grainy snapshots that were required to illustrate this new movement.

"I am bored with the modern anti-hero and anti-theatre," he stated. "The present poverty in the Arts stems, as indeed does most poverty, from lack of money," he added. Indeed, it was poverty that the late 1950s and '60s producers cried when the subject of a photo call came up; it was cheaper and easier to have someone snapping away during a dress rehearsal, without having to set up his own lighting and engaging the union cast in a further expensive call.

Late in his career, McBean had two publishing projects that sadly never bore fruit. One was to be a lavish tome of his Shakespearean photographs, to honor the four-hundredth anniversary of the Bard's birth in 1964. The other was an autobiography, for which McBean had the assistance of the author Sewell Stokes. Robert Morley – who had been helped with his own biography by Stokes – suggested a title: "It Can't Be Beaton." McBean suggested another: "Look Back in Angus." (Some quotations in this essay are taken from the typescript of this unfinished work.)

A Darker Side of the Moon: The Photographs of Angus McBean, a retrospective of Angus McBean's photographs, was exhibited in 1976 in York, England, at the Impressions Gallery, one of the few photographic galleries in England at that time. By this time, he had sold his archive to Harvard University, some forty thousand glass plates, weighing eight tons.

The first book on his work appeared in 1982 (*Angus McBean*, Quartet Books, London, with Adrian Woodhouse). Three years later, in 1985, a second collection appeared (*Angus McBean*, Masters of Photography series, Macdonald and Co., London). The notice caused by the exhibitions and books coaxed McBean out of retirement to do a series of fashion photos in color for the French magazine, *L'Officiel*, which led to further work for *Vogue*. He worked sporadically for the newly-appreciative worlds of fashion and popular culture until his death in 1990.

Angus McBean's photographs are preserved in many institutional collections, including (in addition to the photographer's archive of negatives and proofs in the Harvard Theatre Collection) the Victoria and Albert Museum, the British Library, and the National Portrait Gallery (London), the Shakespeare Library (Stratford-upon-Avon), and the Mander and Mitchenson Collection (Greenwich, London).

SHAKESPEARE PRODUCTIONS

RICHARD BURTON as Henry, Prince of Wales and King, in *Henry IV*, Parts I and II. Shakespeare Memorial Theatre, Stratford-upon-Avon, 1951.

Richard Burton (1925–1984) appeared in both parts of *Henry IV* in the Stratford production in 1951, as part of a Cycle of the Historical Plays on the occasion of the Festival of Britain. Part I was directed by John Kidd and Anthony Quayle, and Part II was directed by Michael Redgrave. Also in the cast were Harry Andrews, Alan Badel, Barbara Jefford, Rachel Roberts, and Ian Bannen. Anthony Quayle played Sir John Falstaff.

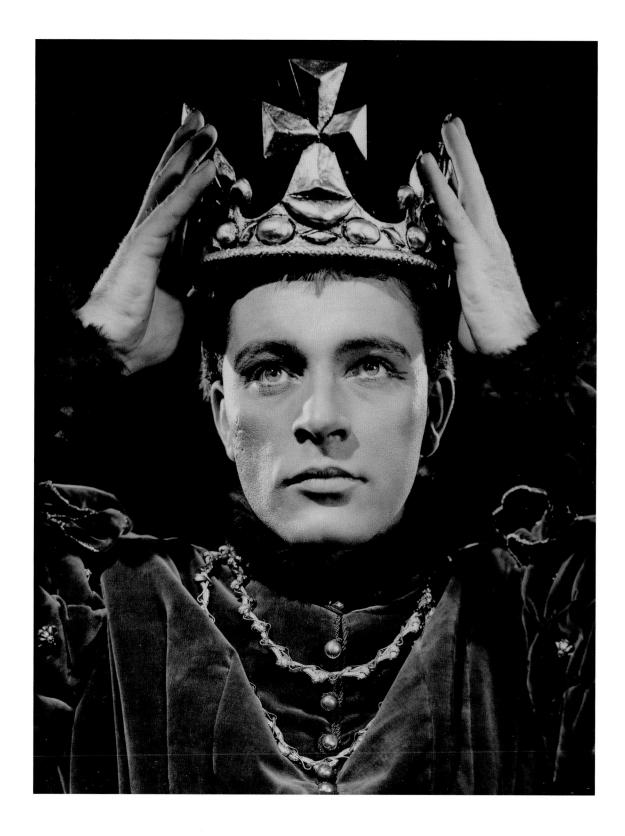

[3]

Powys Thomas as Oberon and Muriel Pavlow as Titania in *A Midsummer Night's Dream*. Shakespeare Memorial Theatre, Stratford-upon-Avon, 1954.

The imaginative costumes and scenery, designed by Motley (the collective name of the design team comprised of Elizabeth Montgomery and the sisters Margaret and Sophia Harris), were the chief attractions of this Stratford production. The director, George Devine, reportedly regarded Oberon and Titania as "unpleasant, cruel, nasty people," and the fairies were made to be grotesque and unsentimental. Oberon wore a cloak of leaves that allowed him to disappear into the scenery when he turned his back.

Charles Laughton as Bottom in *A Midsummer Night's Dream*. Shakespeare Memorial Theatre, Stratford-upon-Avon, 1959.

This production of *A Midsummer Night's Dream*, featuring Charles Laughton, was directed by Peter Hall. Laughton's spellbound Bottom did not have the customary ass's head, just the ears and hooves. Kenneth Tynan wrote that Laughton's Nick Bottom "behaves in a manner that has nothing to do with acting, although it perfectly hits off the demeanor of a rapscallion uncle dressed up to entertain the children at a Christmas party."

Laughton was born in Scarborough, Yorkshire, England, and served during the First World War with the Huntingdonshire Cyclist Regiment. After many stage credits, his attentions turned mostly to film, and in 1950 he became an American citizen. In 1958, however, Laughton returned to the London stage, in Jane Arden's *The Party*, whose cast included Elsa Lanchester and Albert Finney. He made his final theatre appearances in *A Midsummer Night's Dream* and *King Lear* at the Shakespeare Memorial Theatre in 1959, although his failing health may have compromised both performances.

A Midsummer Night's Dream. Shakespeare Memorial Theatre, Stratford-upon-Avon, 1949.

Michael Benthall's 1949 Stratford production emphasized the balletic elements of the play, presenting distinctly mature and feminine fairies in the manner of a corps de ballet. Mendelssohn's famous score was employed as incidental music.

Written in 1595 or 1596 and first published in 1600, and therefore among Shakespeare's early works, the romantic play relates the adventures of four young Athenian lovers and a group of amateur actors, and their interactions with the Duke and Duchess of Athens, Theseus and Hippolyta, and the fairies who inhabit a moonlit forest. The play is one of Shakespeare's most popular works for the stage and is widely performed across the world. It has been supposed that the play might have been written for a wedding, while others suggest it was written for the Queen to celebrate the feast day of St. John. However, no concrete evidence exists to support either theory. In any case, it would have been performed at the Theatre and, later, the Globe in London.

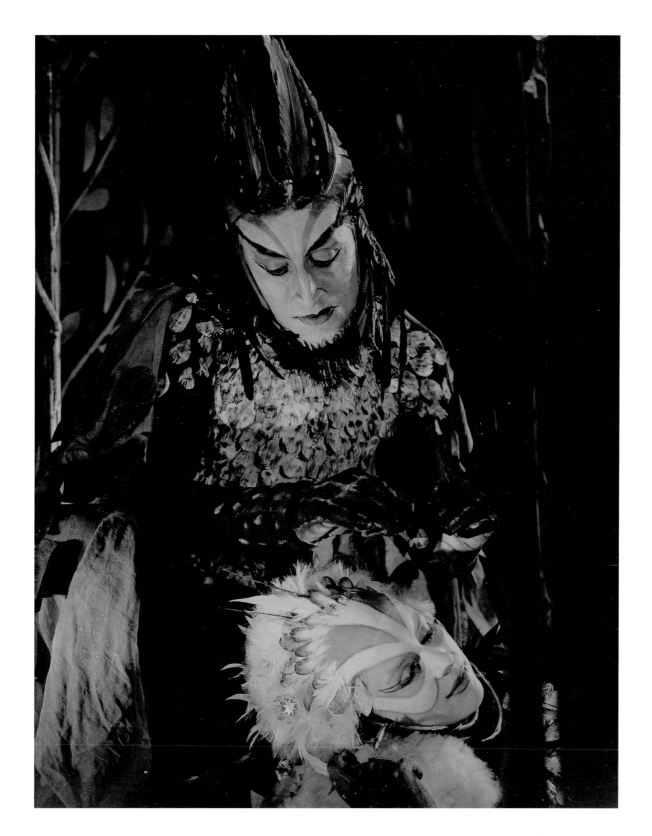

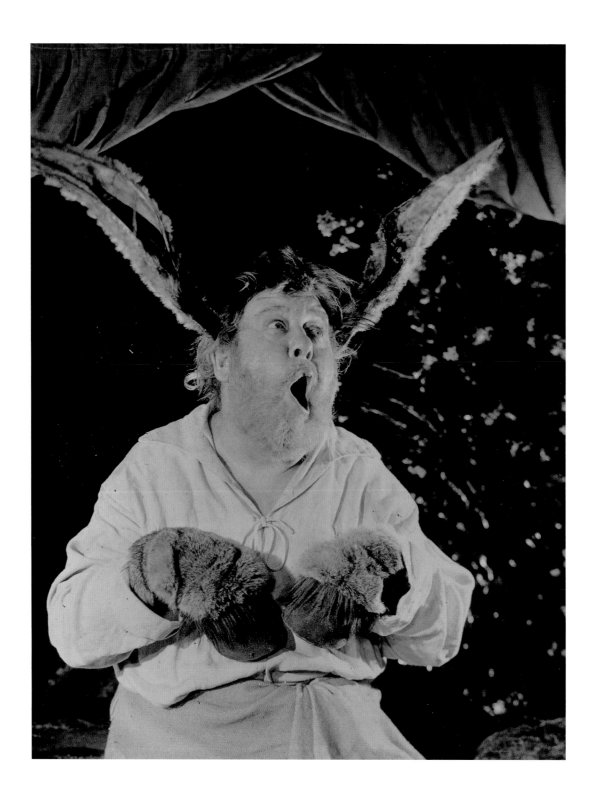

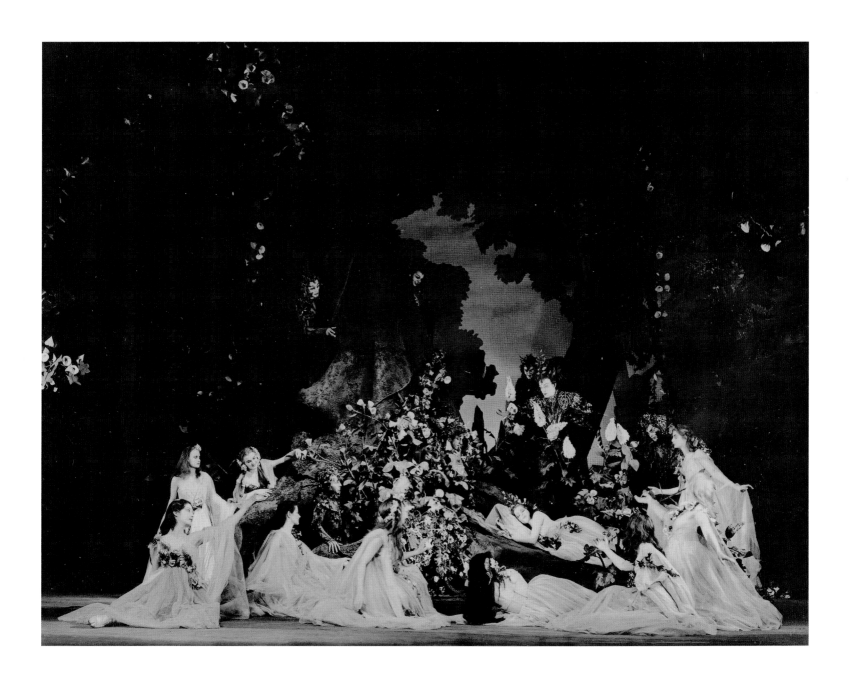

Laurence Olivier in *Macbeth*. Shakespeare Memorial Theatre, Stratford-upon-Avon, 1955.

The attraction of this Stratford *Macbeth*, designed by Roger Furse and directed by Glen Byam Shaw, was unquestionably the appearance of Laurence Olivier as Macbeth and Vivien Leigh as Lady Macbeth. The prospect of seeing this popular theatrical duo as the nefarious Scottish royal couple must have been irresistible. Olivier's association with this notoriously difficult, bad-luck play went back to his Birmingham Repertory days in 1928, when he played Malcolm in a modern-dress production. He had attempted the role of Macbeth once before, at the Old Vic in 1937, without any particular success.

Of the 1955 Stratford production, Kenneth Tynan wrote in *The Observer* that "Nobody has ever succeeded as Macbeth," but that Olivier's distinguished performance had the advantage of creating an arc of increasing despair that culminated in a conclusion of great power. His portrayal was hailed by Harold Hobson in *The London Times* as "the best Macbeth since Macbeth's."

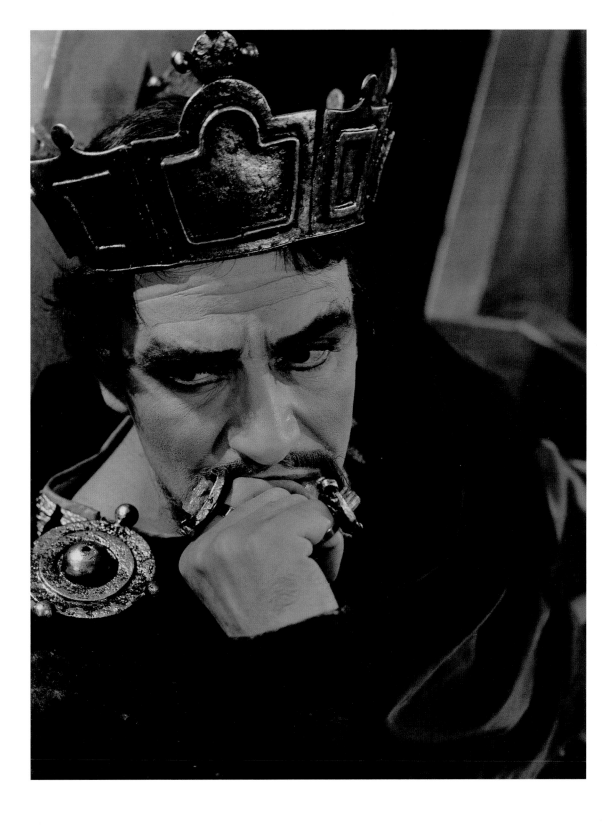

Vivien Leigh in *Macbeth*. Shakespeare Memorial Theatre, Stratford-upon-Avon, 1955.

In 1955, Vivien Leigh appeared as Lady Macbeth opposite Laurence Olivier, in the same season in which they appeared in *Twelfth Night*.

Leigh received scant praise for her portrayal of Lady Macbeth, although the critic Harold Hobson noted in *The London Times* that Leigh's "pale and exquisitely lovely Lady Macbeth does at least explain why Macbeth married her, a mystery that too many Lady Macbeths leave unelucidated."

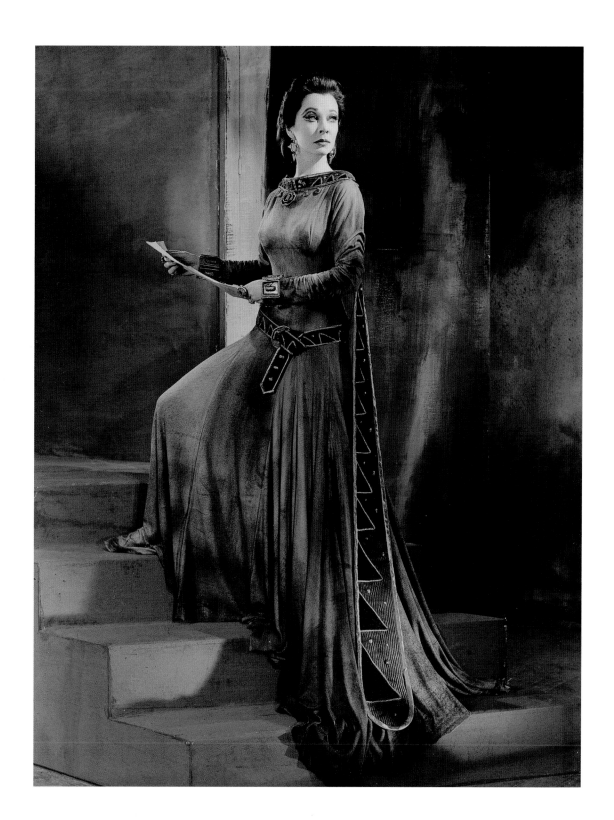

MICHAEL DENISON as Sir Andrew Aguecheek, William Devlin as Antonio, and Vivien Leigh as Viola (disguised as Cesario) in *Twelfth Night*. Shakespeare Memorial Theatre, Stratford-upon-Avon, 1955.

By 1955, Vivien Leigh had sufficiently recovered from a breakdown to perform in three productions during the Stratford season, and she was able to complete the season with considerable success. Along with *Twelfth Night*, she appeared in *Titus Andronicus*, the first time that difficult, bloody play was produced at Stratford, and in *Macbeth*, for which she received much praise. *Twelfth Night* was directed by John Gielgud and also starred Laurence Olivier as Malvolio. Previously Gielgud had enjoyed considerable success in the role of Malvolio at Sadler's Wells in 1931, just as Olivier had as Toby Belch at the Old Vic in 1937.

ZOË CALDWELL as Margaret and Michael Redgrave as Benedick in *Much Ado About Nothing*. Shakespeare Memorial Theatre, Stratford-upon-Avon, 1958.

This production was directed by Douglas Seale, and the fashionable later-period costumes were by Motley. The scene between Margaret and Benedick takes place at the beginning of the last act.

The Australian-born actress Zoë Caldwell (b. 1933) has had a career of impressive range and variety. She achieved great success on Broadway in such plays as *The Prime of Miss Jean Brodie* and *Master Class*. Michael Redgrave (1908–1985) starred in productions at Stratford, at the Old Vic, with Gielgud at the Queen's Theatre, and, later, on Broadway. In this production the role of Beatrice was played by Googie Withers.

IAN BANNEN as Orlando and Vanessa Redgrave as Rosalind (disguised as Ganymede) in *As You Like It*. Royal Shakespeare Company, Aldwych Theatre, London, 1961.

Vanessa Redgrave (b. 1937) is the multitalented daughter of Michael Redgrave and a member of an English theatrical dynasty. She has been a great Shakespearean actress (in addition to her many other West End and film credits), dating from her engagement in 1959 with the Shakespeare Memorial Theatre.

On March 20, 1961 the Shakespeare Memorial Theatre was reborn as the Royal Shakespeare Company, at which time this production appeared both in Stratford and at the Aldwych Theatre in London. The first-season program explained, "This theatre is now the Royal Shakespeare Theatre's London home. Its stage, with its new jutting apron, is the same as that at Stratford-upon-Avon. Both theatres are directed by Peter Hall."

The Scottish-born actor Ian Bannen (1928–1999) played Orlando opposite Redgrave's Rosalind, under the direction of Michael Elliott. Richard Negri's costumes were anything but period-correct.

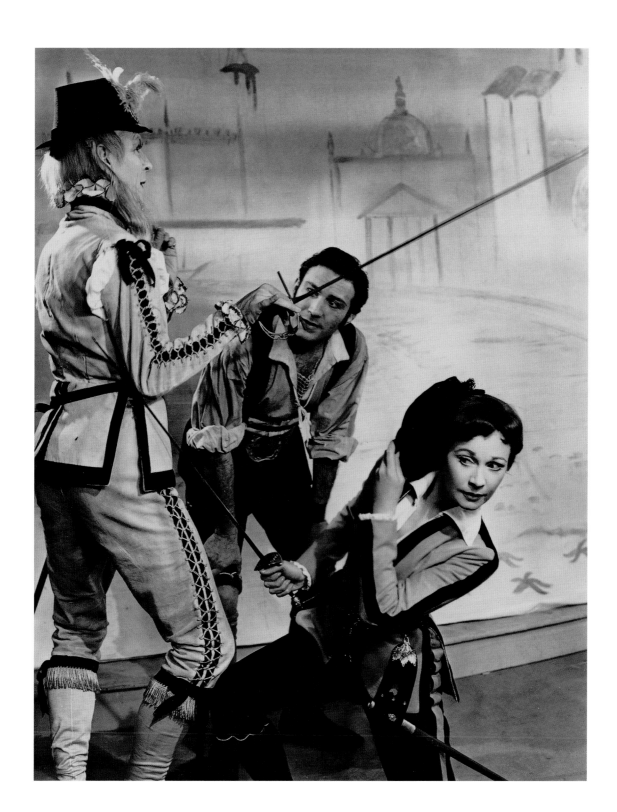

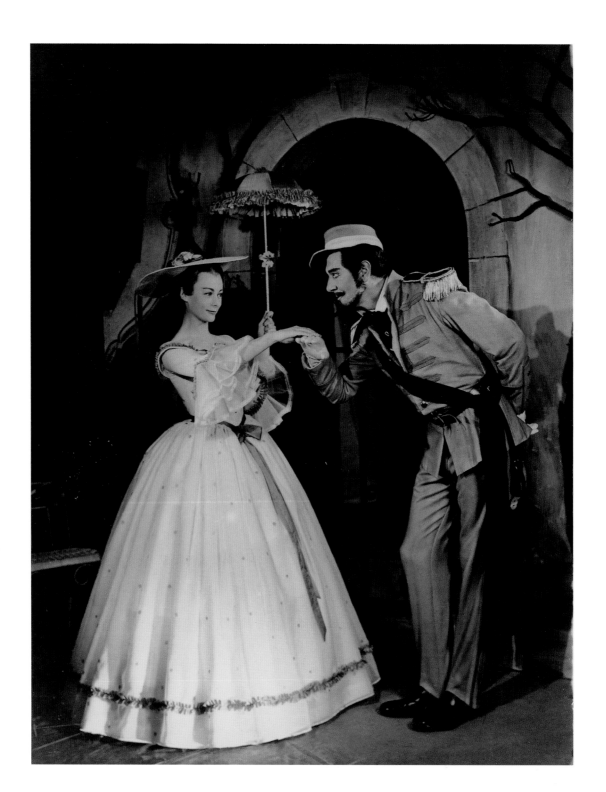

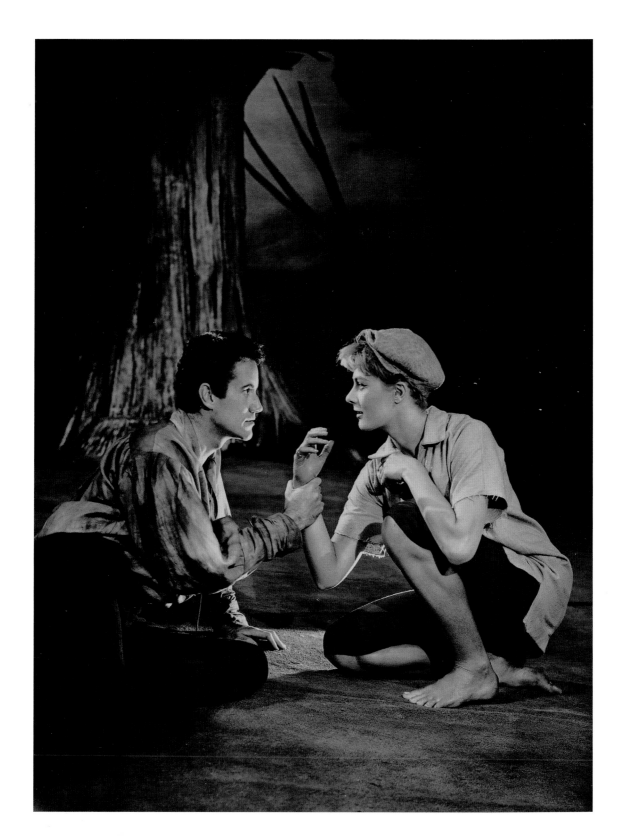

P AUL SCOFIELD as Lear and Diana Rigg as Cordelia in *King Lear*. Royal Shakespeare Company, Stratford-upon-Avon, 1963.

The celebrated stage actor Paul Scofield (1922–2008) – who declined a knighthood several times, supposedly because he did not fancy being called "Sir Paul" – appeared for the first time at the Shakespeare Memorial Theatre in Stratford during the 1946–1947 season. In 1962, after his success as Sir Thomas More in the original stage version of Peter Bolt's *A Man for All Seasons* (1960), he returned to Stratford for Peter Brook's production of *King Lear*, with Irene Worth as Goneril and Diana Rigg (b. 1938) as Cordelia. During this period the Royal Shakespeare Company productions also appeared at the Aldwych Theatre in London.

Although McBean's close relationship with Stratford had largely ended by this time, he was invited to photograph this production. He rated the production "magnificent" and his photographs a great success.

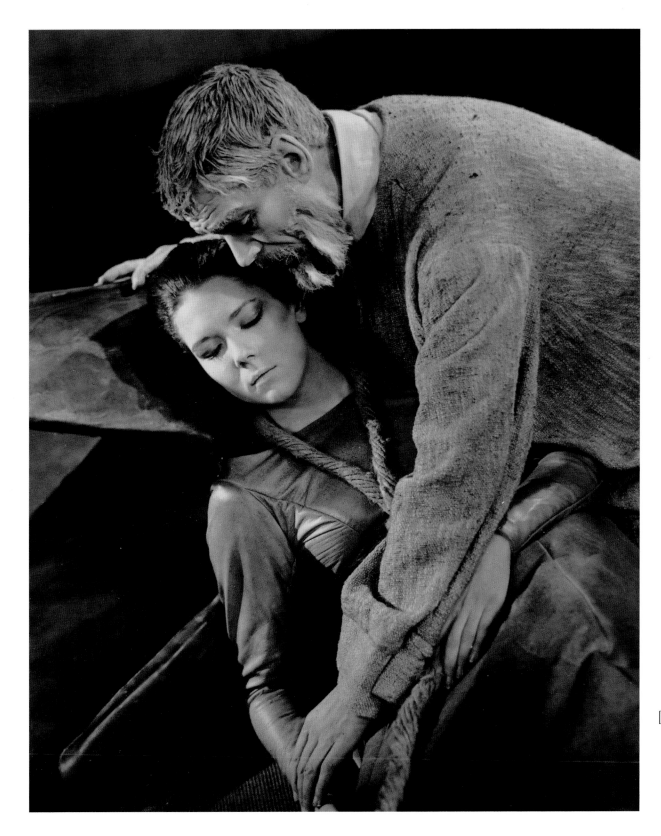

EDITH EVANS as the Countess of Rossillion and Zoë Caldwell as Helena in *All's Well That Ends Well*. Shakespeare Memorial Theatre, Stratford-upon-Avon, 1959.

For this production of *All's Well That Ends Well* at Stratford in 1959, director Tyrone Guthrie had the collaboration of Tanya Moiseiwitsch as designer, together with an accomplished cast. Edith Evans (1888–1976) had a long, varied, and distinguished career both in comedy and drama. She is remembered particularly for her Shakespeare, Shaw, and Restoration roles, as well as for her definitive Lady Bracknell in Wilde's *The Importance of Being Earnest*, which is preserved in the 1951 film directed by Anthony Asquith.

DOREEN ARIS as Miranda and John Gielgud as Prospero in *The Tempest*. Shakespeare Memorial Theatre, Stratford-upon-Avon, 1957.

In the 1957 Stratford production of *The Tempest*, directed by Peter Brook, John Gielgud (1904–2000) appeared as Prospero and Doreen Aris as his daughter, Miranda. This was the third of Gielgud's four appearances in this play, and the most embittered. As well as directing, Brook co-designed and co-composed the play. At the time of this production, Brook had directed a *Hamlet* for the same company, which later appeared at the Moscow Art Theatre; a Paris production of *Cat on a Hot Tin Roof*; a New York Metropolitan Opera remounting of *Eugène Onegin*; and the London version of the Parisian musical *Irma la Douce*, which later went to Broadway.

FAY COMPTON as Juno in *The Tempest*, "Masque of the Seasons," with three mermaids. Old Vic Theatre Company, London, 1954.

The popular West End actress Fay Compton (1894–1978) began her career in pantomime and musical comedy, later switching gracefully between Shakespeare and lighter fare. She also appeared in more than fifty films, usually in supporting roles. For the 1953–1954 Stratford season a masque-like production of *The Tempest* was mounted, in which the role of Juno called for her to sing as well as act. The production was directed by Robert Helpmann and designed by Leslie Hurry. Also in the cast were Claire Bloom as Miranda, Michael Hordern as Prospero, Richard Burton as Caliban, Robert Hardy as Ariel, and John Neville as Ferdinand.

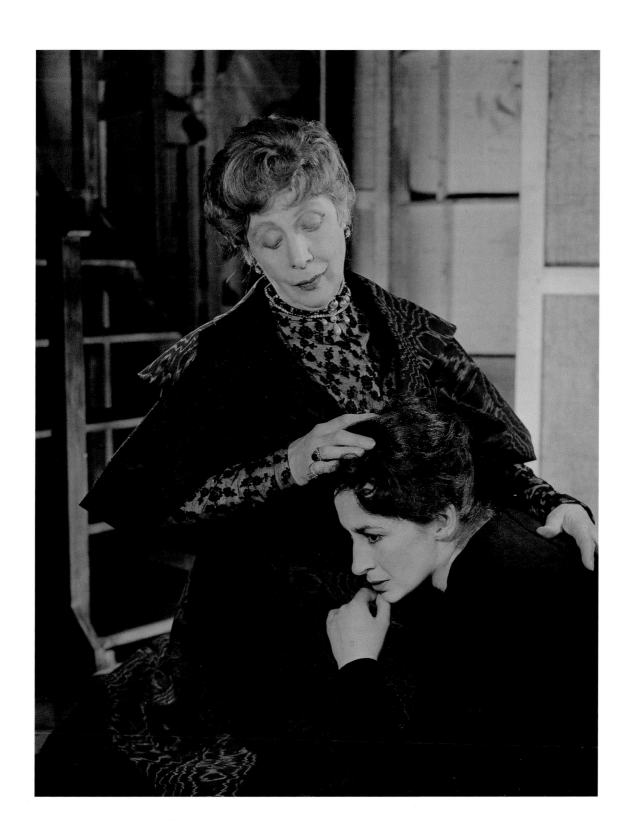

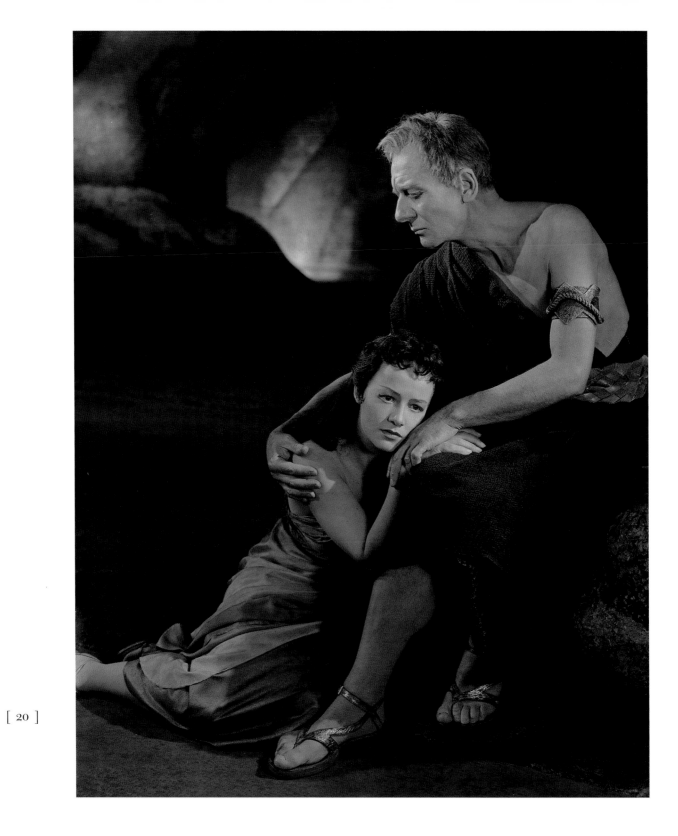

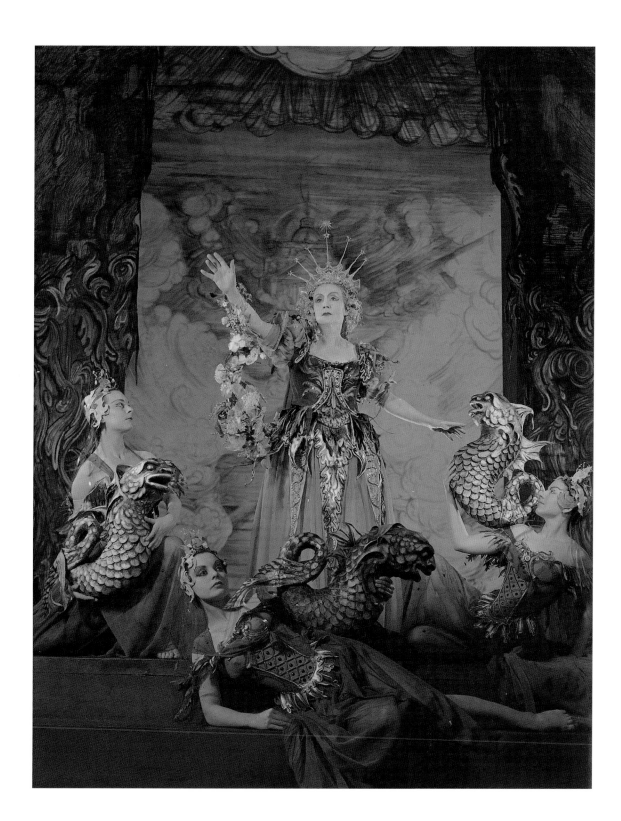

ALEC CLUNES as Caliban in *The Tempest*. Shakespeare Memorial Theatre, Stratford-upon-Avon, 1957.

Alec Clunes (1912–1970) appeared as a particularly grotesque and beastly Caliban in the 1957 Peter Brook *Tempest*. Clunes began a long association with the Old Vic Theatre in 1936. There he played several important parts, but never achieved the status of actors such as Olivier, Gielgud, or Richardson. He joined the Shakespeare Memorial Theatre in 1957 to play Brutus and Caliban. This production of *The Tempest* transferred to the Theatre Royal, Drury Lane later that year. Two years later, at the same theatre, he took over the part of Henry Higgins in *My Fair Lady* from Rex Harrison.

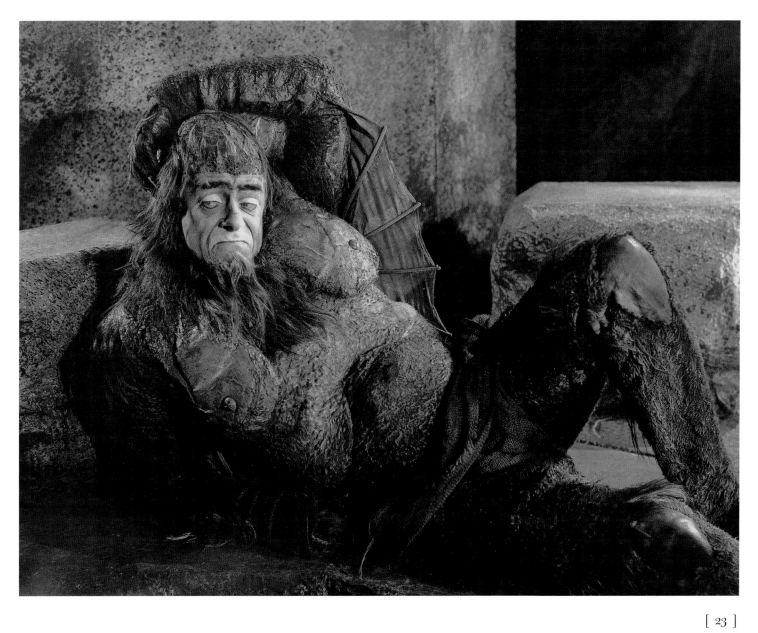

Diana Wynyard as Portia in *The Merchant of Venice*. Shakespeare Memorial Theatre, Stratford-upon-Avon, 1948.

Diana Wynyard (1906–1964), married to the director Carol Reed, was active on stage and screen throughout the inter-war years and well into the 1950s. Her range was considerable, from boulevard comedy to Shakespeare; today she is best remembered as the head of the family in the 1933 film of Noël Coward's stage epic *Cavalcade*, whose film adaptation received the Academy Award for Best Picture. Joining the Shakespeare Memorial Theatre at Stratford in 1948, she played Portia, Katherine, Lady Macbeth, Beatrice, and other parts, all in that one season. In this production of *The Merchant of Venice*, directed by Michael Benthall, with designs by Sophie Fedorovitch, Robert Helpmann played Shylock and Paul Scofield played Bassanio.

Emlyn Williams as Shylock in *The Merchant of Venice*. Shakespeare Memorial Theatre, Stratford-upon-Avon, 1956.

Emlyn Williams (1905–1987) seldom performed in Shakespeare's plays, but he was briefly a member of the Old Vic company (in 1937) and the Shakespeare Memorial Theatre at Stratford (in 1956). In the latter season, he portrayed Shylock in Margaret Webster's production of *The Merchant of Venice*, pictured here, as well as Iago in *Othello* and Angelo in *Measure for Measure* – a part he had first essayed at the Old Vic twenty years earlier.

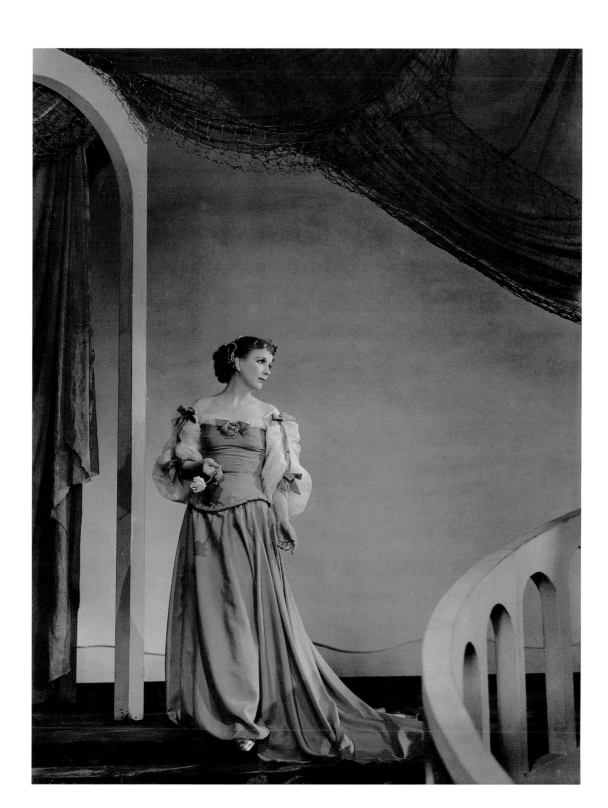

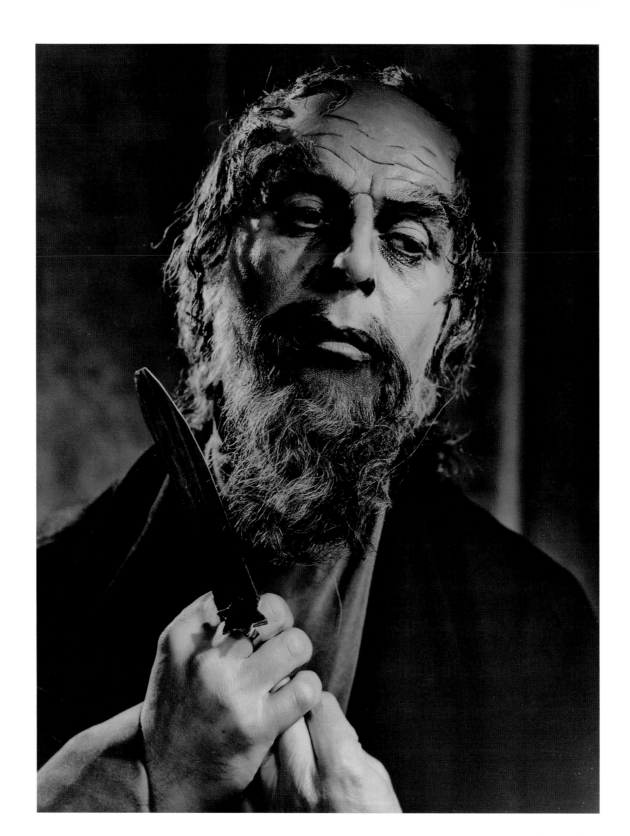

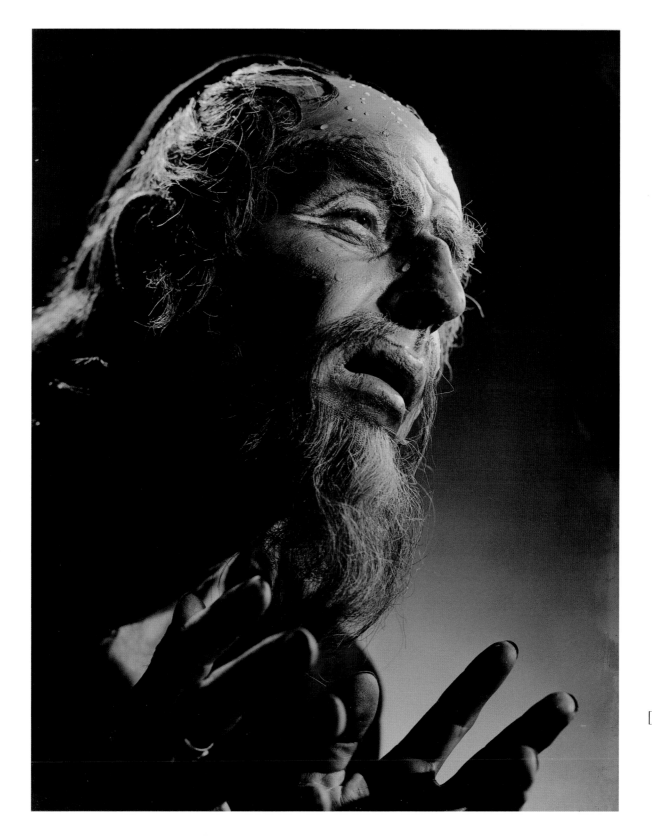

ROBERT HELPMANN in *Hamlet.*
Shakespeare Memorial Theatre, Stratford-
upon-Avon, 1948.

Robert Helpmann (1909–1986), the Aus-
tralian-born ballet dancer and actor, had the
unique distinction in the 1940s of appearing as
Hamlet both in the play and the ballet, the latter
with his own choreography. Remembered today
for his ballet career as well as his film roles for
the Powell and Pressburger partnership (*The
Red Shoes*, *The Tales of Hoffmann*), Helpmann
made several respected forays into Shakespeare
in addition to this 1948 portrayal of the Danish
prince at the Stratford.

McBean must have found Helpmann a bizarre
and surreal subject, as the actor wildly overdid
his makeup and histrionics. In this studio scene
the mood is aided by some eerily guttering can-
delabra that were likely not part of the stage set.

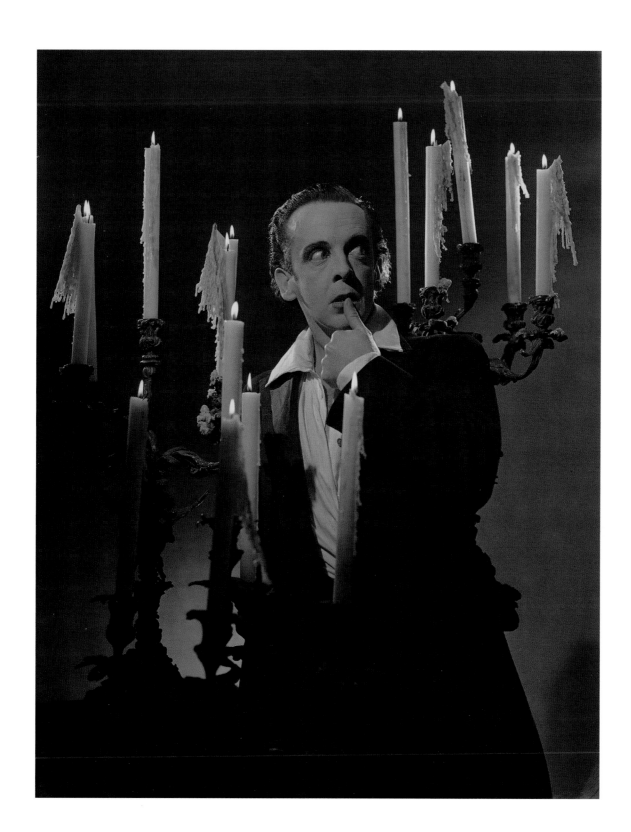

Laurence Olivier as Hamlet and Cherry Cottrell as Ophelia in *Hamlet*. Old Vic Theatre, London, 1936.

Laurence Olivier (1907–1989) made his first Shakespearean appearance as Katherine in *The Taming of the Shrew* in 1922 in a boys' production at the Shakespeare Memorial Theatre, Stratford. He first appeared as Hamlet at the Old Vic Theatre in 1936–1937, in an uncut version of this notoriously long play; later that season the production was taken to Kronborg Castle in Elsinore, Denmark. In 1948, Olivier appeared in his own film version of the play, for which he won Academy Awards for Best Actor and Best Picture.

This photograph was published in *The Sketch*, and his appearance in that magazine provided McBean with an entrée to any theatre. McBean recalled this as a "lovely, lively picture, pretty good considering that at that time I was using very slow plates indeed, at least by modern standards. I was rather apt to open the shutter and keep it open until the subject started to move!" Regarding Olivier's makeup, "He also painted a line under his eyes which ran down right across his cheekbone. When I commented on it, he said, 'Oh yes, tired boy stuff, don't you dare remove it with your bloody retouching, old boy.'"

Rosanna Seaborn as Cassandra in *Troilus and Cressida*, with Robert Emhardt as Priam, John Garside as Nestor, Colin Keith-Johnston as Hector, and Robert Harris as Troilus. London Mask Theatre production, Westminster Theatre, London, 1938.

This famous modern-dress production of *Troilus and Cressida* was the initial production of the London Mask Theatre, created by J. B. Priestley and Ronald Jeans. It was directed by Michael Macowan and designed by Peter Goffin. Other cast members included Max Adrian as Pandarus, Ruth Lodge as Cressida, and Oriel Ross as Helen.

Ron Haddrick as Hubert de Burgh and Christopher Bond as Arthur, Duke of Bretagne, with two executioners in *King John*. Shakespeare Memorial Theatre, Stratford-upon-Avon, 1957.

McBean claimed to have been the only photographer to have captured at least one production of every Shakespearean play, and for a time he entertained the idea of producing a volume devoted to the entire canon. He especially prized opportunities to photograph and add the less-often-produced plays, like *King John*, to his repertory. In this photograph of the gruesome Shakespeare history play, directed by Douglas Seale, Hubert de Burgh and his henchmen prepare to blind the young Arthur.

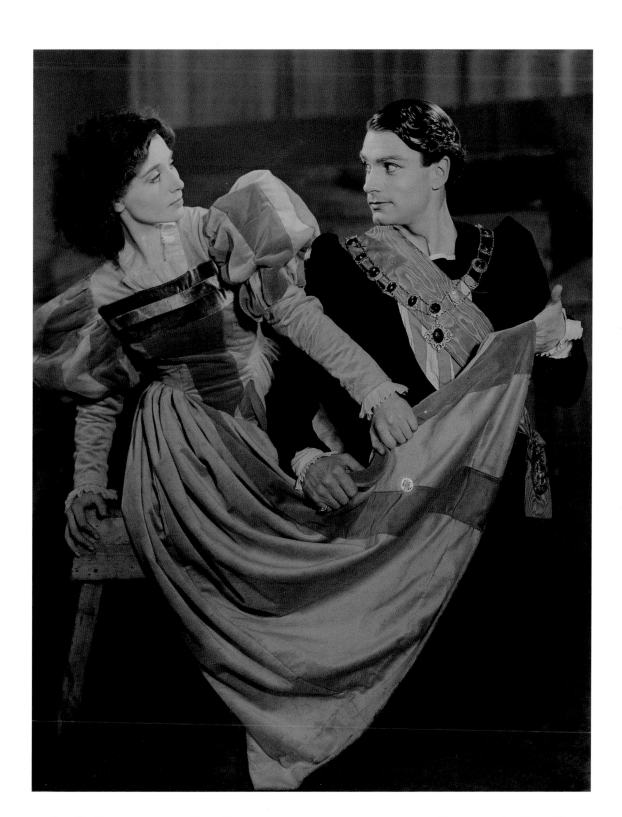

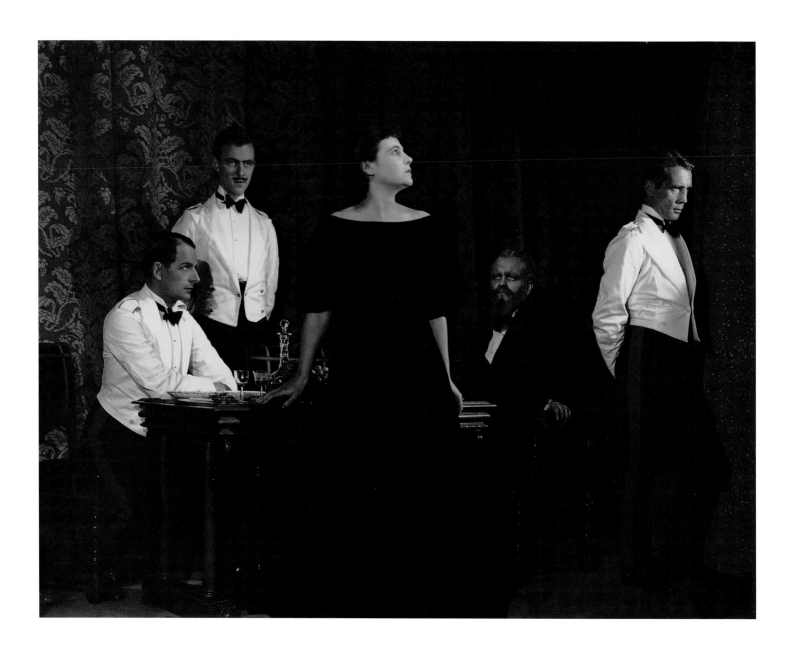

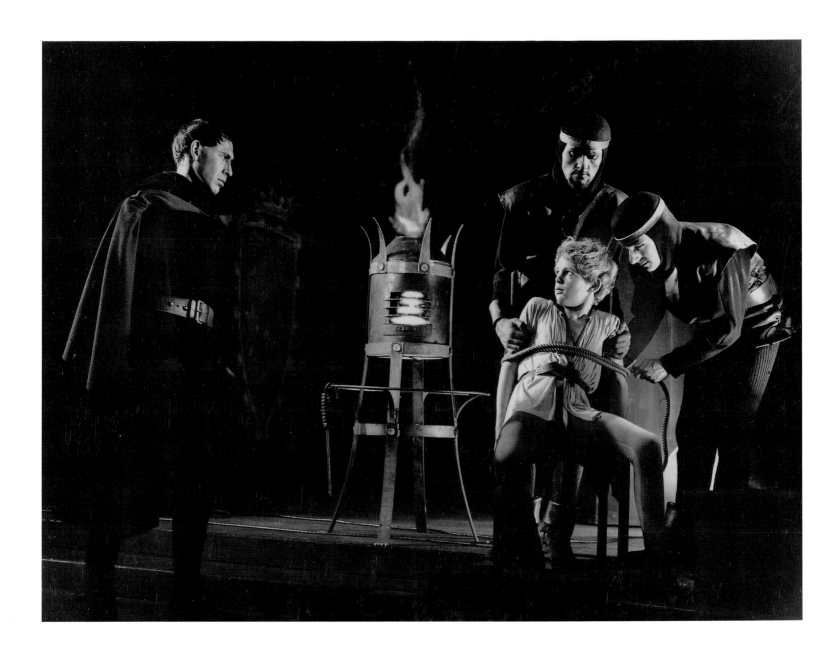

THE MERRY WIVES OF WINDSOR. Old Vic Theatre Company, London, 1959.

Shakespeare's comedy *The Merry Wives of Windsor* was a vehicle to enable the roguish fat knight Sir John Falstaff to make a reappearance after having been abandoned by his old companion Prince Henry, from the two parts of *King Henry IV*. Falstaff is bettered by the two clever wives, but in the end the scores seem to be happily settled.

This popular Old Vic production, directed by John Hale, opened on December 22, 1959. It starred Maggie Smith as Mistress Ford, Moyra Fraser as Mistress Page, and Joss Ackland as Sir John Falstaff. This photograph captures the final scene, as Falstaff is tormented by the fairies and masquers.

A portfolio of McBean's photographs from this production was published in *Theatre World*.

ORSON WELLES as Othello and Gudrun Ure as Desdemona in *Othello*. St. James's Theatre, London, 1951.

The legendary theater, film, and radio wunderkind Orson Welles (1915–1985) had numerous famous encounters with Shakespeare. He directed, and usually starred in, such stage curiosities as a black *Macbeth* (1936), a modern-dress (and scenery-less) *Julius Caesar* (1937), and eccentric, riveting films of *Macbeth* (1948), *Othello* (1952), and the conflation of history plays entitled *Chimes at Midnight* (1966). He appeared frequently on Broadway, but his only London appearance was in this production of *Othello* at the St. James's Theatre, presented by Laurence Olivier – but directed, of course, by Welles himself, who received above-the-title program credits. The Australian actor Peter Finch, later familiar in films, played his Iago.

LAURENCE OLIVIER as Othello and Maggie Smith as Desdemona in *Othello*. National Theatre Company, at the Old Vic Theatre, London, 1964.

One of the most controversial versions of *Othello* was John Dexter's production starring Laurence Olivier, first seen at the National Theatre in 1961, and later filmed for posterity. Olivier's flagrant Africanisms in make-up, wig, voice, and gesture were praised as an acting tour-de-force in the 1960s, but doubtless would be unacceptable today as vestiges of the burnt-cork minstrel tradition. The National Theatre production included Frank Finlay as Iago, Derek Jacobi as Cassio, Joyce Redman as Emilia, and Maggie Smith (b. 1934) as Desdemona. Smith was enough of a film star at the time for her participation to have necessitated a note in the program mentioning appearance "by arrangement with Associated British Elstree Studios Ltd."

McBean regarded this production as "the best production of any Shakespeare play that I have ever seen," one that "crowned my work at the National."

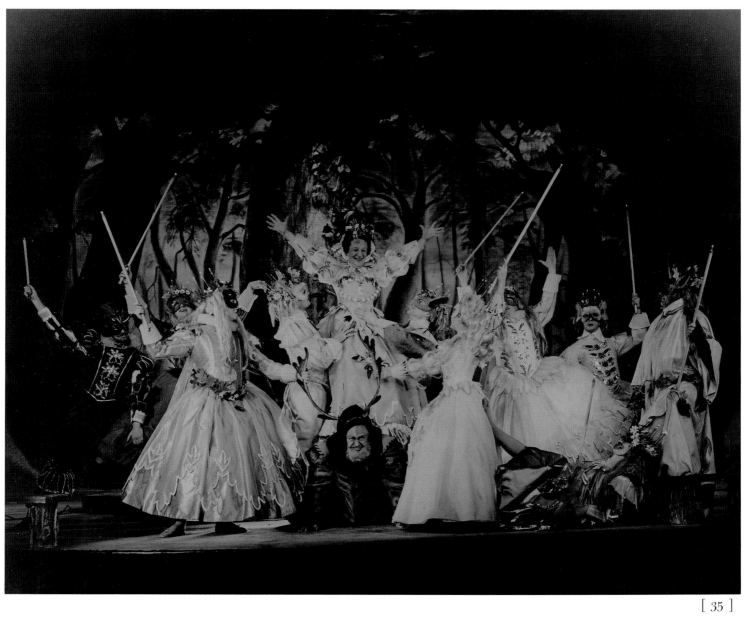

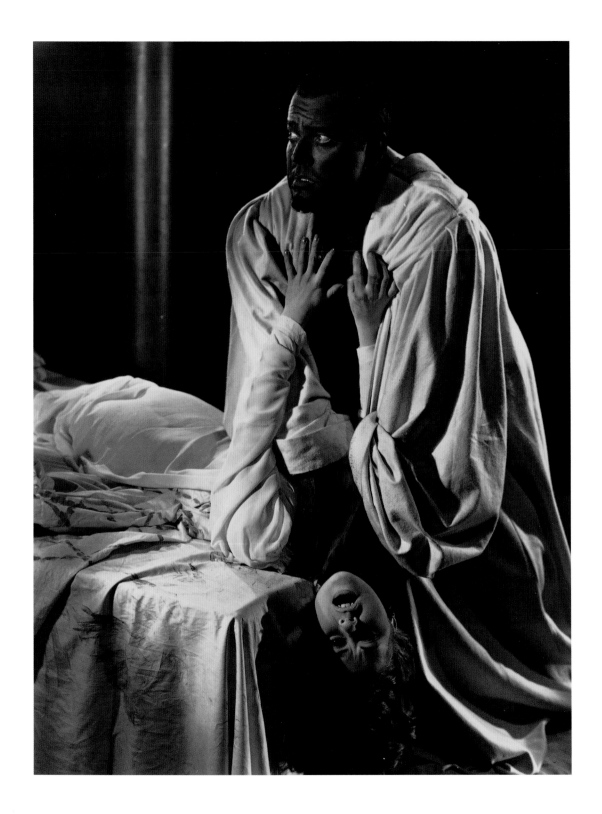

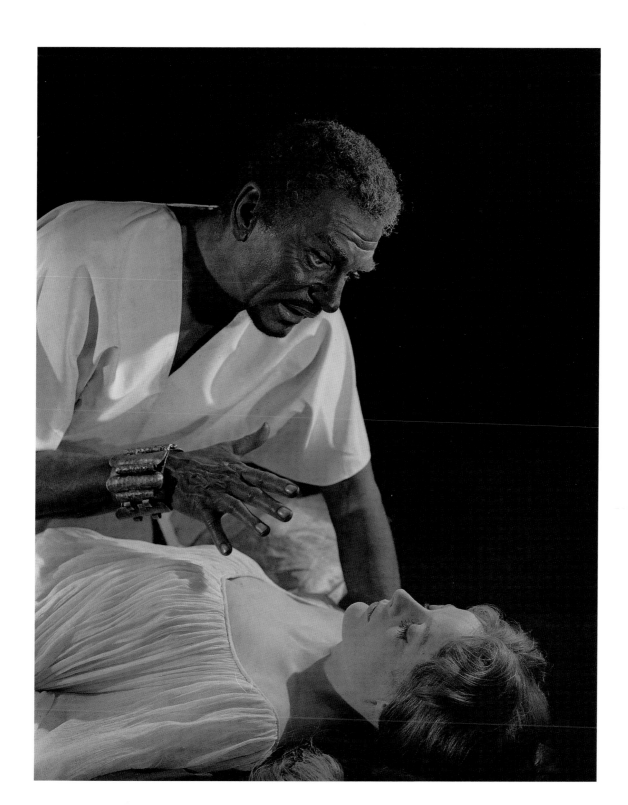

JOHN GIELGUD as Cassius in *Julius Caesar*. Shakespeare Memorial Theatre, Stratford-upon-Avon, 1950.

John Gielgud was, with Olivier, Redgrave, and Richardson, one of the princes of the twentieth-century British stage; and like them, he also became a memorable film personality. He first played small Shakespeare parts in the early 1920s, joining the Old Vic company in 1929, where he quickly became a celebrated Romeo and Hamlet. He also appeared in dozens of boulevard plays in the West End, and directed many of them. Gielgud was responsible for the production of many Russian plays, as well as British comedy classics by Wilde, Congreve, and others. He first played Cassius in *Julius Caesar* in 1950 at Stratford, and repeated this part in the 1953 MGM film directed by Joseph L. Mankiewicz.

PEGGY ASHCROFT as Cleopatra in *Antony and Cleopatra*. Shakespeare Memorial Theatre, Stratford-upon-Avon, 1953.

In this acclaimed Stratford production of *Antony and Cleopatra*, Peggy Ashcroft (1907–1991) starred opposite Michael Redgrave, with Harry Andrews as Enobarbus and Marius Goring as Caesar. Although journalist Michael Billington reported that "the majority verdict was that Peggy had . . . become the Cleopatra of her generation," it was a portrayal that emphasized the Egyptian queen's wit and intelligence over her sensuality.

The production, which presented all forty-two scenes of the play uncut, was directed by Glen Byam Shaw. The glorious bird-like throne that provided a backdrop for Cleopatra's costume was designed by Motley. In London the production was seen at the Prince's Theatre (now the Shaftesbury Theatre).

CLAIRE LUCE as Cleopatra in *Antony and Cleopatra*. Shakespeare Memorial Theatre, Stratford-upon-Avon, 1945.

Shown here in a statuesque pose as the Egyptian queen, Claire Luce (1903–1989) appeared in two productions of *Antony and Cleopatra* in 1945, at Stratford and at the Old Vic Theatre. The Shakespeare Memorial Theatre production, directed by Robert Atkins, included Antony Eustrel as Marcus Antonius. At the right is Berto Pasuka, who later formed Les Ballets Nègres.

McBean recalled that this first session for Stratford was taken in his studio, not on stage: "One day the bell rang: 'Tom English, Press Agent for the Shakespeare Memorial Theatre, here. I was wondering if you could possibly photograph Claire Luce. She is playing Cleopatra for us this season and we think she will look sensational. Get in touch with her at the Savoy. She says she can easily mock up some clothes for you. . .' We must make the barge, the sails of beaten gold. Even a negro oarsman – Berto Pasuka, will do that, he doesn't work during the day. And so my first pictures after the war were taken and triumphantly achieved a double spread in a *Tatler*, tired of austerity and pictures of Royalty in most unbecoming military hats. And so what was virtually a new career was started and an entrée into Stratford-upon-Avon" was secured.

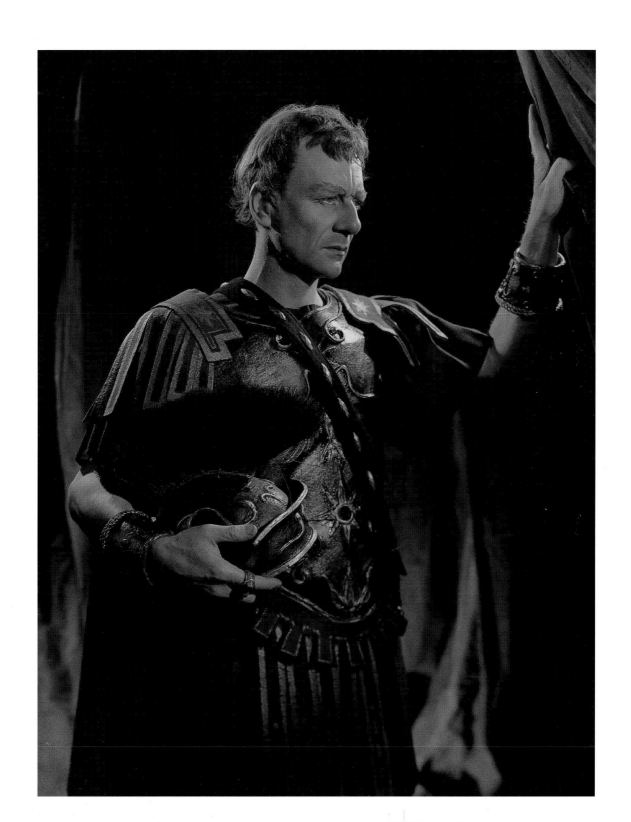

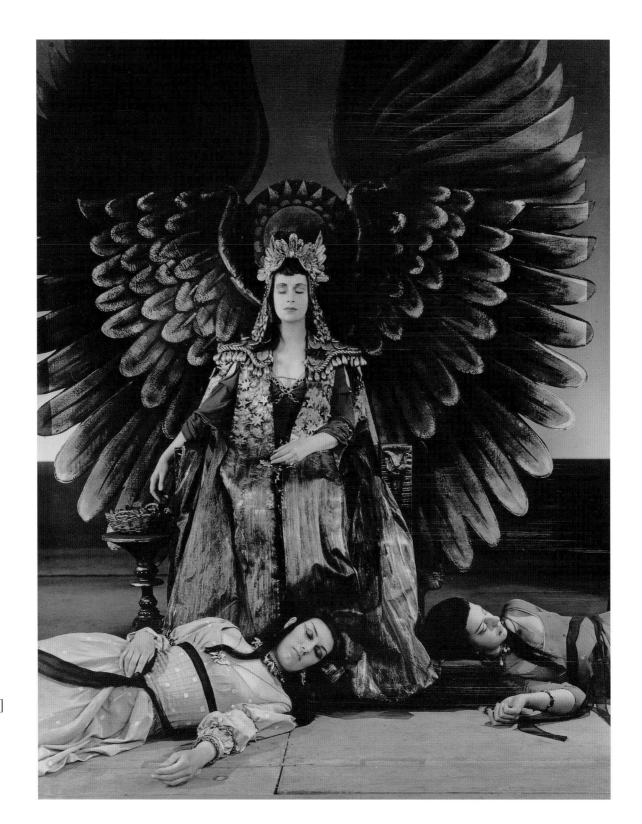

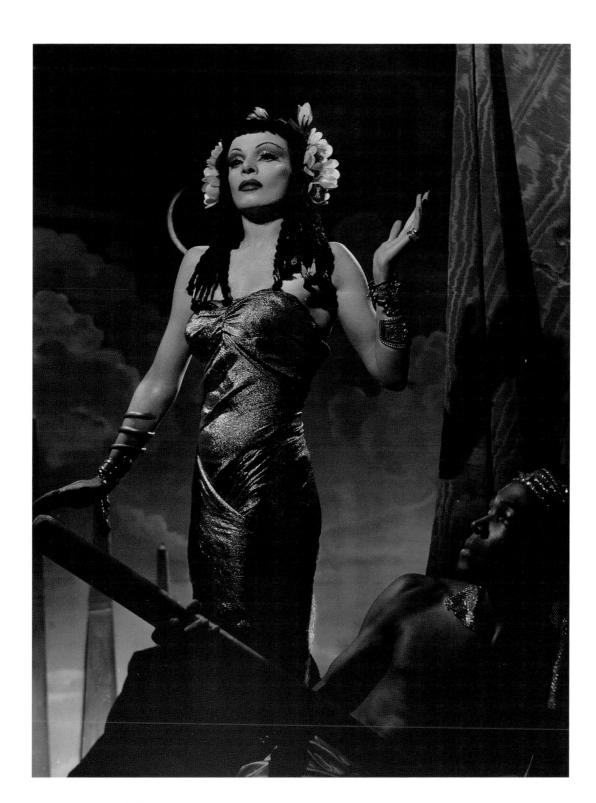

VIVIEN LEIGH as Cleopatra in *Antony and Cleopatra*. Opera House, Manchester, prior to opening at St. James's Theatre, London, 1951.

In 1951, in both London and New York, Laurence Olivier and Vivien Leigh appeared together in both Shakespeare's *Antony and Cleopatra* and Shaw's *Cæsar and Cleopatra*. This irresistible repertory conceit was arranged as part of the Festival of Britain, a massive arts extravaganza meant to brighten the spirits of a grim postwar London. The Shakespeare play was directed by Michael Benthall, the Shaw by Olivier. Leigh had already appeared memorably as Cleopatra opposite Claude Rains as Julius Caesar in the Technicolor film version of the Shaw play, released in 1946.

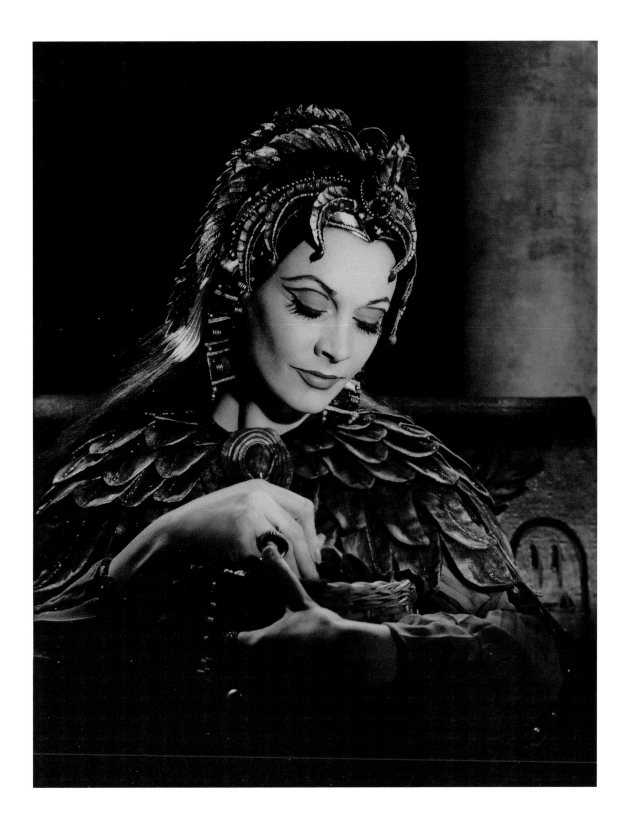

STAGE PRODUCTIONS

Vivien Leigh as Cleopatra in George Bernard Shaw's play *Cæsar and Cleopatra*. Opera House, Manchester, prior to opening at St. James's Theatre, London, 1951.

In his two portraits of Vivien leigh, McBean captures the different natures of the two Cleopatras – one young, hopeful, and impetuous, the other a more experienced enchantress, fondly caressing the fatal asp in a basket she cradles in her arms.

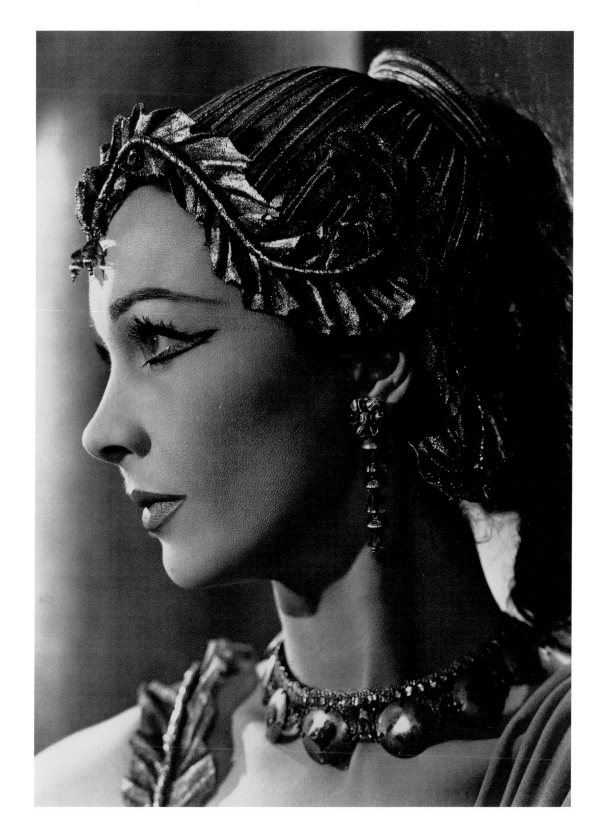

ELIZABETH TAYLOR as Helen in Christopher Marlowe's play *Doctor Faustus*. Oxford University Dramatic Society, 1966.

London-born Elizabeth Taylor (b. 1932) has been a celebrated international film star for much of her life. Among her comparatively infrequent stage appearances was this 1966 production of Marlowe's 1604 play *Doctor Faustus* for the Oxford University Dramatic Society. Taylor played Helen of Troy, opposite her then-husband Richard Burton as Faustus. The couple then filmed this play, as well as Shakespeare's *The Taming of the Shrew*, both released in 1967; the film version of *Doctor Faustus* was generally panned.

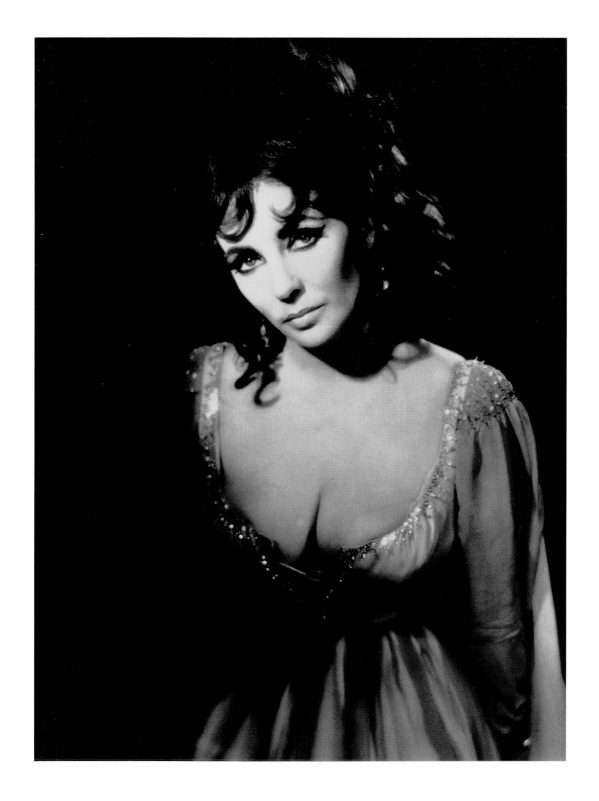

Pamela Brown as Jennet Jourdemaine, Richard Burton as Richard, and John Gielgud as Thomas Mendip in Christopher Fry's comedy *The Lady's Not for Burning*. Globe Theatre, London, 1949.

Welsh actor Richard Burton gained international stardom initially on the West End stage and on Broadway, as well as in Shakespeare, especially at the Old Vic Theatre. His first performance of note was as Richard in the Christopher Fry verse drama *The Lady's Not for Burning*, produced by H. M. Tennant at the Globe Theatre in 1949. The play had first appeared earlier that year in a limited run at a private theatre; then, in a new production under Gielgud's direction, it settled at the Globe after a provincial tour. In New York, with the same principal cast, the production received the Drama Critics Circle Award in 1951 for the best foreign play.

Pamela Brown (1917–1975) studied at the Royal Academy of Dramatic Art, and made her stage debut as Juliet at Stratford in 1936. She also played many roles at the Old Vic, and in 1947 made a successful Broadway debut in *The Importance of Being Earnest*.

McBean felt an affinity for Christopher Fry's works: "I had photographed all his plays since *The Lady's Not for Burning*. I find myself deeply in accord with plays written by poets, with the sweep of the heightened language."

Paul Scofield as Treplef and Mai Zetterling as Nina in Anton Chekhov's play *The Seagull*. Theatre Royal, Brighton, 1949.

The Seagull, whose disastrous reception in St. Petersburg in 1896 caused Chekhov to renounce the stage, has been a perennial presence on the world stage since 1898, when Constantin Stanislavsky revived the play at the Moscow Art Theatre to enormous acclaim.

The play was embraced in London, particularly in a 1936 production directed by Theodore Komisarjevsky that starred Edith Evans as the actress Madame Arkadina, John Gielgud as her son, the playwright Treplev, and Peggy Ashcroft as Nina, the young daughter of a rich landowner.

Paul Scofield was an admirer of Chekhov, and appeared in a number of the playwright's works and in several biographical plays, including *Anton in Eastbourne* (2002). The Swedish actress Mai Zetterling (1925–1994) was best known for films such as *Night Games* and *Loving Couples*. This H. M. Tennent production of George Calderon's translation was directed by Irene Hentschel.

Carol Goodner as Masha, Peggy Ashcroft as Irina, and Gwen Ffrangcon-Davies as Olga, in Anton Chekhov's play *Three Sisters*. Queen's Theatre, London, 1938.

The London stage has always been a welcoming home for the plays of Anton Chekhov, often with top stars in the casts. This *Three Sisters*, produced by Michel Saint-Denis in 1938, had Peggy Ashcroft as Irina, with Carol Goodner (1904–2001) and Gwen Ffrangcon-Davies (1891–1992) as the other siblings, complemented by John Gielgud as Vershinin. The career of Peggy Ashcroft ended with a series of memorable film and television roles (*A Passage to India*, *The Jewel in the Crown*) that brought her a broader international fame.

Published on the cover of *Theatre World* magazine, this is McBean's only surreal photograph that included more than two people. He did not photograph the production itself, but had the actresses come to his studio where he had constructed what rather resembles a dinosaur's pelvis.

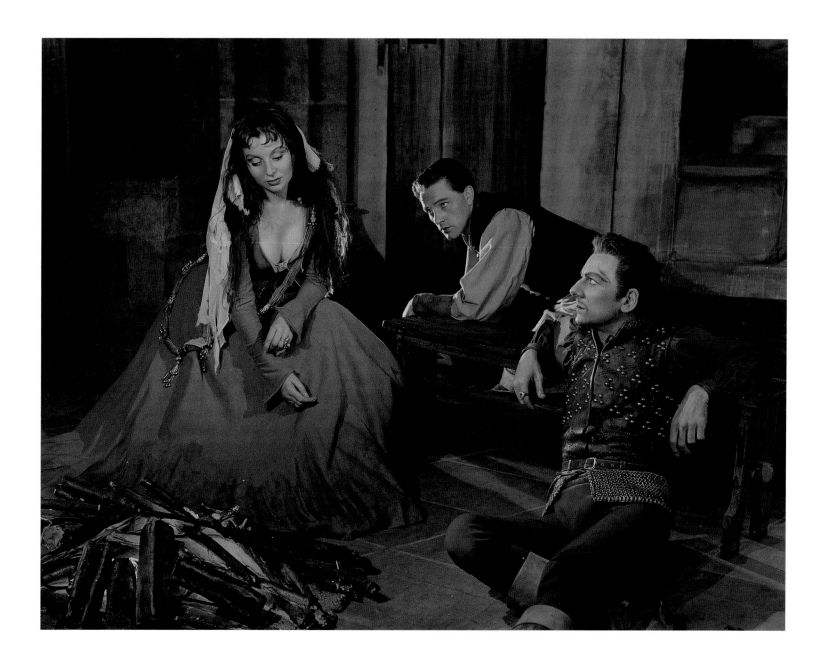

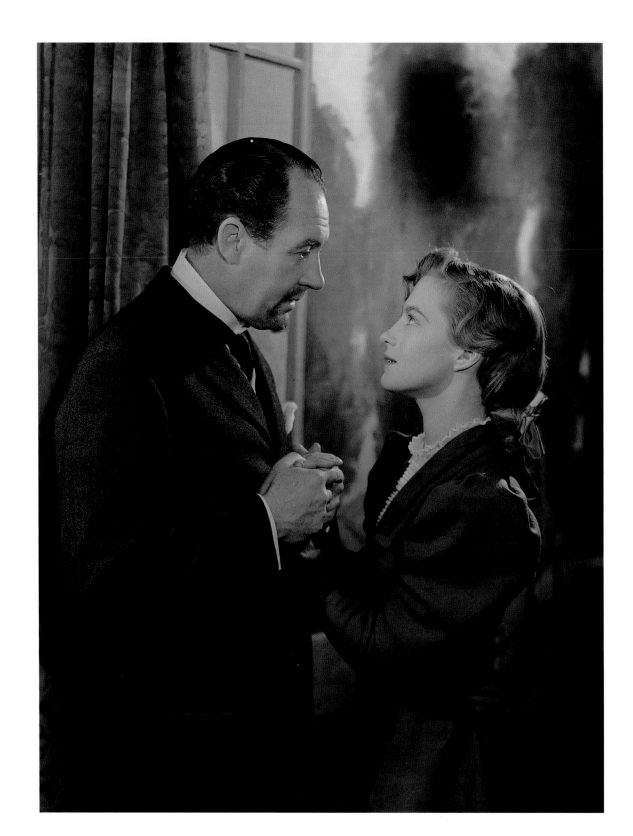

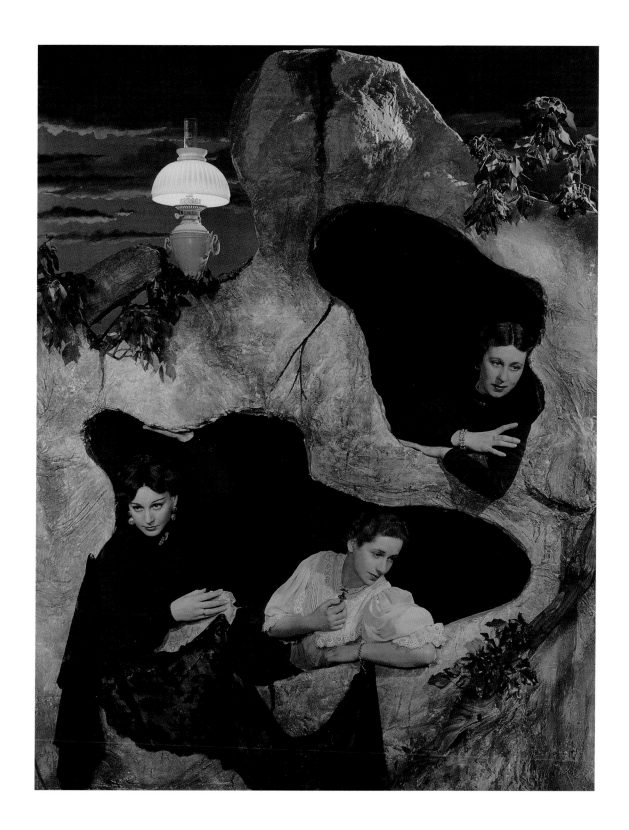

ROBERT HELPMANN in Noël Coward's play *Nude with Violin*. Globe Theatre, London, 1957.

In Noël Coward's 1956 satire on modern art, the role of the valet Sebastien Lacreole was originated by the author, but understudied and later succeeded by John Gielgud, who also directed the production. It was later recast with the dancer Robert Helpmann, who remained in the company in an international tour. When the production was adapted for television for the BBC, Coward played the role himself, and then directed the play when it appeared on Broadway in 1957.

In *Nude with Violin*, Coward punctures the chic art world of pretension, vanity, and snobbery. It is set in modern-day Paris, following the death of the artist Paul Solodin, as his estate is targeted by his circle of friends and family. Blackmail greatly enhances the value of Sorodin's works, though they are ultimately found to have been fraudulent.

IVOR NOVELLO as Nikki in his play *King's Rhapsody*. Palace Theatre, London, 1949.

Ivor Novello (1893–1951) was the other great twentieth-century actor-author-composer of the London stage, alongside Noël Coward, winning him the sobriquet "the English Lehár." Their careers were remarkably similar, with successes in light comedy and romantic operetta, but Novello was a matinée idol in film in the 1920s when Coward was still relatively little known. In *King's Rhapsody*, directed by Murray Macdonald, Novello played a Central European prince who gives up his throne for love. McBean noted that this particular photograph, in which Nikki picks up a flower from the Queen's bouquet at the final curtain, was Novello's own favorite. For more than a year the public thronged to the Palace Theatre to see *King's Rhapsody*; Novello, long a steadfast advocate of McBean and his work, died shortly after a performance in 1951.

NOËL COWARD as Gary Essendine in his comedy *Present Laughter*. Haymarket Theatre, London, 1947.

Noël Coward (1899–1973) was the greatest all-round theatrical talent of the London stage in the twentieth century. His comedies – among them *Private Lives*, *Design for Living*, *Blithe Spirit*, and *Present Laughter* – have taken their place in the classic cavalcade of English comedy, stemming from Shakespeare through Congreve and Sheridan to Gilbert, Wilde, and Shaw. Coward's comic and romantic songs have endured, though many of the musicals and revues in which they appeared have not themselves withstood the test of time. Yet it was his stage personality, the urbane sophisticate strewing bon mots in his unflappably clipped speech, that made Coward a household name. Evidence of this is preserved in his several cinematic turns, including *The Scoundrel*, *In Which We Serve*, *The Astonished Heart*, and *Our Man in Havana*. Coward is seen here at the piano, in one of his chic Sulka dressing gowns; he created the role of Gary Essendine in 1942, and returned to the cast in 1947.

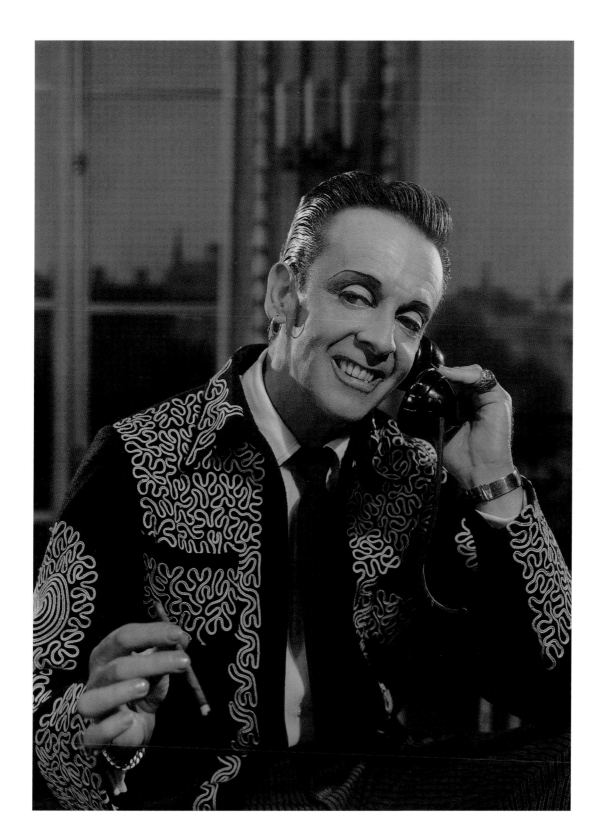

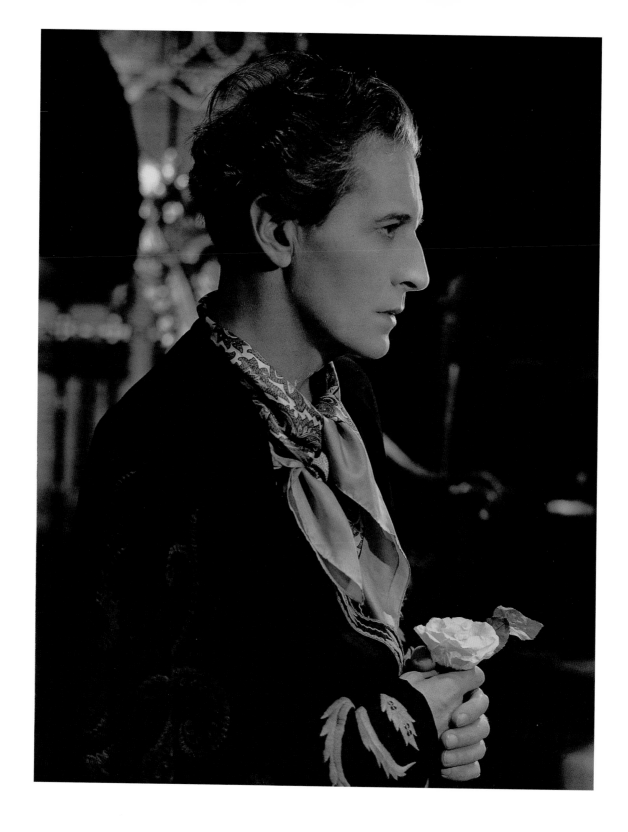

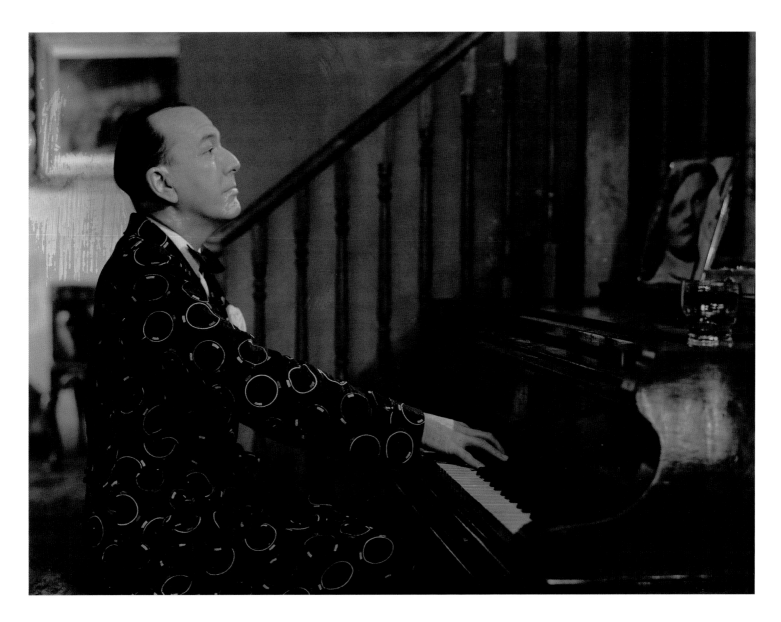

MICHAEL REDGRAVE as Halvard Solness and Maggie Smith as Hilde Wangel in Henrik Ibsen's play *The Master Builder*. National Theatre Company, Old Vic Theatre, London, 1964.

Peter Brook's stellar production of Ibsen's *The Master Builder*, first seen at the Chichester Festival, became an early success for the National Theatre at the Old Vic Theatre. Michael Redgrave, who originally played Solness, was succeeded by Laurence Olivier. (Aline Solness was to have been played by Diana Wynyard, but she died during rehearsals.) Maggie Smith made a striking early appearance in the role of the idealistic young Hilde, alternating with Joan Plowright. The set by the German designer Rudolf Heinrich was then considered "symbolic."

McBean's photograph demonstrates the dramatic lighting effects for stage studies that he made distinctly his own.

ROBERT SPEAIGHT as Thomas à Becket in T. S. Eliot's verse play *Murder in the Cathedral*, 1940.

T. S. Eliot (1888–1965) was born in St. Louis, Missouri, but he settled in London in 1914 and became a British citizen in 1927. His landmark play, *Murder in the Cathedral*, was written in 1935 and concerns the martyrdom of Thomas à Becket in 1170. It is perhaps the most famous of all twentieth-century verse dramas. In the same way that Arthur Miller's play *The Crucible* refers also to current affairs in the United States, *Murder in the Cathedral* can be seen to respond to current world events, specifically as a call to oppose religious repression under the Nazi regime.

Murder in the Cathedral was first performed in the Chapter House of Canterbury Cathedral, the site of Becket's assassination; it had been commissioned by George Bell, Bishop of Chichester, for the Canterbury Festival of 1935. The production then moved to London and ran there for several months in the 130-seat Mercury Theatre in Notting Hill Gate, under the direction of Ashley Dukes. Robert Speaight (1904–1976) played the part of Thomas à Becket in both locations.

DOROTHY TUTIN as Joan and Richard Johnson as the Earl of Warwick in Jean Anouilh's play *The Lark* (*L'Alouette*). Theatre Royal, Brighton, 1955, prior to the Lyric Theatre, Hammersmith, London.

L'Alouette, Jean Anouilh's dramatization of the history of Joan of Arc, was translated into English by Christopher Fry. (It is not to be confused with Fry's own play, *The Lady's Not for Burning*, which is about quite another burning at the stake.) The play's title was suggested by a characterization of Joan by the Earl of Warwick, one of her judges, as a lark that sings a "joyous, crazy song of courage." Anouilh's play did not emphasize political or sociological debates, and he portrayed Joan as a young, lovable, spirited girl. This H. M. Tennent production was directed by Peter Brook, who championed Anouilh's plays.

Dorothy Tutin (1930-2001) made her professional debut playing Princess Margaret in William Douglas Home's play *The Thistle and the Rose* (1949). As a member of the Old Vic Company she played Ann Page in *The Merry Wives of Windsor* and Princess Katherine in *Henry V* during the 1950–1951 season. Michael Redgrave, seeing her in *Henry V*, recommended her for the role of Cecily Cardew in Anthony Asquith's 1952 film of Oscar Wilde's *The Importance of Being Earnest*, opposite Redgrave himself.

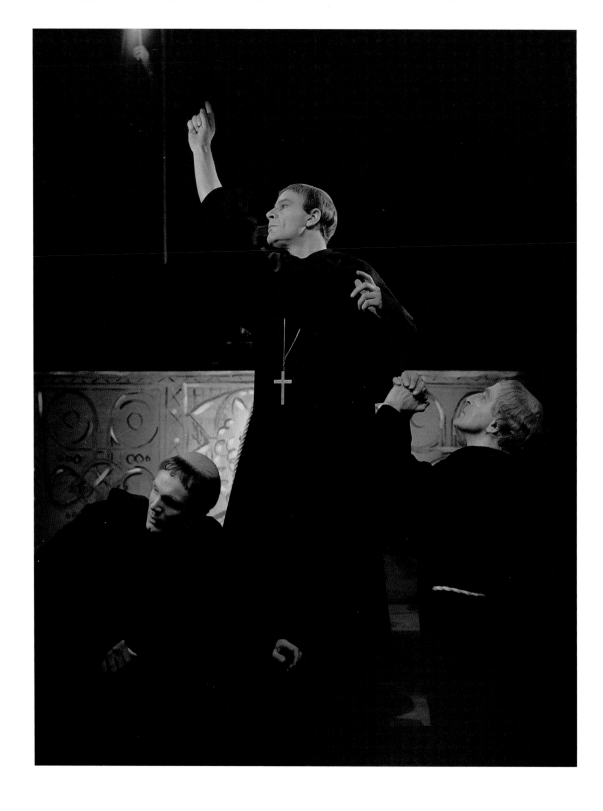

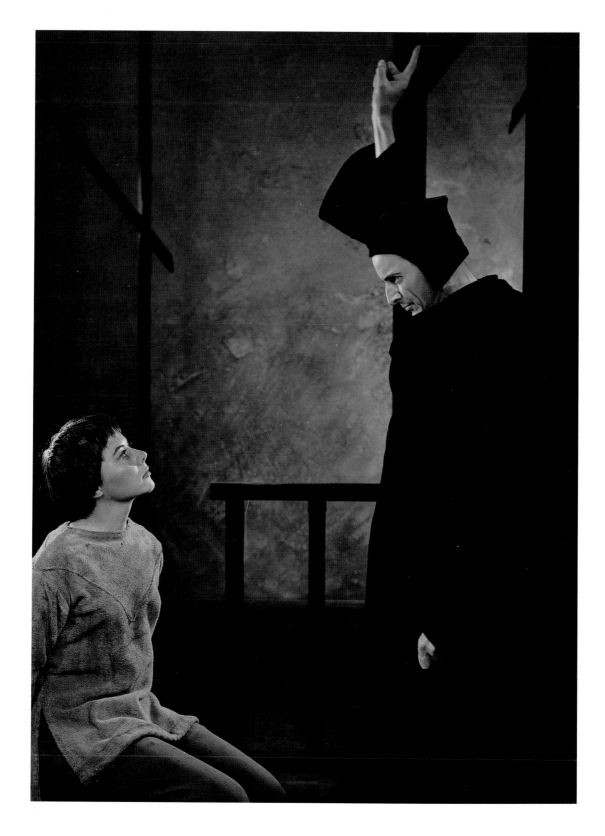

B ARBARA JEFFORD as Joan in George Bernard Shaw's play *Saint Joan*. The Old Vic Company, Old Vic Theatre, London, 1960.

George Bernard Shaw's *Saint Joan* was first seen in New York in 1923 at the Garrick Theatre with Winifred Lenihan as Joan. It was produced at the New Theatre in London three months later, with Sybil Thorndike in one of her most memorable creations, and with designs by Charles Ricketts. It has been revived in London many times. In this 1960 Old Vic production directed by Douglas Searle, the part of Joan was taken by Barbara Jefford (b. 1930). Soon after this season, the Old Vic would house the first productions of Britain's new National Theatre, which would eventually move a bit north to its present Thames-side location.

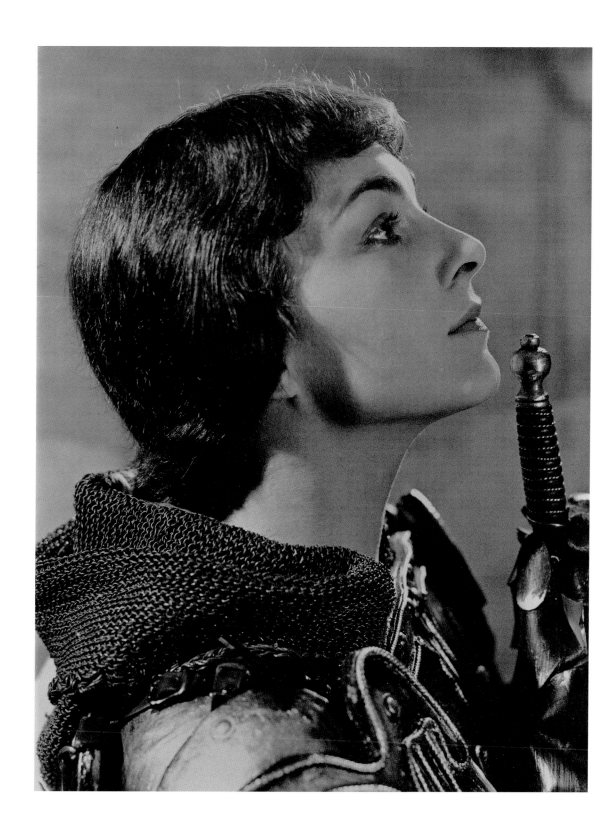

VIVIEN LEIGH as Jennifer Dubedat in George Bernard Shaw's play *The Doctor's Dilemma*. Haymarket Theatre, London, 1941.

After her first long period in Hollywood, and a 1940 stop on Broadway to play Juliet, Vivien Leigh returned to the West End as Jennifer Dubedat in Shaw's *The Doctor's Dilemma*. Produced by H. M. Tennent and directed by Irene Hentschel, the play was a success at the Haymarket and subsequently went on tour across wartime Britain. The first production of *The Doctor's Dilemma* had been given in 1906, for nine matinées only, at the Royal Court Theatre, with Lillah McCarthy as Jennifer Dubedat. Leslie Caron took on the part for the 1958 British film version.

As occurred frequently, McBean photographed this production out of town – on this occasion in Manchester – prior to the London opening. But he recalled that both the director and the star complicated matters: "In the modern manner the action (and the furniture) had been pushed right down stage to reduce the gap between actors and audience to a minimum; admirable for them, but this hardly makes a photographer's job any easier; there is no room to work, and to add to the confusion I was asked if I didn't mind the press photographers coming in for a short while as Miss Leigh didn't want to have two photo calls."

VIVIEN LEIGH as Blanche DuBois in Tennessee Williams's play *A Streetcar Named Desire*. Aldwych Theatre, London, 1949.

On October 11, 1949, before the two-year run of Tennessee Williams's powerful Pulitzer Prize-winning play had finished in New York, the play appeared in London at the Aldwych Theatre, in a production directed by Laurence Olivier.

In 1951, Leigh was paired with Marlon Brando in the film version by Elia Kazan, who had directed the original Broadway production. Leigh's performance won the 1951 Academy Award for Best Actress. Brando was nominated for, but did not win, Best Actor. The film successfully retained the power of the stage production in spite of significant censorship, including references to rape, nymphomania, and homosexuality that were seen on stage.

Leigh's portrayal of Blanche, the fragile schoolteacher who clings pretentiously to memories of grandeur while determinedly laying claim to charity, took its toll on her, leading her to say that playing the role "tipped me over into madness." However, Williams had only praise for Leigh's characterization, saying that she brought to the part "everything that I intended, and much that I had never dreamed of."

VIVIEN LEIGH as Paola and Claire Bloom as Lucile in Jean Giraudoux's play *Duel of Angels*. Theatre Royal, Newcastle-on-Tyne, 1958.

Christopher Fry made the English adaptation of Jean Giraudoux's chilling play *Pour Lucrèce*, which was suggested by the Roman legend of Lucretia. Vivien Leigh and Claire Bloom (b. 1931) played effectively against one another, one a bold adulteress, the other a priggish magistrate's wife. The play, which was presented jointly by H. M. Tennent and Laurence Olivier, was directed by Jean-Louis Barrault. The decor was designed by Roger Furse and the costumes by Christian Dior.

In most productions the stars reserved veto rights over the photographs to be used for publicity purposes. According to Angus McBean, the photographic session for this production was most successful from his point of view, except that these rival beauties each adamantly refused to allow the use of any photograph that showed the other to better advantage.

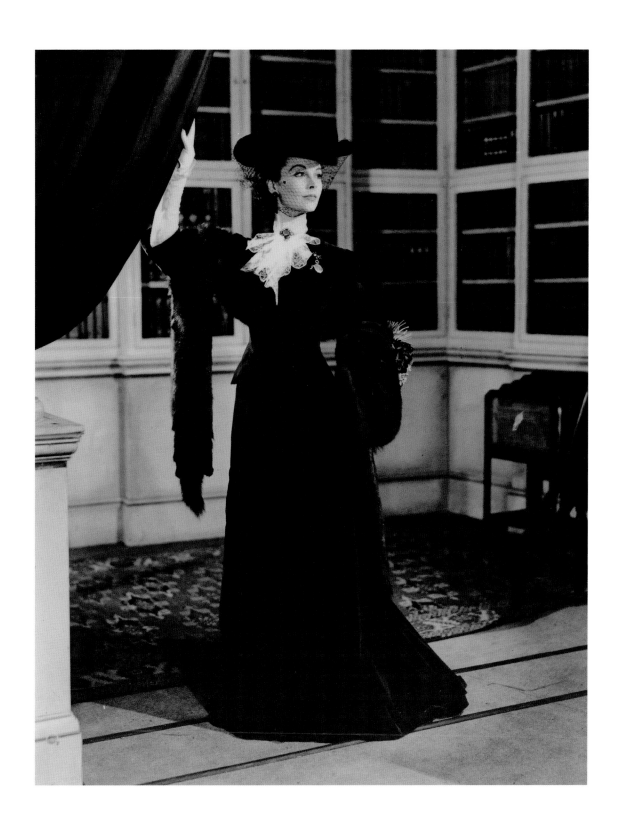

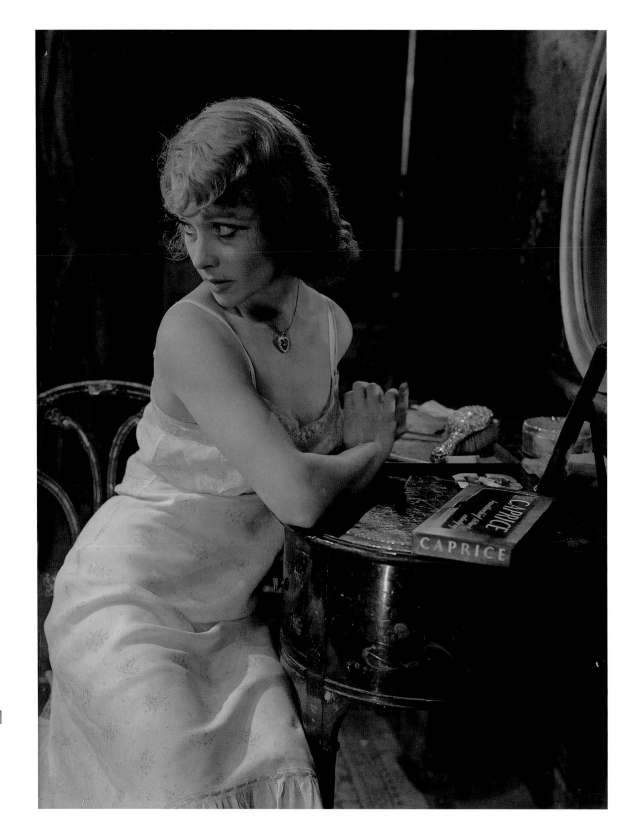

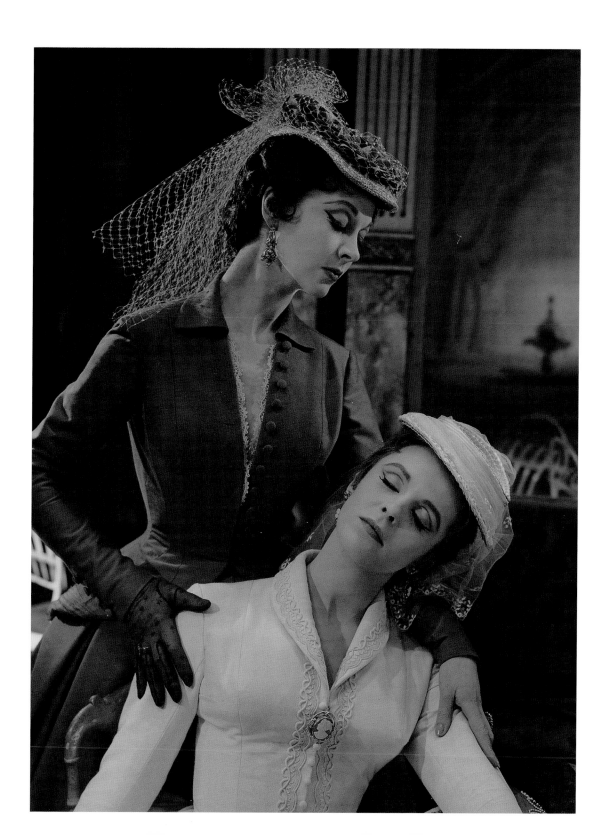

ALEC GUINNESS as the Unidentified Guest in T. S. Eliot's play *The Cocktail Party*. Chichester Festival production, 1968. Photographed at the Theatre Royal, Nottingham, prior to opening at Wyndham's Theatre, London.

Alec Guinness (1914–2000) enjoyed a distinguished international stage and screen career. He burst into the public's consciousness as Herbert Pocket in David Lean's film *Great Expectations* (1946); his other film roles, including those in the famous series of Ealing comedies in the 1950s, are too numerous to mention. In 1950 he directed T. S. Eliot's *The Cocktail Party* at Henry Miller's Theater on Broadway, also taking the role of the Unidentified Guest; he reprised both roles in 1968 in London, where this portrait was taken.

EDITH EVANS as Elizabeth Sawyer in *The Witch of Edmonton*. Old Vic Theatre, London, 1936.

The Witch of Edmonton, a collaborative play by Thomas Dekker, John Ford, and William Rowley, was first performed in 1621, but remained unpublished until 1658. It was revived for Edith Evans at the Old Vic in 1936. The leading character was modeled after the real Elizabeth Sawyer, who was executed as a witch in April 1621. The play's Elizabeth is a poor, lonely, spurned old woman, who turns to sorcery only after she has already been unjustly accused of it.

McBean had been a mask-maker before turning to photography, and this mask is one he designed.

One of the reasons for Angus McBean's popularity among performers was the trouble he took to look after their vanities. Of Edith Evans, who was acutely conscious of her defects, he recalled her having commented, "Oh, why didn't you tell me it was dear Mr. McBean? He will retouch us out of all recognition."

PEGGY ASHCROFT in the title role and Sian Phillips as Julia in John Webster's play *The Duchess of Malfi*. Royal Shakespeare Company. Shakespeare Memorial Theatre, Stratford-upon-Avon, 1960.

John Webster's violent, gothic play *The Duchess of Malfi*, supposedly based on true events, involves greed, incest, mistaken killings, and murder by means of a poisoned Bible. It was written for the King's Men and was first produced at the Globe Theatre in 1614.

This 1960 production, presented both at Stratford and at the Aldwych Theatre in London, was directed by Donald McWhinne. Peggy Ashcroft starred as the Duchess, Eric Porter played her twin brother Ferdinand, Duke of Calabria, Max Adrian portrayed her calculating brother, the murderous, lascivious Cardinal, and Patrick Wymark played the malcontent Daniel de Bosola. Ashcroft had appeared in the same role at the Haymarket Theatre in 1945. That production accentuated the incestuous relationship with her brother Ferdinand, then played by John Gielgud.

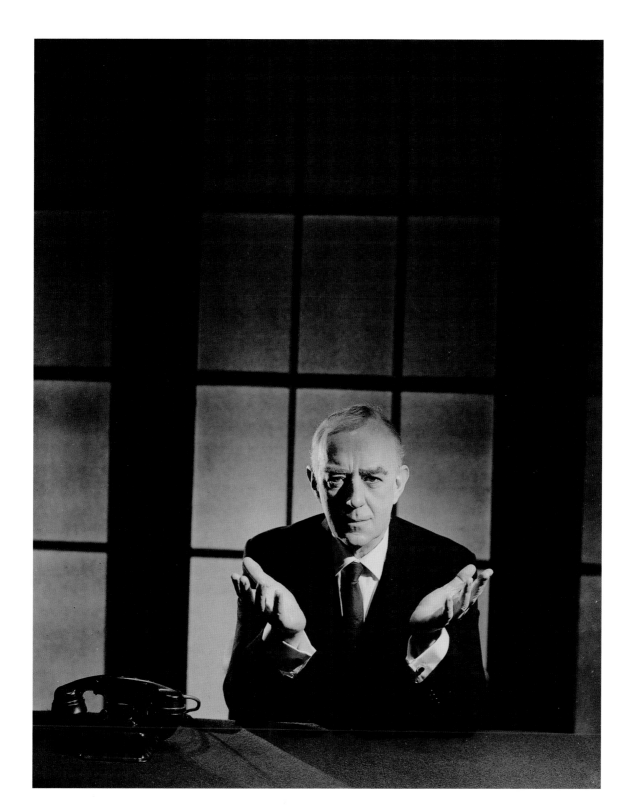

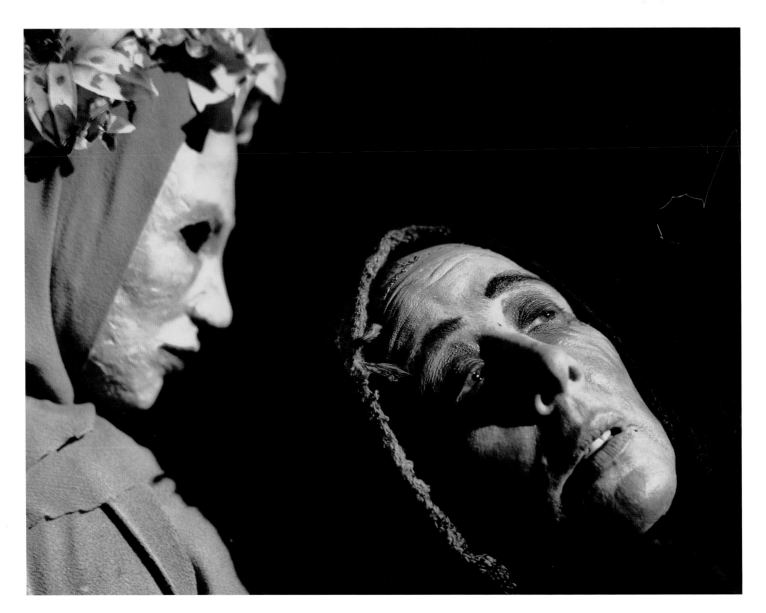

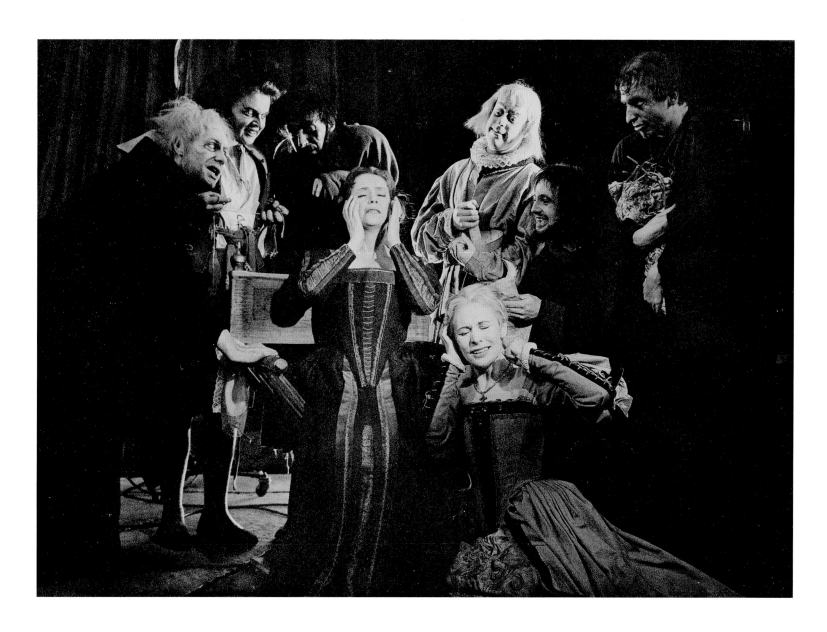

Anton Walbrook, Diana Wynyard, and Rex Harrison, as Otto, Gilda, and Leo, in Noël Coward's comedy *Design for Living*. Globe Theatre, London, 1939.

Noël Coward's comedy *Design for Living* was originally produced in New York in 1933, with Alfred Lunt, Lynn Fontanne, and the author in the leading roles. The triangular plot concerning two men and one woman "who love each other very much" was considered too bold for the West End at that time, so London had to wait until 1939 for a production.

McBean's montage of the three stars suggests both the sexual situation and the "design" motif. This photograph was used for the poster for the Globe Theatre run, composed so that it could be displayed vertically or horizontally. In the theatrical program it appeared in this orientation. This photograph was also published in *The Sketch* in January of that year. (McBean's name appears on the T-square.)

Hermione Gingold as Jane Banbury and Hermione Baddeley as Julia Sterroll in Noël Coward's play *Fallen Angels*. Ambassadors Theatre, London, 1949.

Noël Coward's comedy *Fallen Angels* was first presented at the Globe Theatre in 1925 with Tallulah Bankhead and Edna Best as two married women who once had the same lover, and who in the memorable second act get drunk as they reminisce together. In 1949 the play was revived at the Ambassadors Theatre for Hermione Gingold (1897–1987) and Hermione Baddeley, (1906–1986), both stars in revue. Directed by Willard Stoker, it followed the one-act *Fumed Oak*, in which the two stars also appeared.

McBean recalled that at the time of this production "*les deux* Hermiones" were not on speaking terms, and "wouldn't even change in the same room. I had to produce a picture which for reasons of policy was to be usable any way up. It entailed lying these two extremely difficult girls in close proximity on the floor, hands on each other's shoulders." In the theatrical program the image appeared in this orientation.

Cyril Ritchard, Katharine Hepburn, and Robert Helpmann in George Bernard Shaw's play *The Millionairess*. New Theatre, London, 1952.

This is one of McBean's best-known montages, showing the three stars of Shaw's *The Millionairess* surrounded by one- and five-pound notes.

Australian-born Cyril Ritchard (1897–1977) was adept in comic and villainous roles both on the stage and the screen; however, his true métier proved to be a combination of the two, the comic villain. In 1954 he gave the first performances of his legendary Captain Hook in the Moose Charlap musical version of James M. Barrie's *Peter Pan*, opposite Mary Martin in the title role, first at the Winter Garden, New York, and subsequently on NBC Television.

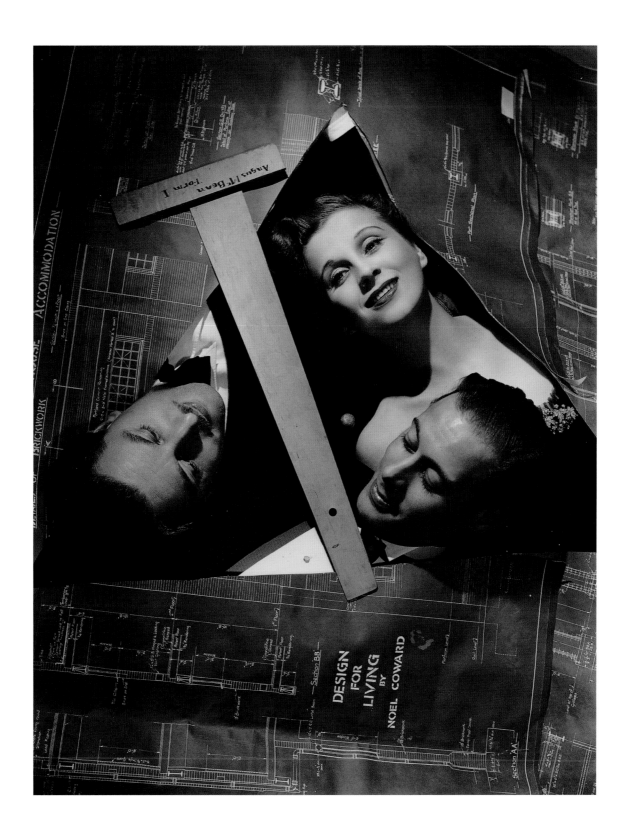

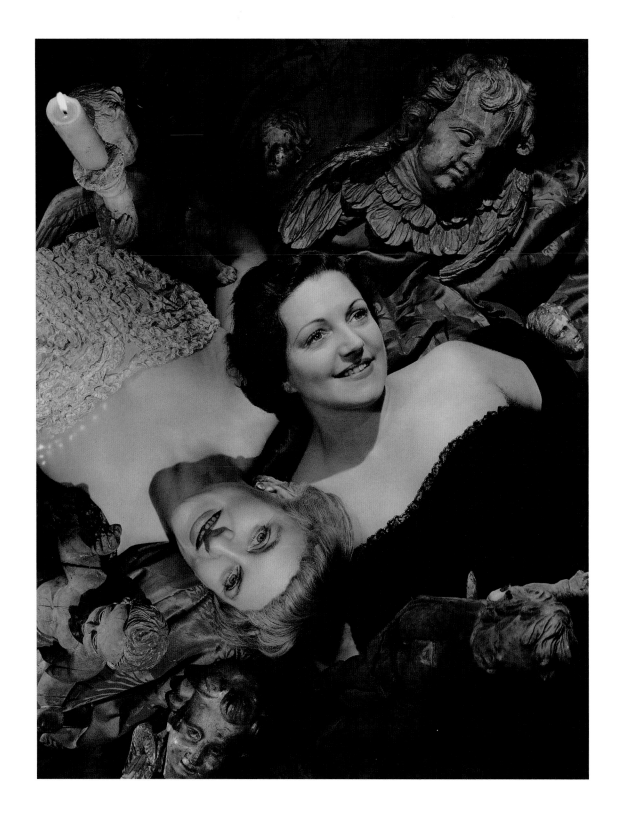

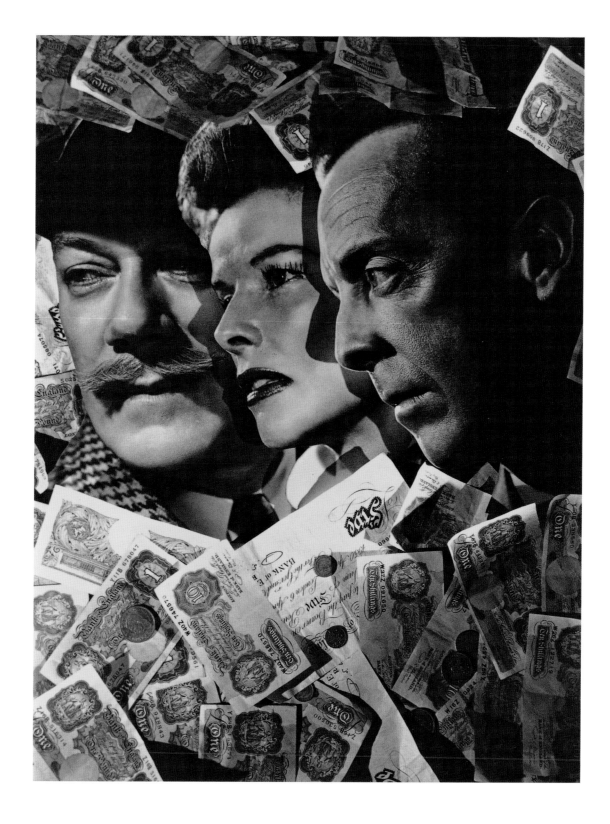

KATHARINE HEPBURN as Epifania in George Bernard Shaw's play *The Millionairess*. New Theatre, London, 1952.

Shaw's *The Millionairess* (described by the author as a "Jonsonian comedy") was originally produced in German in 1936 by the Burgtheater company at the Akademietheater in Vienna. It was seen in London very briefly during the war, but received a far more glamorous production at the New Theatre in 1952. (Built in 1903, the New Theatre was later known as the Albery Theatre and is currently the Noël Coward Theatre.) This production starred the Hollywood legend Katharine Hepburn (1907-2003) in her only West End appearance. Opposite her Epifania (the title role) were Cyril Ritchard, as Adrian Blenderbland, and Robert Helpmann, playing an Egyptian doctor. Hepburn's breathtaking gown was by Pierre Balmain. The production transferred to the Shubert Theatre on Broadway in 1952, under the auspices of the Theatre Guild. H. M. Tennent's earlier London production, starring Edith Evans, had been cancelled in 1940 after a pre-West End tour because of the Blitz.

Another photograph from this session was published on the cover of the August 1952 issue of *Theatre World*.

EMLYN WILLIAMS as Morgan Evans in his play *The Corn is Green*. Duchess Theatre, London, 1938.

Emlyn Williams was a Welsh actor, author, director, and play-doctor (*South Pacific* was one of his famous fixes). He first gained international attention with his thriller *Night Must Fall*, seen in London and New York in 1935. In 1951 he toured widely with a one-man show in which he impersonated Charles Dickens; four years later he repeated the accomplishment with a portrayal of Dylan Thomas. His other great successes included his play *The Corn is Green*, and he is shown here as the promising Welsh schoolboy, Morgan Evans, in the original 1938 production, which featured Ethel Barrymore as the schoolmistress Miss Lilly Moffat. *The Corn is Green* was filmed with Bette Davis and later with Katharine Hepburn. (A musical version starring Bette Davis, titled *Miss Moffat*, closed after disastrous Philadelphia tryouts.)

OPENING SCENE of *My Fair Lady*, in front of the Theatre Royal, Covent Garden, 1960.

Although the theatre photographs of the original production of the Lerner and Loewe musical were taken by Cecil Beaton, who had designed the costumes, McBean was called in to re-photograph the production two years later with a new cast that starred Ann Rogers and Alec Clunes, with Zena Dare as Mrs. Higgins.

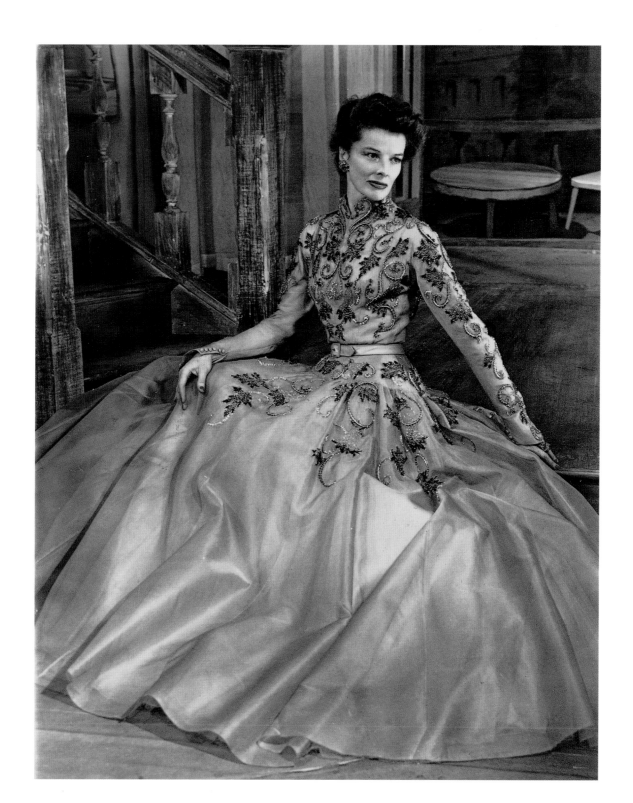

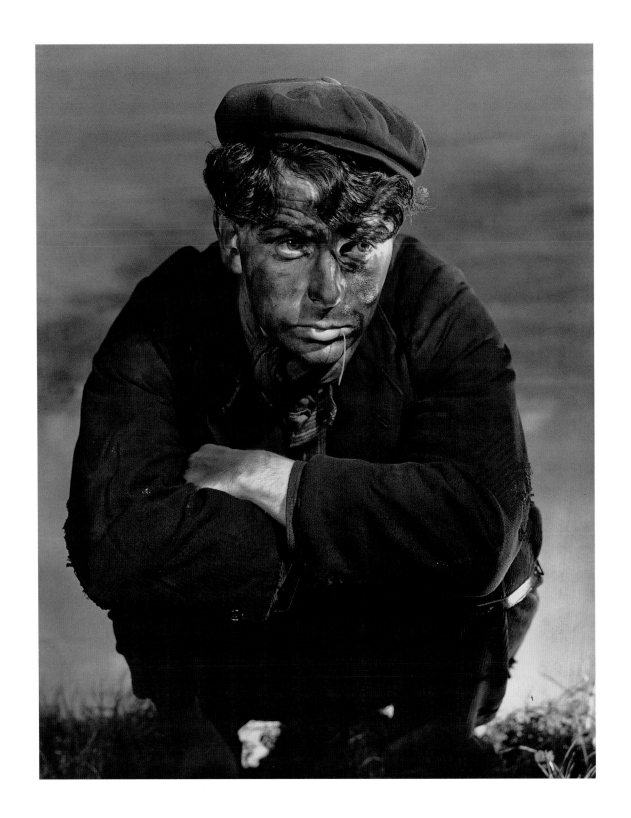

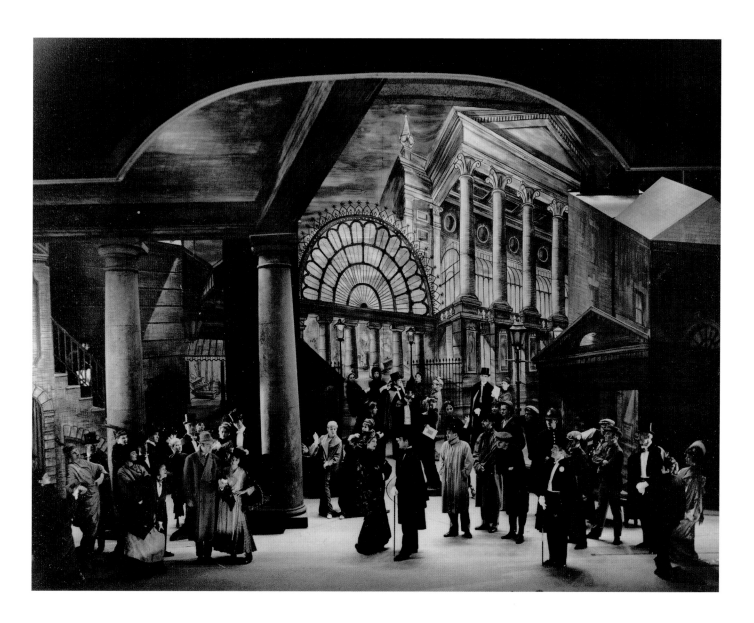

DEMOT WALSH and Margot Grahame as Charles and Ruth Condomine, and Kay Kendall as Elvira, in Noël Coward's play *Blithe Spirit*. Composite photograph.

In this revival of Coward's popular play, Demot Walsh and Margot Grahame (1911–1982) played Charles and Ruth Condomine, and Kay Kendall (1926–1959) played the ghost of Charles's first wife, Elvira. Grahame was popularly known as the "aluminium blonde," after Jean Harlow, the famous "platinum blonde."

This is a trick double-exposure shot showing the ghost of Elvira (visible only to Charles and the audience) as a translucent spirit. The remainder of McBean's photographs of this production showed the character as she appeared onstage, as a fully opaque person.

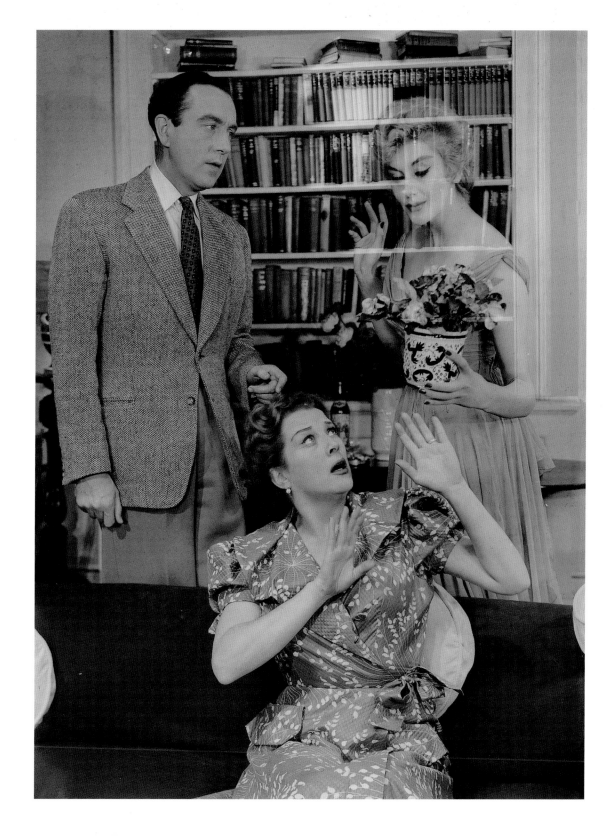

GWEN FFRANGCON-DAVIES as Cicely Cardew, John Gielgud as John Worthing, and Edith Evans as Lady Bracknell in Oscar Wilde's play *The Importance of Being Earnest*. Globe Theatre, London, 1939.

This revival of Wilde's immortal comedy is legendary for the sure-fire team of John Gielgud and Edith Evans, who had appeared together in many productions. Gwen Ffrangcon-Davies was forty-eight years old when she played the ingenue role of Cicely Cardew. Of Evans's characterization, *John O'London's Weekly* stated, "No Lady Bracknell has ever wholly failed, but it is permissible to think that none has ever quite so grandly succeeded."

BETTY FELSTEAD as Lady Jedburgh, Anna Halinka as Lady Paisley, and Ailsa Gamley as Mrs. Cowper-Cowper in Noël Coward's operetta *After the Ball*. Opera House, Manchester, prior to the Globe Theatre, London, 1954.

After the Ball was a musical adaptation of Oscar Wilde's play *Lady Windermere's Fan*. H. M. Tennent produced, and Doris Zinkeisen designed the costumes. Owing to Coward's absence from London because of tax difficulties, the musical's stage direction was entrusted to the dancer, choreographer, and actor Robert Helpmann.

Helpmann's fussy direction was characterized by designer Tony Walton, on the occasion of a revival, as "every little meaning has a movement all its own." Coward was horrified by the stylized and exaggerated acting when he finally saw the production; he remarked that a more appropriate title would be "St. Vitus's Dance." With difficulty, Coward was able to tone down some of the artifice.

Equally troubling was that the noted American soprano Mary Ellis had been cast in the role of Mrs. Erlynne, but it turned out that her voice had entirely lost its appeal. Again, Coward had to intervene, deleting most of her songs.

VIVIEN LEIGH and Charles Laughton as street performers in the film *St. Martin's Lane*, 1938.

In this touching film, Vivien Leigh is a homeless girl named Liberty ("Libby") who meets a street performer, Charles Staggers, played by Charles Laughton. Staggers takes her under his wing until well-to-do Harley Prentiss (played by Rex Harrison) meets her and makes her a famous and wealthy star. This tender tragi-comedy, directed by Tim Whelan, presented a sympathetic portrait of the lives of England's street buskers. The film was released in the United States in 1940 under the title *Sidewalks of London*. It led in part to Leigh's opportunity to play a very different character in the film role of her career: Scarlett O'Hara in *Gone With the Wind*.

Vivien Leigh was Angus McBean's favorite subject. Referring to the time of this film, he wrote, "From then on until the early days of the war, Vivien did little stage work, but many films, and I was always photographing her. She came to the studio with Charles Laughton and I took a whole lot of pictures as stills for her film *St. Martin's Lane*. . . . The pictures were not very good, but they were much used."

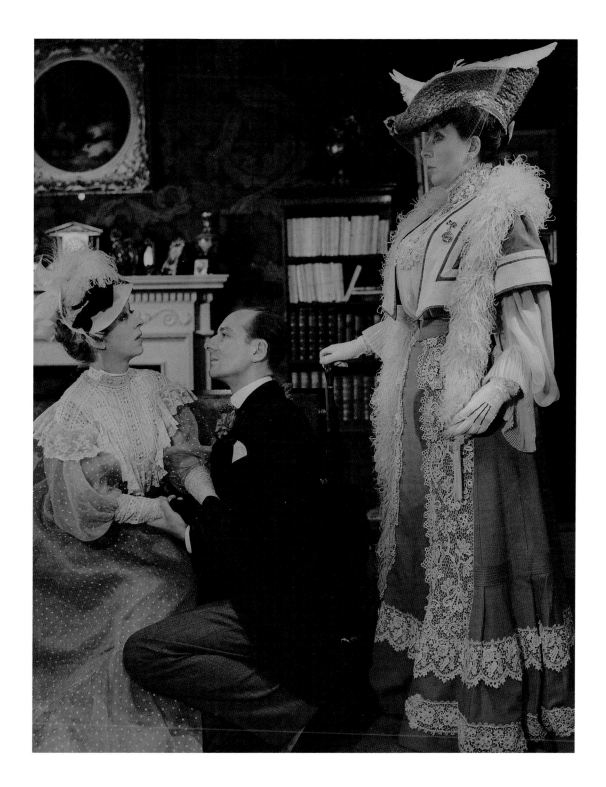

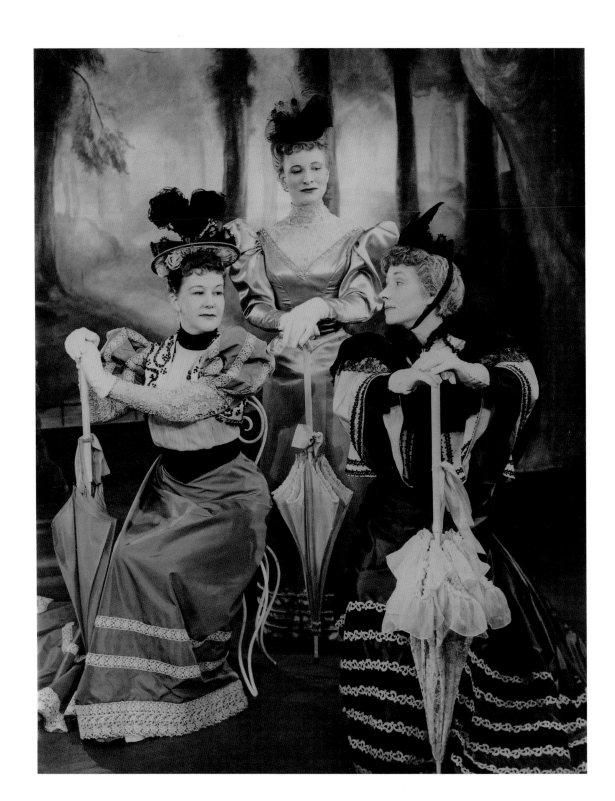

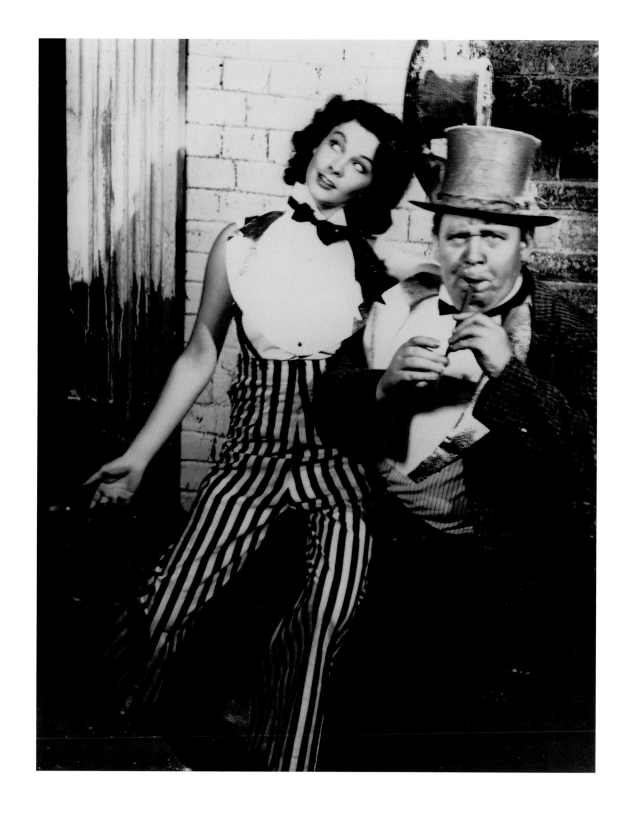

ELSA LANCHESTER as Peter in J. M. Barrie's play *Peter Pan*. Palladium Theatre, London, 1936.

Throughout the 1930s, in the days before it became a palace of Christmas pantomime, the London Palladium was the long-time home of J. M. Barrie's masterpiece, *Peter Pan*. Among the actresses who played the boy who would not grow up were Nova Pilbeam, Anna Neagle, and Elsa Lanchester (1902–1986), who starred opposite her husband, Charles Laughton, in the 1936–1937 season. Laughton's Captain Hook was not generally admired (one critic compared him to "one of the three little pigs dressed up as the Big Bad Wolf"), and he did not join the provincial tour after the London run. Lanchester's characterization of Peter Pan was brittle, stylized, and somewhat menacing.

MARGARET RUTHERFORD as Miss Evelyn Whitchurch in John Dighton's farce *The Happiest Days of Your Life*. Theatre Royal, Brighton, 1948, prior to opening at the Apollo Theatre, London.

In 1948, Margaret Rutherford (1892–1972) appeared in one of her greatest stage triumphs as Miss Evelyn Whitchurch in *The Happiest Days of Your Life*, a riotous farce about the frantic amalgamation of a boys' and girls' school just in time for Parents' Day. The Apollo Theatre production, presented by H. M. Tennent and directed by Richard Bird, ran for 605 performances. Two years later, it was made into a film that preserves Rutherford's daft headmistress and Alistair Sim's equally eccentric headmaster. (In 1954, Sim made his own sensation as a distracted headmistress, as well as her unscrupulous brother, in *The Belles of St. Trinian's*.)

MARGARET RUTHERFORD as Mrs. Danvers and Celia Johnson as the Second Mrs. de Winter in Daphne du Maurier's play *Rebecca*. Queen's Theatre, London, 1940.

Margaret Rutherford is remembered today for her eccentric comic parts on the British stage and screen. Just before her breakthrough performance as the dotty medium in Noël Coward's *Blithe Spirit* (1941), she appeared in the uncharacteristic part of the evil Mrs. Danvers in the London stage version of Daphne du Maurier's *Rebecca* at the Queen's Theatre. In the stage production, Celia Johnson (1908–1982) appeared as the Second Mrs. de Winter. (The United States premiere of Alfred Hitchcock's famous film version had already taken place a month before; the British film release was delayed.)

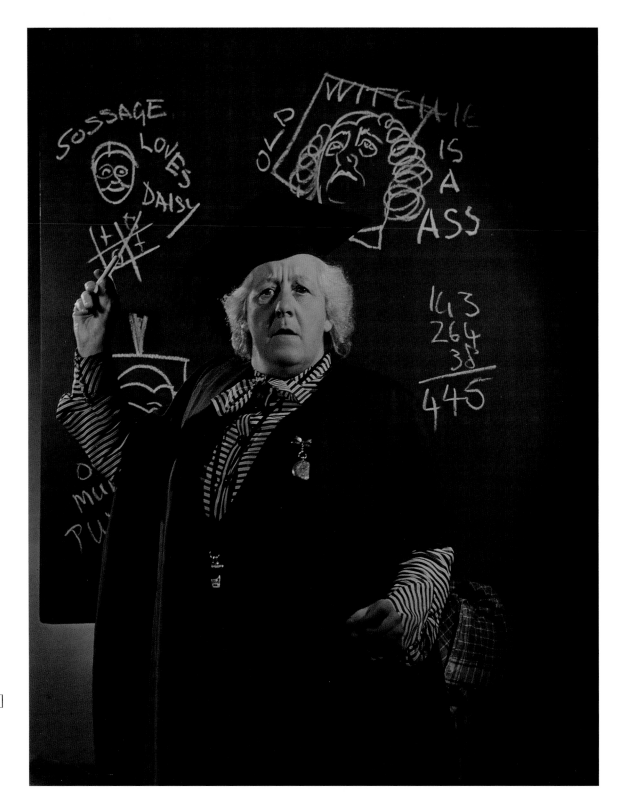

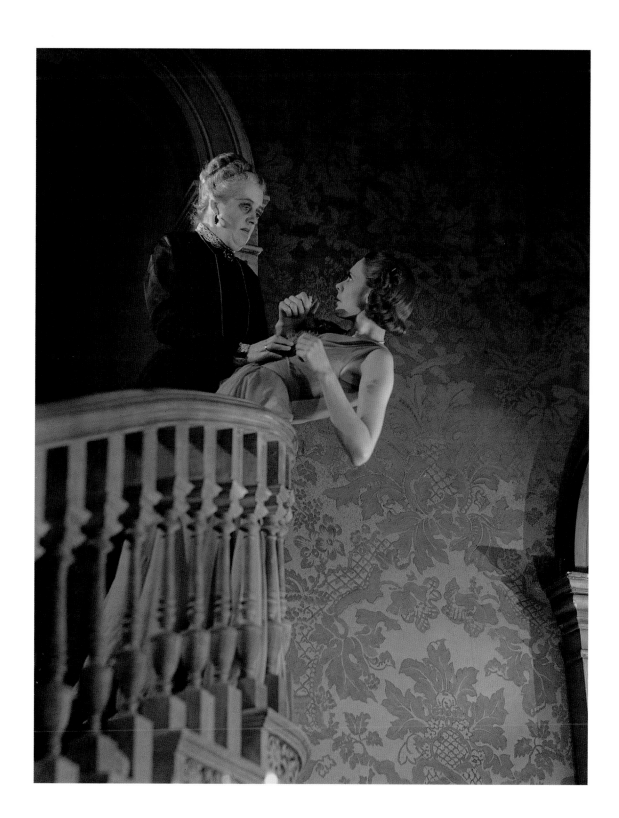

ROBERT MORLEY as the Prince Regent in Norman Ginsbury's play *The First Gentleman*. New Theatre, London, 1945.

Robert Morley (1908–1992) starred in this play about the life of Prince Regent George Augustus Frederick Hanover, the pleasure-loving "first gentleman of Europe," before his accession to the throne as King George IV. The role played to the portly actor's popular image as a foppish, pompous, upper-class dandy, although in fact Morley's range was much broader, having included the title role of *Oscar Wilde* (1936), Henry Higgins in Shaw's *Pygmalion* (1937), Undershaft in the film *Major Barbara* (1941), and a missionary in the film *The African Queen* (1951).

The production, which was later transferred to the Savoy Theatre, also starred Wendy Hiller as Princess Charlotte, of whom Morley wrote that "on some evenings, after she had died in the second act it seemed a waste of time continuing with the play."

NORMAN WISDOM as Charley Wykeham in Frank Loesser's musical *Where's Charley?* Opera House, Manchester, 1957, prior to the Palace Theatre, London.

Frank Loesser's 1948 musical, with a book by the legendary George Abbott, was based on Brandon Thomas's even more popular and enduring farce *Charley's Aunt*, which was first staged in 1892 with W. S. Penley in the title role.

Ray Bolger created the part of Charley Wykeham for the original Broadway production of *Where's Charley?*, which was directed by Abbott and choreographed by George Balanchine. It opened at the St. James Theatre on October 11, 1948, where it ran for 792 performances. The production pictured here was directed by William Chappell and featured the London-born comedian Norman Wisdom (b. 1915) as Charley. After a tryout tour, it opened at London's Palace Theatre on February 20, 1958, and enjoyed a long run of 404 performances.

Wisdom appeared in about forty films, most of them low-budget slapstick comedies, in which he was usually cast as a straight man. He is perhaps best known to American audiences for his performance as a vaudeville sidekick in the film *The Night They Raided Minsky's*, opposite Jason Robards.

DANNY LA RUE. Palace Theatre, London, 1968.

Danny La Rue (b. 1927), England's most famous female impersonator, began as a stand-up comic in his private club in the 1960s, speaking in a rich baritone while wearing the most glamorous gowns. A popular personality in Christmas pantomimes, such as *Queen Passionella and the Sleeping Beauty* (1969), La Rue gave the traditionally boisterous dame roles a gorgeous, sexy slant. He (she) is seen here at the time of his (her) London revue at the Palace Theatre.

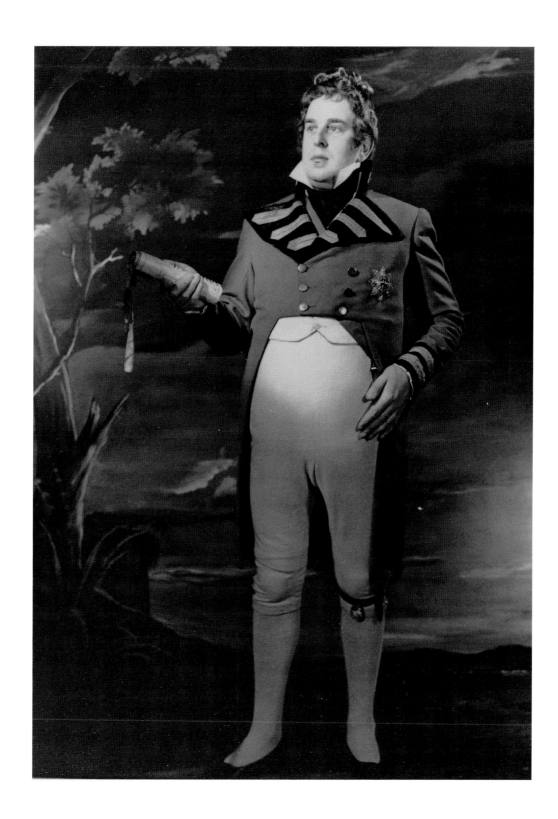

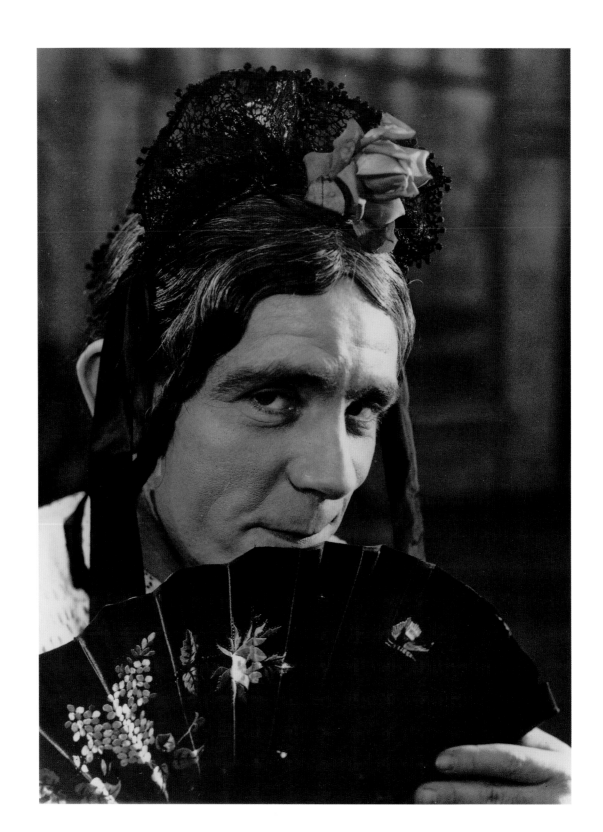

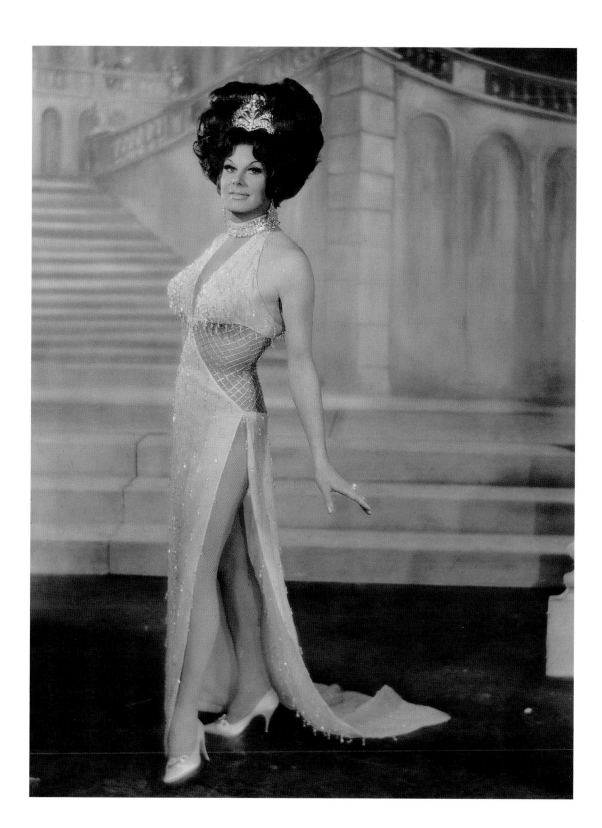

OPERA AND DANCE

K ATHLEEN FERRIER as Orfeo in Gluck's opera *Orfeo ed Euridice*. Glyndebourne Festival, 1947.

The legendary British contralto Kathleen Ferrier (1912–1953) had but a regrettably short career. Beginning as a concert singer, she appeared in the premiere of Benjamin Britten's *The Rape of Lucretia* at the Glyndebourne Festival in 1946. Ferrier appears here as Orfeo in Gluck's opera *Orfeo ed Euridice* (composed in 1762), which was her debut role at Glyndebourne in 1947. She performed again at Covent Garden (under Sir John Barbirolli) in the year of her premature death. Her recordings still recall her warm, beautiful voice in folk songs as well as opera.

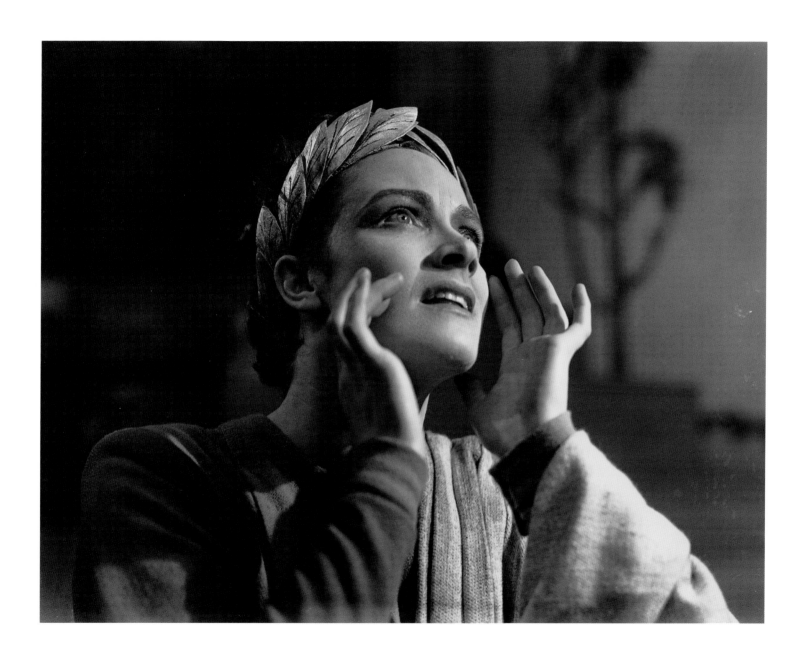

Maria Callas. Portrait, 1954.

Maria Callas (1923–1977), who was born in New York City to Greek parents, was perhaps the most famous operatic soprano of the twentieth century, the archetype of the diva, whose accoutrements included an overbearing mother and ecstatic, adoring fans who hailed her as "La Divina."

Her parents were not well matched, and in 1937 her mother returned to Greece with the children. But eight years later, Callas returned to the United States to reunite with her father and make the round of auditions. After singing for Edward Johnson, the general manager of the Metropolitan Opera, she was engaged, and frequently sang there and at the Royal Opera, Covent Garden. She also recorded roles for EMI in London. Callas made her official debut at La Scala in *I Vespri Siciliani* in December 1951, and this legendary Milanese institution became her artistic home throughout the 1950s.

At the time of this studio portrait, the singer apparently was a blonde. McBean recalled the occasion: "At one point I suggested that Miss Callas should put on some of the jewellery she had taken off. 'No, Mr. McBean,' she said, 'I wish the pictures to be very simple. You will provide your fine photography and I will produce any necessary glamour.'"

RICHARD BONYNGE and JOAN
SUTHERLAND. Portrait, 1964.

This dual portrait of the husband-and-wife team of conductor and soprano represents two of the most famous Australian musicians in history, and one of the world's legendary artistic partnerships. Both of them moved to London to study at the Royal College of Music. Joan Sutherland (b. 1926) studied voice, and in 1951 she sang in performances of Eugène Goossens's opera *Judith*. She made her official European debut as the First Lady in *Die Zauberflöte* at the Royal Opera House, Covent Garden, on October 28, 1952. Richard Bonynge (b. 1930) studied piano, eventually giving up his scholarship to become a coach for singers. They married in 1954 and performed as a duo in recitals. It was Bonynge who persuaded Sutherland to concentrate on the *bel canto* repertoire, since the range and technique came so naturally to her. In 1962, when the conductor of a concert of opera arias became ill, Bonynge substituted. From that time on, he conducted virtually all of his wife's performances, and their careers were bound up to the extent that they tended only to accept engagements together.

BLANCHE THEBOM. Portrait, 1950.

McBean photographed the American mezzo-soprano Blanche Thebom (b. 1918) in his studio. After a series of conventional portrait poses, the singer suggested he might photograph her with her own hair, which reached the floor when let down. McBean contrived this pose, which required that the singer lie down on a bed of sand. He tore a sheet of wrapping paper to fit the contours of her hair in order to protect it from the grit.

JEAN WATSON as Dalila in Camille
Saint-Saëns's opera *Samson et Dalila*.
Sadler's Wells Theatre, London, 1952.

Based on the book of Judges, *Samson et Dalila* was originally conceived as an oratorio, but as an opera it was dedicated in 1877 to the singer Pauline Viardot, who championed the work although she herself was never to sing it on stage. Dalila is one of the great roles for mezzo-soprano; two of her arias are particularly well known: "Mon cœur s'ouvre à ta voix" and "Printemps qui commence."

The Canadian contralto Jean Watson (b. 1909) was born in Ireland. Her first engagement outside of Canada was at the annual Bethlehem Bach Festival in Pennsylvania in 1940. This was followed by concert engagements conducted by Bruno Walter, Serge Koussevitzky, and Eugene Ormandy. For five seasons beginning in 1949, Watson performed frequently at Covent Garden, including in the premiere of Vaughan Williams's opera *The Pilgrim's Progress* in 1951, when she sang the part of Madam By-Ends. She also appeared in many European opera houses, including Bayreuth in 1955, and took part in several opera recordings, notably Britten's *Peter Grimes*. Shortly afterward, Watson retired from singing owing to illness.

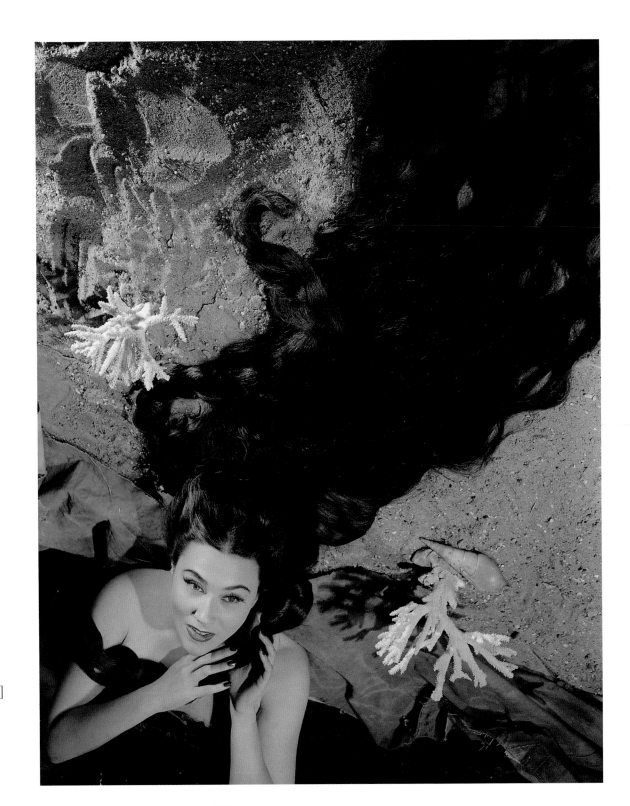

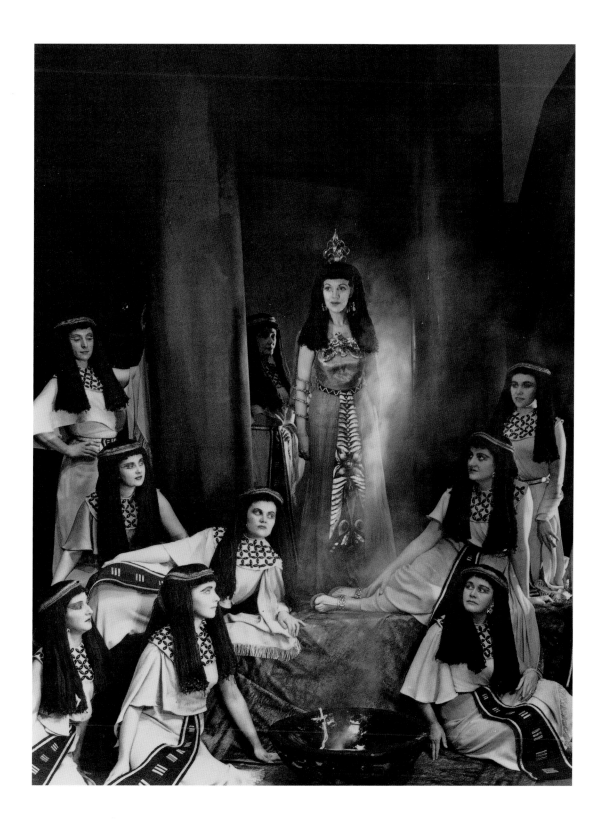

Benjamin Britten. Portrait, 1948.

The late 1940s was a period of great productivity for Benjamin Britten (1913–1976), who rose to a secure preëminence among British composers with the operas *Peter Grimes* (1945), *The Rape of Lucretia* (1946), *Albert Herring* (1947), an adaptation of *The Beggar's Opera* (1948), *Billy Budd* (1951), and *A Midsummer Night's Dream* (1960), among many other concert, dramatic, and vocal works.

McBean's portrait captures Britten's boyishness, but belies the composer's single-minded and altogether businesslike approach to music-making.

Peter Pears as Grimes, with the Borough folk, in Benjamin Britten's opera *Peter Grimes*. Sadler's Wells Royal Theatre, London, 1945.

Benjamin Britten's tragic and hugely successful opera *Peter Grimes*, based on George Crabbe's poem *The Borough*, was first heard at Sadler's Wells in June 1945. The production was directed by Eric Crozier, designed by Kenneth Green, and conducted by Reginald Goodall. Peter Pears sang the demanding role of the haunted and besieged fisherman Grimes. The cast also included Joan Cross as Ellen Orford, Catherine Lawson as Auntie, Roderick Jones as Balstrode, Owen Brannigan as Swallow, and Norman Platt as Ned Keene.

Peter Pears as Grimes with Leonard Thompson as the boy apprentice in Benjamin Britten's opera *Peter Grimes*. Sadler's Wells Royal Theatre, London, 1945.

PETER PEARS as Albert in Benjamin Britten's opera *Albert Herring*. Glyndebourne Festival, 1947.

Albert Herring is one of Britten's perenially popular operas, about a shy, naïve boy who is, to his great humiliation, elected Queen of the May in the market town of Loxford after each of the possible girls is ruled out on moral grounds. The original production was directed by Frederick Ashton and designed by John Piper. Frederick Sharp and Nancy Evans, seen through the window in this photograph, played the high-spirited Sid and Nancy.

PETER PEARS as Captain Macheath and three doxies in Benjamin Britten's adaptation of *The Beggar's Opera*. English Opera Group, Arts Theatre, Sadler's Wells Theatre, London, 1948.

The Beggar's Opera was first performed in London in 1728, at Lincoln's Inn Fields. John Gay's ballad opera, which fitted existing music to a new libretto, established a fashion that would last for decades; in 1928, it was transformed in Berlin into *Die Dreigroschenoper* (*The Threepenny Opera*) by Bertolt Brecht and Kurt Weill. In 1948, it was adapted as a more operatic work by Benjamin Britten, in a production by Britten's own English Opera Group, staged by Tyrone Guthrie. The production was first seen at the Arts Theatre in Cambridge and then, after a tour, at Sadler's Wells. The production starred the tenor Peter Pears (1910–1986), Britten's partner and preferred interpreter, as the highwayman Macheath.

NANCY EVANS as Lucretia and Otakar Kraus as Tarquinius, with Emelie Hooke and Richard Lewis as the female and male chorus, in Benjamin Britten's opera *The Rape of Lucretia*. The English Opera Group. Royal Opera House, Covent Garden, London, 1946.

Britten's powerful chamber opera *The Rape of Lucretia* was based on André Obey's play *Le Viol de Lucrèce*. The play was derived in turn from Livy's account of the violation of Lucretia, the virtuous wife of a Roman general, by Sextus Tarquinius, the Prince of Rome, and her resultant suicide. As was the case with most of Britten's stage works, his collaborators were close friends with whom he worked repeatedly. Ronald Duncan wrote the libretto of *The Rape of Lucretia*, John Piper designed the production, and Eric Crozier was the stage director. Mezzo-soprano Nancy Evans (1915–2000) alternated with Kathleen Ferrier in the role of Lucretia.

Not, it appears, a devotee of contemporary music, McBean wrote, "it seems doubtful if I would ever have seen a Britten opera unless I had photographed so many of them."

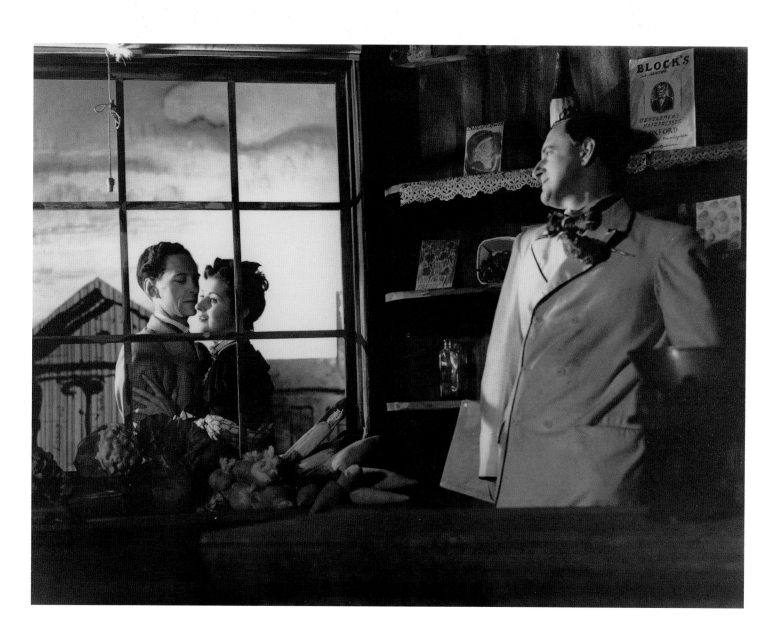

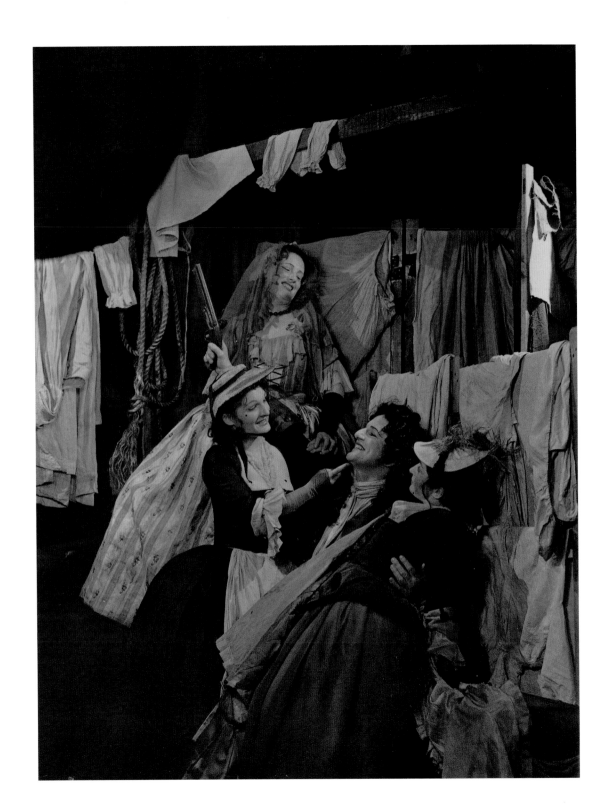

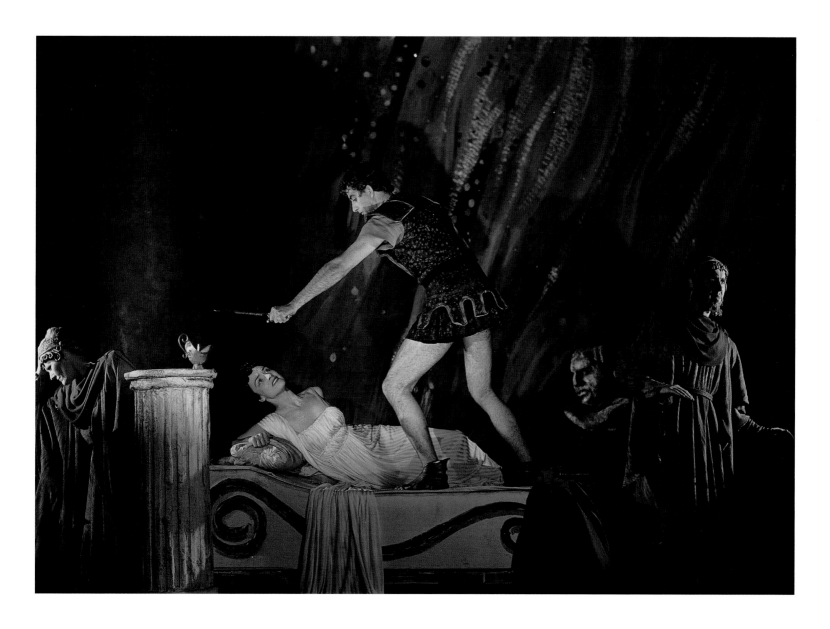

ODERICK JONES as Sir John Falstaff, with six fairies, in Ralph Vaughan Williams's opera *Sir John in Love*. Sadler's Wells Theatre, London, 1946.

Sir John in Love is a four-act comic-opera version of Shakespeare's *The Merry Wives of Windsor*, composed by Ralph Vaughan Williams (1872–1958). The composer himself compiled the libretto, supplementing the Shakespearean text with contemporary poetry and a few passages from the other "Falstaff" plays. The opera was first seen in 1929 at the Royal College of Music, London, in student performances. The Sadler's Wells production was conducted by Sir John Barbirolli.

Shakespeare's incorrigible but endearing fat knight appeared in three plays, the first two being the two parts of *King Henry IV*. It is held that *The Merry Wives of Windsor* was written at the request of Queen Elizabeth I; Vaughan Williams's title was taken from her supposed remark to Shakespeare that "I should like to see Sir John in love."

NDREW DOWNIE as Ralph Rackstraw and Eric House as Sir Joseph Porter in Gilbert and Sullivan's comic opera *H. M. S. Pinafore*. Her Majesty's Theatre, London, 1962.

In 1961, fifty years after the death of W. S. Gilbert, the English copyright on the Gilbert and Sullivan operettas expired, and the D'Oyly Carte Opera company lost its monopoly on these beloved and lucrative operettas. The first non-D'Oyly Carte productions on the London stage included 1962 productions of *H. M. S. Pinafore* and *The Pirates of Penzance* at Her Majesty's Theatre under the auspices of H. M. Tennent. Directed by Tyrone Guthrie, these productions were imported from Canada's Stratford Festival, where they had been produced two years earlier.

AVID BLAIR as Captain Belaye and Elaine Fifield as Pineapple Poll in John Cranko's ballet *Pineapple Poll*. Sadler's Wells Theatre, London, 1951.

Pineapple Poll was a light-hearted ballet derived from the music of the Gilbert and Sullivan operettas interwoven with other Sullivan music, compiled and arranged by the conductor Charles Mackerras. The plot, taken from one of Gilbert's "Bab" Ballads, "The Bumboat Woman's Story," takes place aboard the H. M. S. *Hot Cross Bun*. The choreography was by John Cranko, the sets and costumes by the cartoonist Osbert Lancaster. The first performance, by Sadler's Wells Theatre Ballet, took place on March 13, 1951.

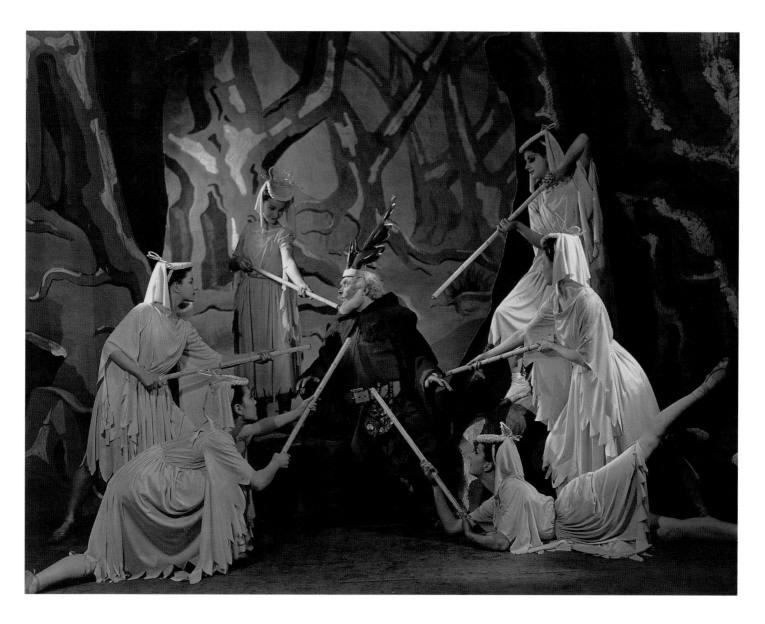

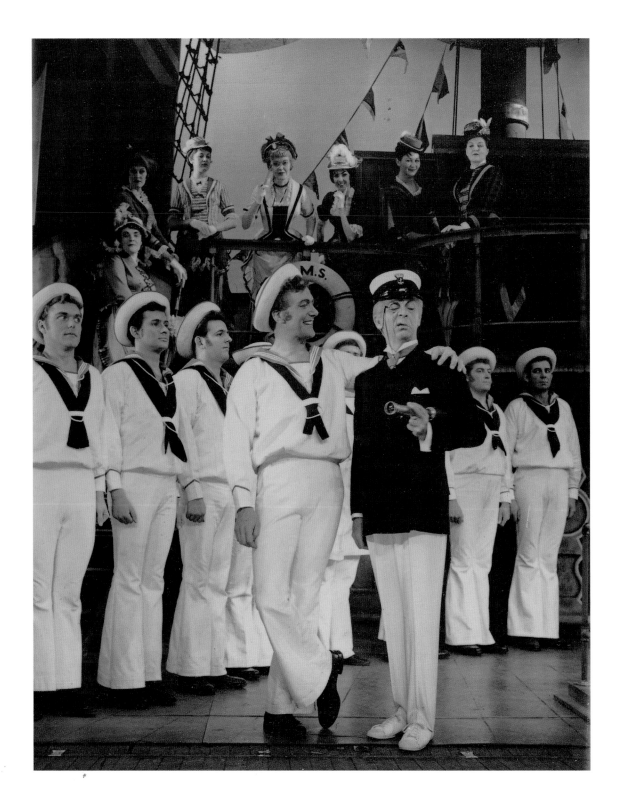

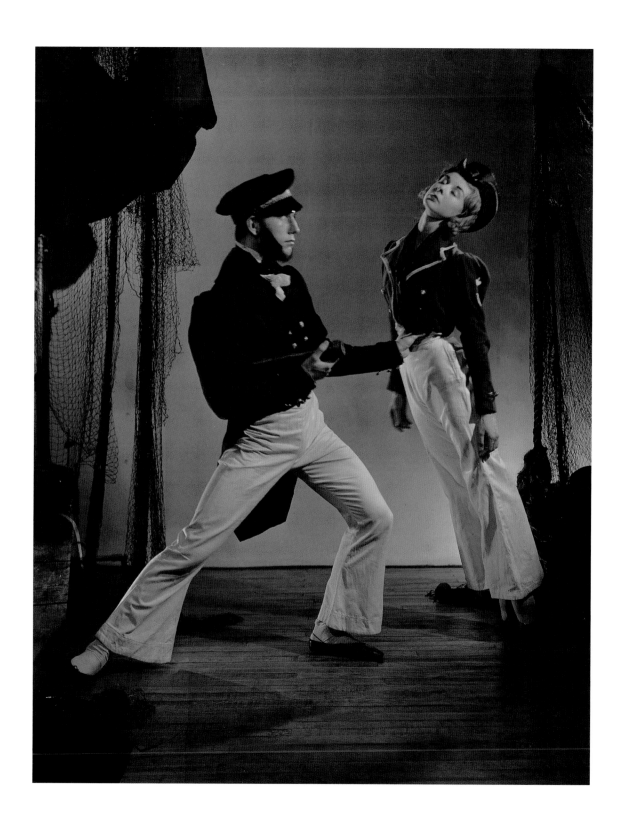

MARTHA GRAHAM as Jocasta in *Night Journey*. Character portrait, 1954.

Martha Graham (1894–1991) was one of the pioneers of American modern dance. Her father had been an early psychologist, and she claimed to have learned to judge peoples' motives from their movements – a talent, it is said, that she exploited in the creation of many of her dance classics. She appeared with her company in London at the Saville Theatre as Jocasta in *Night Journey*, a version of the Oedipus myth that she had choreographed in 1947, with music by William Schuman and designs by Isamu Noguchi. McBean was captivated by her presence: "It was when Grancie Goodman was doing the London publicity for Martha Graham that I was to meet this most remarkable dancer of my experience. Though I have no equipment to assess her importance to the dance, for me she has the same kind of magic that Pavlova had, the compelling presence that prevents you looking at anyone else on the stage when she is there."

RAM GOPAL. Character portrait, 1951.

Ram Gopal (1912–2003) was a master of Indian classical dance. He had a Burmese mother and a Rajput father who was a barrister, and they lived in a mansion called Torquay Castle. He was invited to the United States by La Meri, an American dancer who specialized in non-Western forms of dance, and made his solo debut in New York City in 1938. He made many tours to Britain and the United States before and after the Second World War, causing an explosion of interest in Indian dance in England around the 1970s. At one time he choreographed a pas de deux that he danced with Alicia Markova.

A similar photograph was published in the October 25, 1950 issue of *The Sketch*.

VIOLETTA ELVIN in Roland Petit's ballet *Ballabile*. Costume portrait, 1950.

Violetta Elvin (b. 1924) was Britain's own Soviet ballerina. Born in Moscow, she was a soloist at the Bolshoi – as Violetta Prokhorova – when she met the British architect Harold Elvin, married him, and left Moscow for London. She made her British debut on the second night of the Sadler's Wells Theatre Ballet's first season at Covent Garden, as one of the Bluebirds in *Sleeping Beauty*. Elvin used her married name professionally, and attained considerable popularity in a career that lasted a decade. *Ballabile*, Roland Petit's first ballet for Sadler's Wells, debuted at the Royal Opera House, Covent Garden, on May 5, 1950.

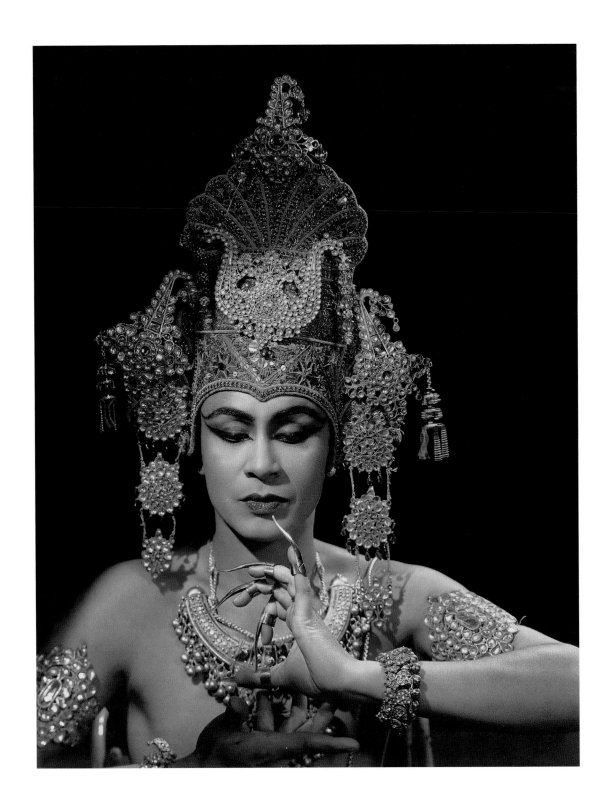

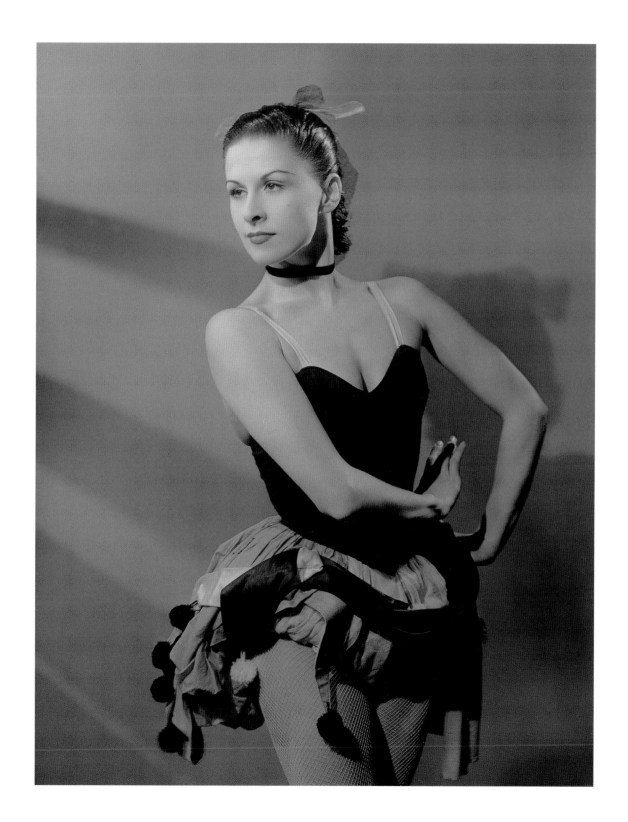

DOLLY PICK and Henri Barjac in *La Forêt Enchantée*, from the Folies Bergère revue *Ah! Quelle Folie*. Winter Garden Theatre, London, 1958.

Although the Folies Bergère is still in existence, the height of its fame and popularity was the period between 1890s and the 1920s. Located at the intersection of the rue Richer and the rue Trévise, it opened in 1869, under the name Folies Trévise, taking its present name in 1872. It was patterned after London's Alhambra music hall, returning the favor by sending its productions on tour to London and other cities.

Featured performers at the Folies included the American dancer Loïe Fuller in the early 1890s. Josephine Baker, the African-American expatriate singer, dancer, and entertainer, performed there from 1926 on, her "banana dance" being a particular attraction. Maurice Chevalier appeared there frequently. However, it was always the erotically charged dancing and scenes that filled the seats and provided its attraction.

The revue entitled *Ah! Quelle Folie* (whose title may have been inspired by the lyric "Ah! Quelle erreur, quelle folie," from Gluck's opera *Armide*) was a touring import of a show that had a long run at the Folies in Paris.

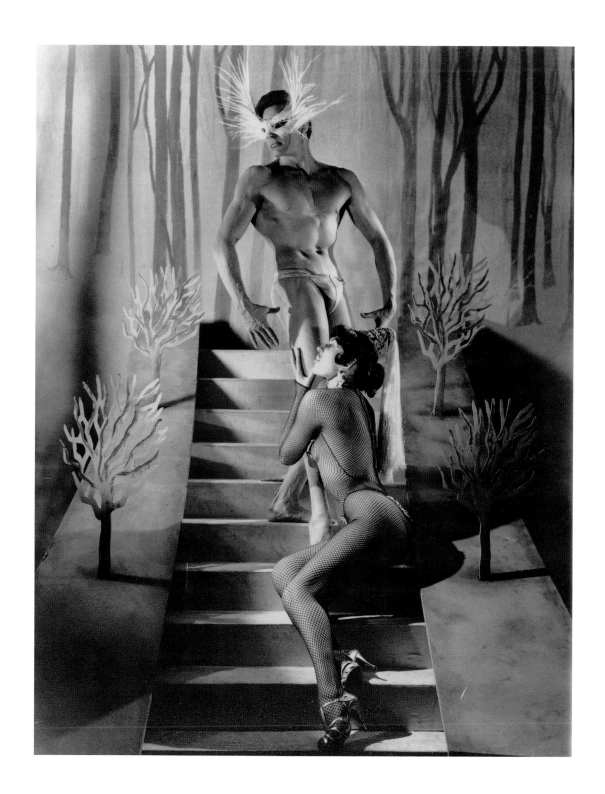

PORTRAITS

A‍UDREY HEPBURN. Composite portrait, 1951.

Audrey Hepburn (1929–1993) appeared in a number of London stage productions in the early 1950s before rising to international celebrity with her film roles, beginning with *Roman Holiday* in 1953, opposite Gregory Peck. Among her best-remembered films are *Sabrina* (1954), *Love in the Afternoon* (1957), *The Nun's Story* (1959), *Breakfast at Tiffany's* (1961), and *Charade* (1963).

Out of this studio session came photographs that were used for advertising purposes, with slogans such as "Your Skin is Not for Burning" – a reference, of course, to Christopher Fry's play. McBean recalled the circumstances: "At one time I needed a model for a beauty production – 'The beauty that dares to come close.' I chose a little girl out of the chorus line of a now-forgotten revue, buried her in sand, and produced what was to become a quite famous photograph. I paid her the usual four guineas fee and she was delighted, brushed off the sand and went back to her revue."

[124]

R‍ICHARD BURTON. Portrait, 1953.

Born Richard Walter Jenkins in the village of Pontrhydyfen, Wales, the son of a coal miner, Richard Burton adopted the name of the schoolmaster, Philip H. Burton, who first coached him in drama and in English. His first stage appearance, in Liverpool in 1944, was in Emlyn Williams's play *The Druid's Rest*. In that same year he was conscripted to serve in the British Royal Air Force.

Burton's first film, *The Last Days of Dolwyn*, was made in 1947, at which time he met the actress Sybil Williams, whom he married two years later. (They divorced in 1963, after his affair with Elizabeth Taylor became widely known.) In 1949, Burton appeared in the West End in a highly successful production of Christopher Fry's verse drama *The Lady's Not For Burning*, together with John Gielgud, Pamela Brown, and Claire Bloom in her debut role. Although rehearsals reportedly began the day after his wedding, he and Bloom began an affair during the run of the play.

Burton starred in more than seventy-five films; though nominated for Academy Awards seven times, he never won. It is ironic that of his several stage appearances on Broadway, many remember him only for his sole musical role, as Arthur in *Camelot*.

I‍NGRID BERGMAN. Portrait, 1955.

There was never a more photogenic woman of the screen than the admired Swedish actress Ingrid Bergman (1915–1982). Named after Princess Ingrid of Sweden, she was born in Stockholm and at the age of eighteen enrolled in the Royal Theatre of Dramatic Art. Within a year she left the theatre to work in film. By the time she was brought to America by David O. Selznick in 1939, she had appeared in eleven films and become Sweden's leading film star. Many of her films are well remembered, but perhaps her most famous roles were in *Casablanca* and Alfred Hitchcock's *Spellbound* and *Notorious*. She appeared five times on Broadway, most importantly in Maxwell Anderson's *Joan of Lorraine*, for which she won the Tony Award for Best Actress.

During the filming of *Stromboli* in 1949, Bergman became pregnant from an affair with the director Roberto Rossellini. This led to her denunciation on the floor of the U.S. Senate by Edwin C. Johnson, a Democratic senator from Colorado, as "a horrible example of womanhood and a powerful influence for evil." A floor vote resulted in her being declared persona non grata. The scandal forced Bergman to exile herself to Italy, leaving her husband, Petter Lindström, and their daughter in the United States. This photograph was made before her return to America in 1956.

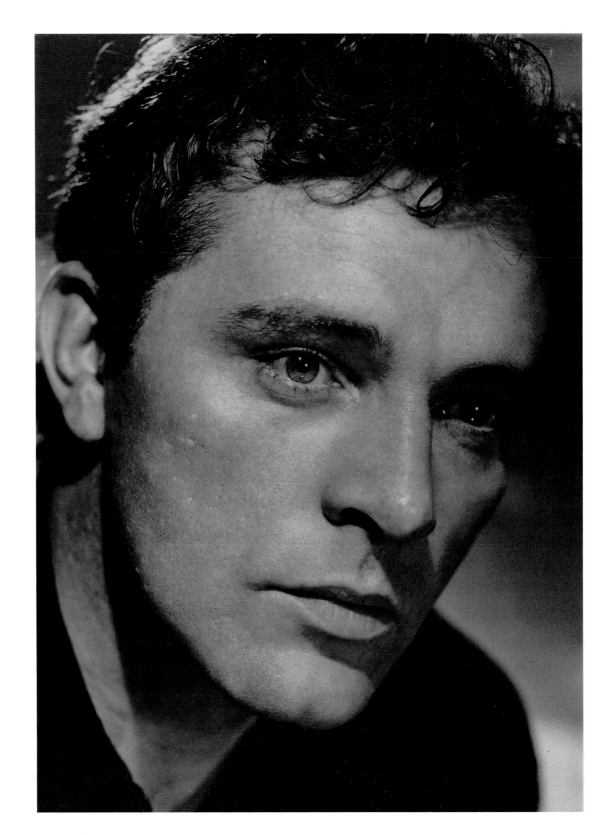

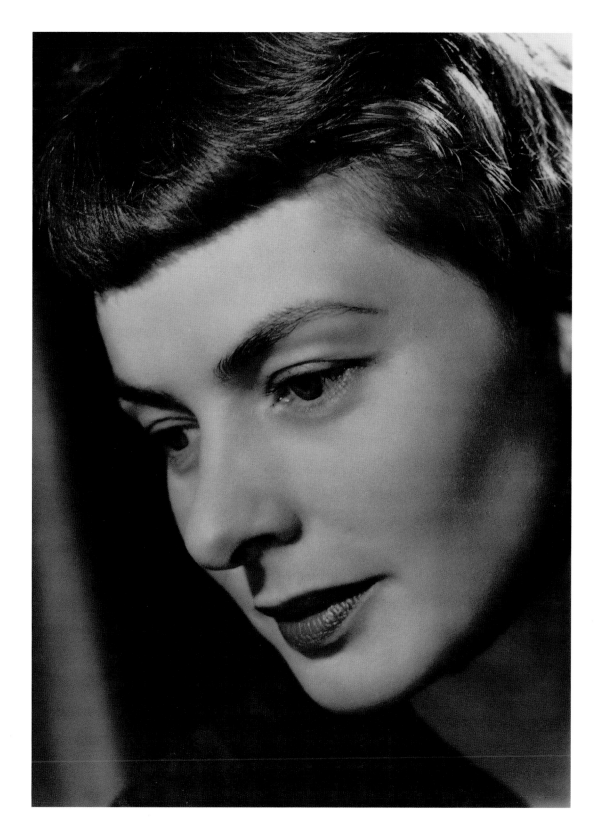

Vivien Leigh in S. N. Behrman's play *Serena Blandish*. Character portrait, 1938.

This photograph was taken at Leigh's first visit to McBean's Belgrave Road studio, at the time of her appearance at the Gate Theatre in the title role in *Serena Blandish; or, The Difficulty of Getting Married*. Based on Enid Bagnold's novel, this dramatization by S. N. Behrman became more popular in America than in England. At the time of this studio session, Leigh had also been filming *Charing Cross Road* with Charles Laughton, and was appearing as Pamela in *Because We Must* at Wyndham's Theatre, then as Jessica Morton in *Bats in the Belfry* at the Ambassadors' Theatre – two stage roles that are now virtually forgotten.

One of McBean's favorite photographs, and the only one hanging on the walls of his house, this is one of the pictures that Leigh sent to David Selznick in Hollywood when she was pursuing the part of Scarlett O'Hara in *Gone With the Wind*. Angus McBean recalled that "After first meeting Vivien, with Ivor Novello in *The Happy Hypocrite*, I next photographed her with Stewart Granger, at the Gate Theatre, in a play called *Serena Blandish*, which gave me my favourite picture of her – the one in the hat. It has hung on my wall ever since." This photograph was used by the Royal Mail in 1985 for a commemorative stamp honoring Vivien Leigh.

Lupe Vélez. Portrait, 1936.

Lupe Vélez (Guadelupe Vélez de Villalobos, 1908–1944), the "Mexican Spitfire," began as a showgirl on the Mexico City revue stage and appeared in Hollywood starting in the late 1920s. She played primarily dramatic roles until she became a comedienne in talkies and had a series of "Spitfire" films built around her. The temperamental star was notorious for her newsmaking love affairs, most notably with Gary Cooper, and for her tempestuous marriage to Johnny Weismuller. Her popularity waned by the mid-1940s, and she committed suicide at the age of thirty-six. This photograph was taken in 1936 while she was appearing in the London revue *Transatlantic Rhythm* at the Adelphi Theatre.

Luise Rainer. Portrait, 1939.

Born in Düsseldorf, Germany and educated in Vienna, Luise Rainer (b. 1910) enchanted Hollywood in the 1930s with her teary, accented performances.

She made her first appearance on the stage at the Dumont Theatre in Düsseldorf in 1928. In 1935, after appearing in a number of German-language plays and films, she was persuaded by an MGM talent scout to move to the United States, who felt she might be well suited to the same type of roles as Greta Garbo.

In Hollywood, Rainer was coached in English by Constance Collier, and first appeared in *Escapade* (1935), co-starring with William Powell. She won consecutive Academy Awards for Best Actress, first for her portrayal of Anna Held in *The Great Ziegfeld* (1936, the same year Garbo had been nominated for *Camille*), and then as the Chinese peasant O-Lan in *The Good Earth* (1937). Among her American stage roles was Miss Thing in J. M. Barrie's play *A Kiss for Cinderella* in 1942, directed by Lee Strasberg.

This photograph was taken at the time when Ranier made her first appearance in England, as Françoise in Jacques Deval's play *Behold the Bridge*, at the Shaftesbury Theatre in London.

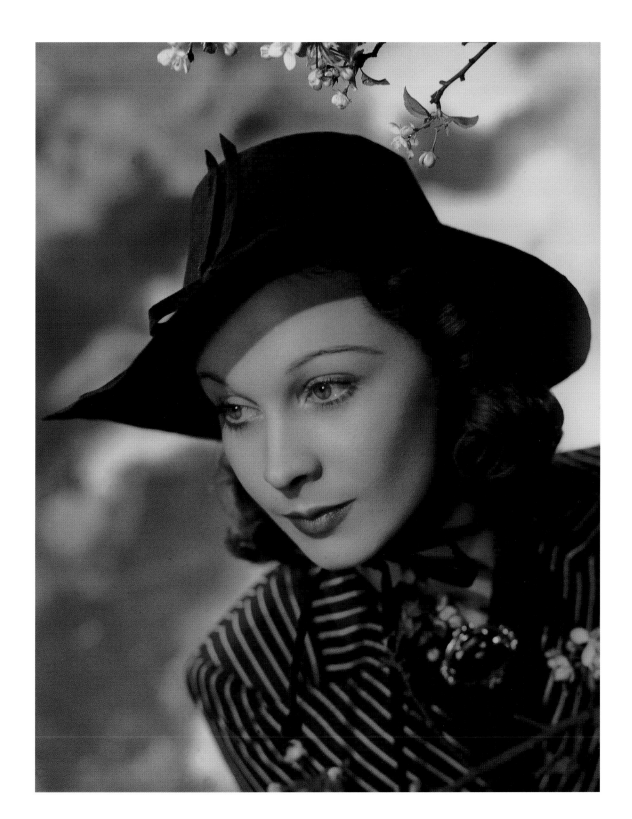

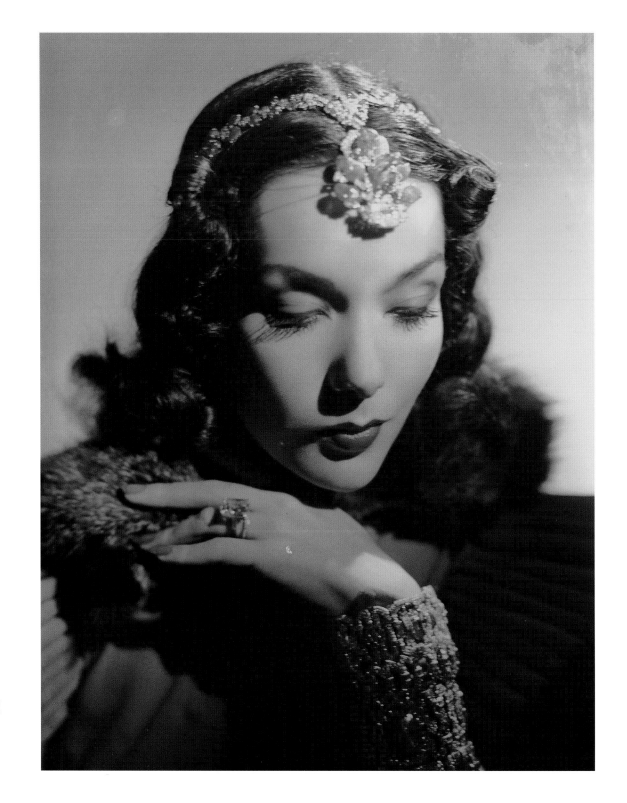

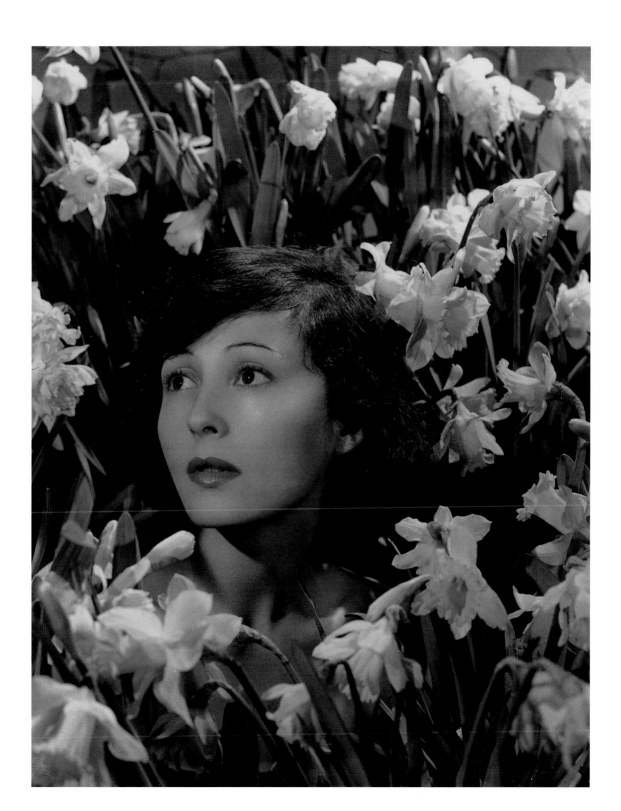

JEAN BATTEN. Portrait, 1937.

The legendary aviator Jean Batten (1909–1982) was born in Rotorua, New Zealand. In 1934 she flew solo from England to Australia. During the mid-1930s she amazed the world with her solo distance and endurance records, some of which stood unchallenged for decades, and for which she was awarded the Harmon Trophy in consecutive years from 1935 through 1937. To the rest of the world she was the best-known New Zealander for many years, and in her native country, schools, buildings, parks, and an airport terminal have been named in her honor. She became a recluse later in life, and died alone in 1982 in a hotel in Palma de Mallorca, Spain, of complications from a dog bite.

This photograph was published in *The Sketch*. McBean recalled that he had to persuade Batten to be photographed wearing her flying cap.

JILL FURSE. Portrait, 1938.

Jill Furse (1915–1944) was the sister of theatrical designer Roger Furse. She married the poet and artist Laurence Whistler (brother of the artist Rex Whistler) in 1939, and died in 1944, whereupon her husband married her younger sister, Judith. She appeared a few films, notably *Goodbye, Mr. Chips* (1939), which starred Robert Donat.

PENELOPE DUDLEY-WARD. Portrait, 1938.

Penelope Anne Rachel Dudley-Ward (1919–1982) was born in London, the elder daughter of The Right Honourable William Dudley-Ward and socialite Freda Dudley-Ward, who is best remembered for having been mistress to the Prince of Wales, the future King Edward VIII. Known as "Pempie," Dudley-Ward appeared in a dozen British films during the 1930s and 1940s, including Shaw's *Major Barbara* in 1941, starring Robert Morley and Wendy Hiller, in which she played Sarah Undershaft. She retired from the screen in 1948, following her second marriage.

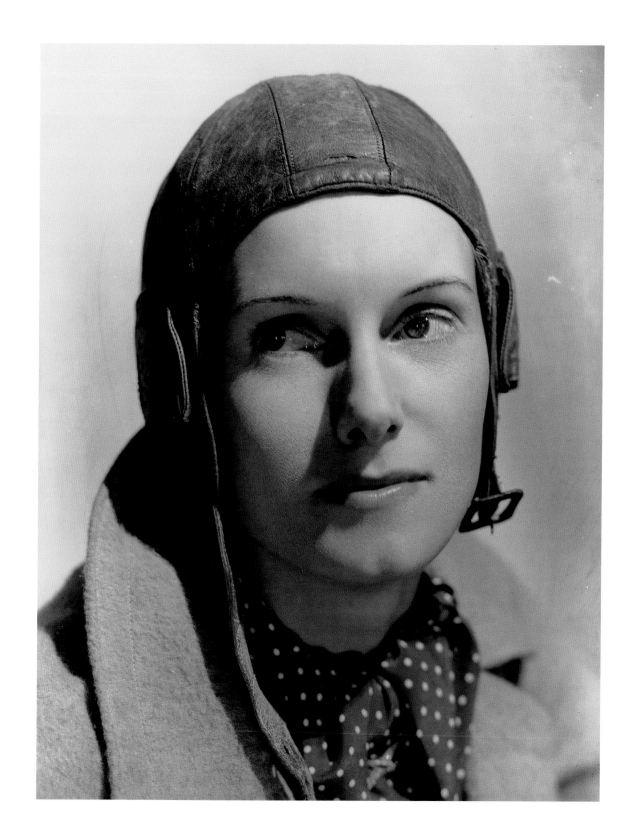

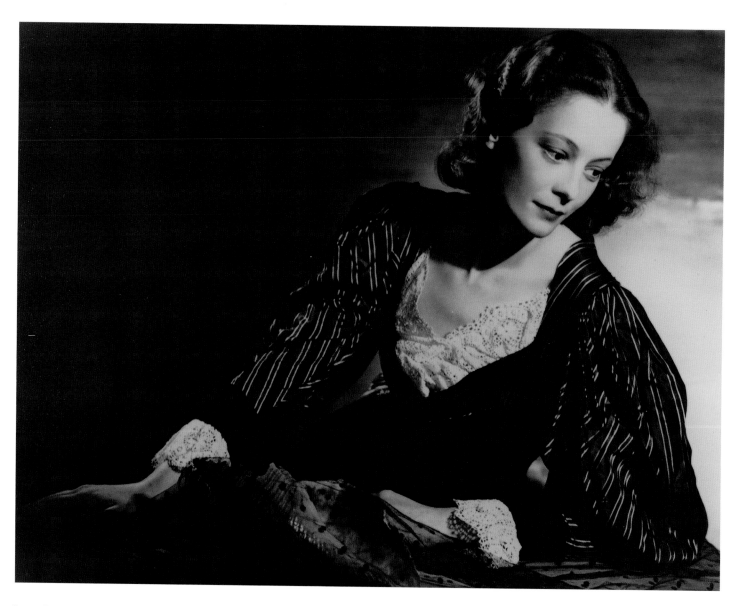

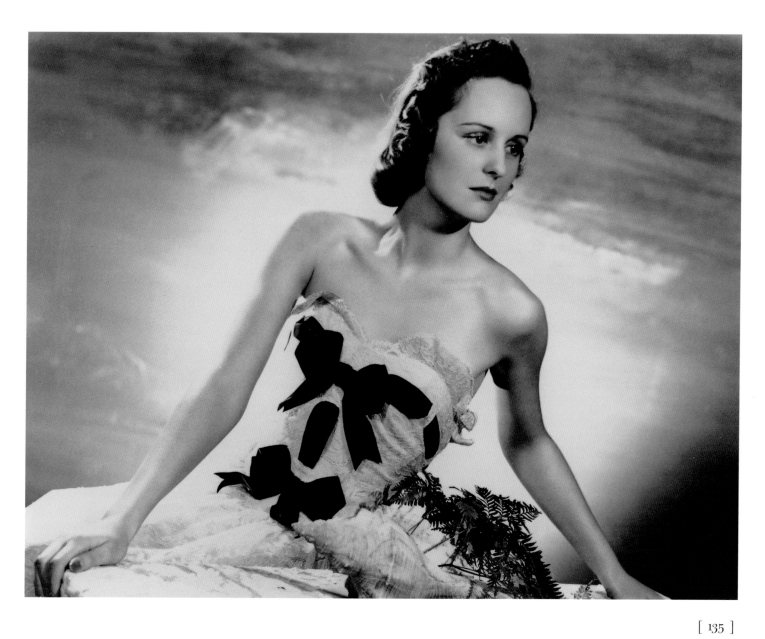

BRUCE INGRAM. Portrait, 1950.

Captain Bruce Ingram (1900–1963), who was directly descended from the original publisher of *The Illustrated London News*, attracted many important writers and photographers to that magazine, and produced many issues that became collectors' items. It was Ingram's own idea to have himself photographed on the occasion of his fiftieth birthday with bound volumes of every edition of *The Illustrated London News* (which claimed to be the longest-existing publication in the world) that had appeared since its founding in 1842. According to the photographer, "these were all dragged out, truckload after truckload. I built a wall with a window, out of the bound copies, through which I caused Captain Ingram to peer. 'I must go now,' he said, after a few shots, and rushed off, leaving the unstable structure swaying dangerously. It collapsed, half burying me." McBean had a further connection with *The I.L.N.*: the company also published the magazine *The Sketch*, which published many of McBean's photographs, including a series of surreal images in the 1930s.

MAE WEST. Portrait, 1948.

Mae West (1893–1980) was a larger-than-life personality. During her stage career in the 1920s she appeared in more than a dozen plays, the most successful of which – *Sex*, *The Drag*, and *Diamond Lil* – she also wrote. Her portrayals became notorious for pushing the limits of public sexuality, and her 1928 play *Pleasure Man* was shut down by the police after two performances. Later in her career, after starring in racy films such as *I'm No Angel* and *She Done Him Wrong*, she returned to the stage with her successful play *Catherine was Great* as well as revivals of *Diamond Lil*.

This photograph, which was published in *The Tatler and Bystander* on April 11, 1948, was taken at the time when West was appearing in *Diamond Lil* at the Prince of Wales Theatre. She is shown posing with a puppet that McBean himself made. McBean had appeared with the same puppet in a photograph that was published in *The Sketch* in 1934.

CECIL BEATON as Mephistopheles. Costume portrait, 1949.

When Cecil Beaton (1904–1980) was growing up, his nanny let him use a Kodak 3A camera, a popular model that was considered ideal for learning the basics of photography. She taught him those basics, and they developed their photographs in the basement.

As an adult, Beaton began to design program covers and costumes for charity matinees as he explored other opportunities. He learned the professional craft of photography working in the studio of Paul Tanqueray, until in 1927 he became a photographer for *Vogue* magazine. The compliment that McBean cherished above all others was Beaton's remark that McBean – his exact contemporary – was the best portrait photographer of his era.

After the Second World War, Beaton worked on the Broadway stage. His first assignment was to design sets, costumes, and lighting for a 1946 revival of *Lady Windermere's Fan*, in which he also acted. His most lauded achievement for the stage was the sets and costumes for Lerner and Loewe's *My Fair Lady* (1956). This led to two further Lerner and Loewe film musicals, *Gigi* (1958) and *My Fair Lady* (1964), both of which earned Beaton the Academy Award for Costume Design.

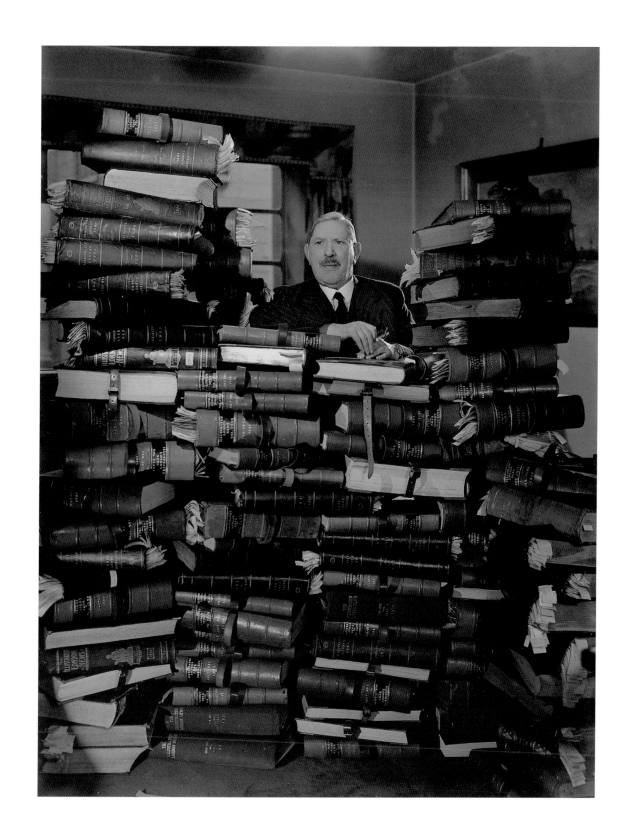

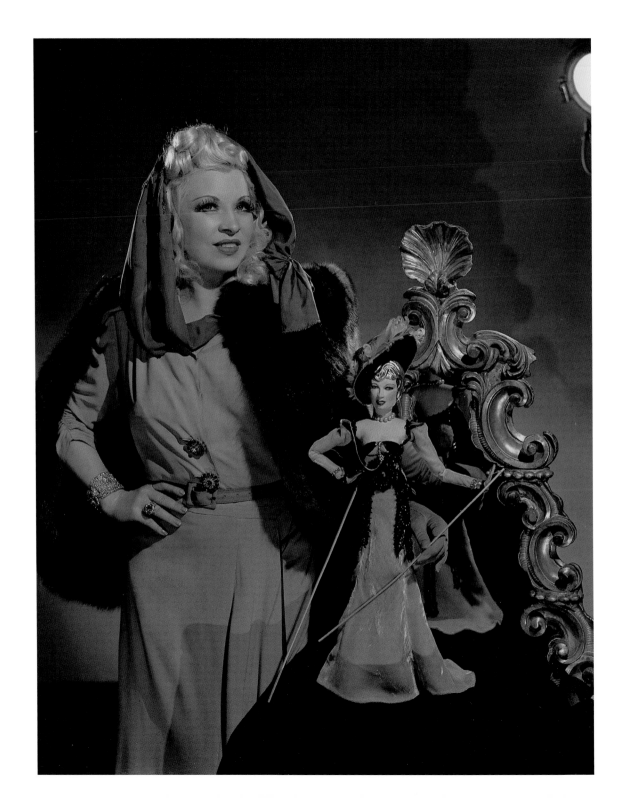

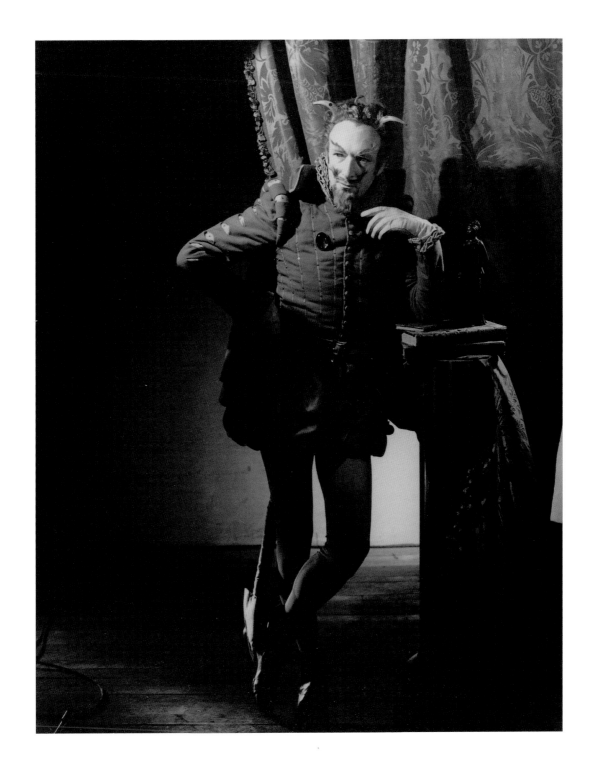

SURREAL AND MONTAGE

HUGH BEAUMONT. Montage composition, 1947.

H. M. Tennent was for many years the most distinguished and successful producing firm on the West End stage. Formed in 1936, it was the creation of Harry Tennent, of the Drury Lane Theatre, and Hugh Beaumont (1908–1976), known to all as "Binkie," who produced everything from the plays of Terence Rattigan to *My Fair Lady* with a high standard of taste, and, often, of luxury. Angus McBean enjoyed a privileged relationship with H. M. Tennent, and was invited to photograph many of their shows.

Beaumont is pictured here manipulating Emlyn Williams and Angela Baddeley on a toy theatre stage representing his production of Terence Rattigan's play *The Winslow Boy*, which had appeared at the Lyric Theatre in 1946. This memorable montage was published in the "Play Personalities" series in the August 6, 1947 issue of *The Tatler*, with the caption "Binkie Pulls the Strings."

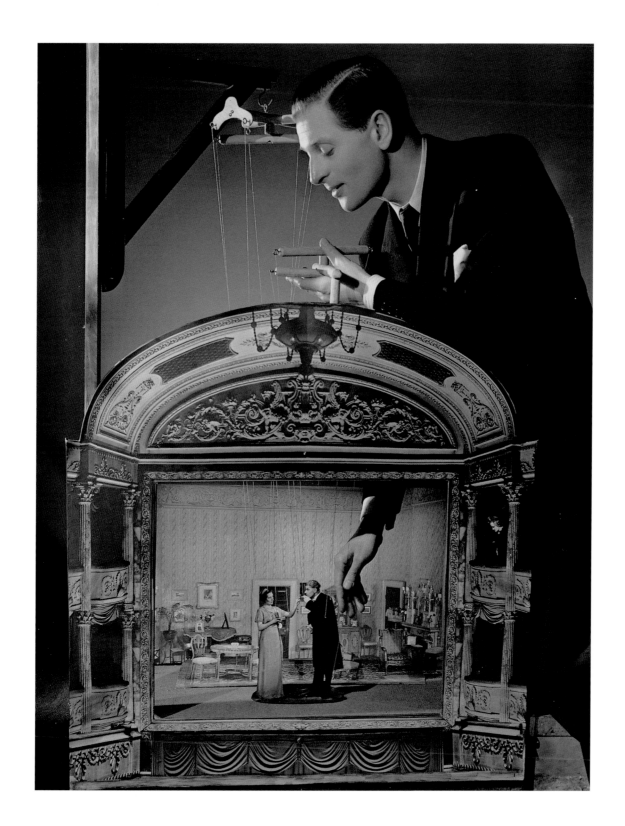

A

AUDREY HEPBURN. Surreal composition, 1951.

Belgian-born Audrey Hepburn had several small parts in British films in the early 1950s, before she became famous for her role as a vacationing princess in David Lean's *Roman Holiday* (1953). She had also appeared on Broadway as Gigi in the stage version of Colette's novella in 1951 (not the musical), and as the title character in Jean Giraudoux's *Ondine* in 1954. Even earlier, Hepburn appeared as a chorine in *Sauce Tartare*, a revue at the Cambridge Theatre directed by Cecil Landau that opened in 1949. Remembering Hepburn from that early stage appearance, a production that he had photographed, McBean suggested her for an advertisement for the skin lotion Lacto Calamine.

This photograph is similar to the one used in those advertisements, which were seen in chemists' shops and popular magazines throughout Britain. The ad photograph was to become McBean's calling card: "Perhaps if I ever go down in photographic history, it will be as the man who took the picture of Audrey Hepburn in the sand – so far it has appeared in every piece which has ever been written about me, and I am tied to it, like Steichen to the wonderful shot of Isadora Duncan in the Parthenon, and Baron de Meyer to the draped face of the Ponds cold-cream advertisement...."

Z

ZIZI JEANMAIRE. Surreal composition, 1949.

The French ballerina Zizi Jeanmaire (b. 1924) came to prominence with Roland Petit's Ballets de Paris, which toured Britain and the United States in the early 1950s. From there she went into films, such as Samuel Goldwyn's *Hans Christian Andersen* in 1952, and later appeared in musicals, including the Broadway revival of Cole Porter's *Can-Can* in 1981. In this typical McBean composition, Zizi (as she was billed) rises from the sand while a bronze statue of Napoleon's Empress Josephine (apparently with footprint tracks) stands in the distance. The juxtaposition had occurred to McBean because Zizi had claimed to bear a physical resemblance to the empress.

B

BEATRIX LEHMANN. Surreal composition, 1937.

Beatrix Lehmann (1903–1979) had an extensive career on the West End stage, with a stage debut as Peggy in a 1924 production of *The Way of the World* at the Lyric Theatre, Hammersmith.

This was the first of McBean's famous "Surrealised Portraits" that were published in *The Sketch*. It was taken at the time when Beatrix Lehmann was appearing in Eugene O'Neill's play *Mourning Becomes Electra* at the Westminster Theatre. McBean had photographed the play, but "now Beatrix wanted pictures of herself, so I quickly made up a setting with things I happened to have around the studio, culminating with a garment of stiff taffeta made to look as if windswept.... It was the most simply achieved of all my surreal effects and certainly one of the best." When the resulting composition was published in December 1937 it was captioned "Vinnie Actonised," with the explanation that Lehmann represented Lavinia, Electra's daughter, in the manner of the surrealistic portraits of William Acton. *The Sketch* asked if McBean could produce more such inventions: "Could I! I did, one a week for three years.... We had great fun with them. They were built on Thursday night and taken on Friday, week after week."

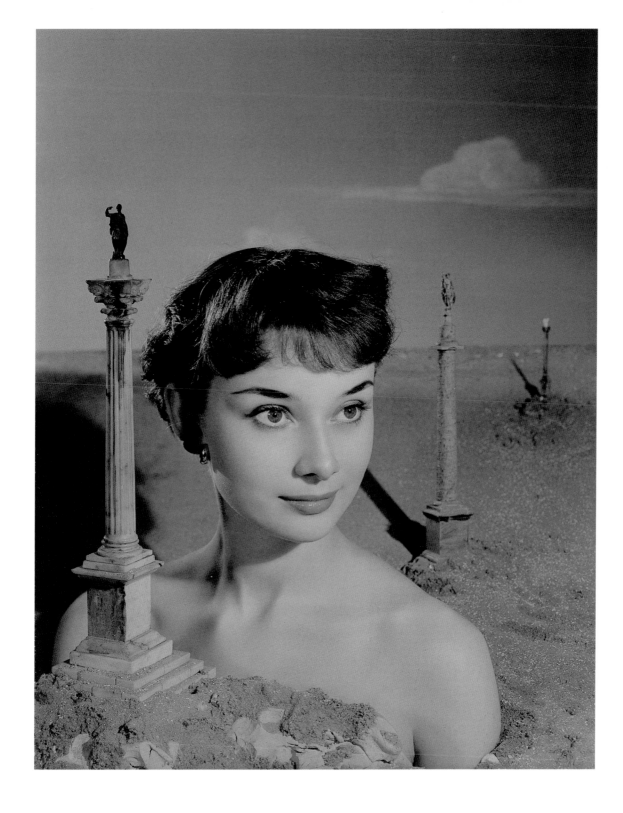

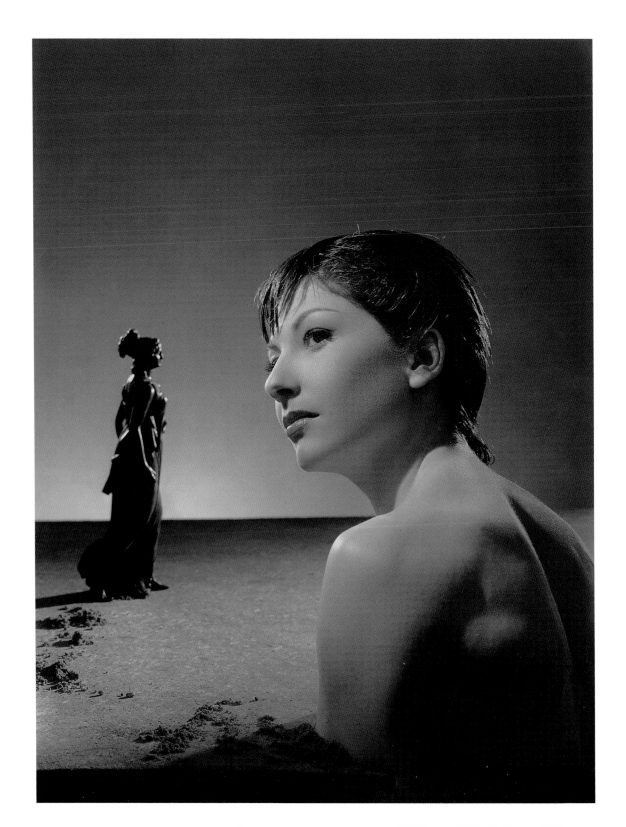

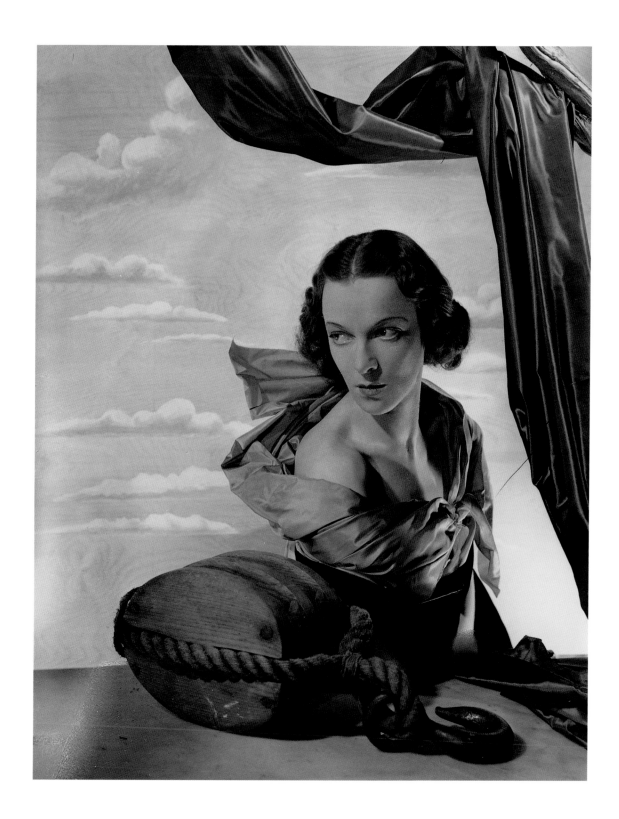

ELSA LANCHESTER. Surreal composition, 1938.

Although she appeared in a number of stage productions, Elsa Lanchester will always be associated more strongly with her roles in such films as *The Private Life of Henry VIII* (1933), *Rembrandt* (1936), *Witness for the Prosecution* (1957), and, of course, *The Bride of Frankenstein* (1935), in which she appears both as the title character and in the prologue as the author, Mary Shelley. In 1929 she married Charles Laughton, with whom she appeared in many films.

This photograph came at the end of the long series of surreal photographs McBean made for *The Sketch*, appearing in the June 22, 1938 issue: "Almost the last one was of Elsa Lanchester, amongst fake ruins just as the war started." The surreal background seemed no longer appropriate: "We did one a week for three years, right up until the war, when its more virile ruins made my dreamlike world of mock disaster seashores and shells a little sick."

TAMARA TOUMANOVA in *La Sylphide*. Surreal composition, 1938.

Tamara Tumanishvili (1919–1997), of Georgian descent, was born in Tyumen, Siberia, while her mother was fleeing from Georgia just after the Revolution, in search of her husband. The reunited family eventually settled in Paris, where Tamara became a student of the former Imperial Ballet star Olga Preobrajenska. Discovered by Balanchine as a young student, Toumanova became one of the three acclaimed "baby ballerinas" in Colonel de Basil's Ballet Russe de Monte Carlo. Among the ballets created for her by Balanchine were *Cotillon*, *Concurrence*, *Le Bourgeois Gentilhomme*, and *Le Palais de Cristal*. In America she appeared in a number of films, including *The Private Life of Sherlock Holmes*, *Tonight We Sing* (in which she portrayed Anna Pavlova), and Alfred Hitchcock's *Torn Curtain*.

Another photograph from this studio session was published in *The Sketch* on July 27, 1938. According to the photographer, "The bit of plaster brick wall [from St. Martin's Theatre] I used for years until it finally fell to pieces. At one point I cut an odd-shaped hole in it. Odd-shaped holes were one of the leitmotifs of surrealism and were taken over with enthusiasm by the general designing of the period. . . . Through my particular hole I arranged for Toumanova, the ballerina, to float for one of my surreal pictures."

PEGGY ASHCROFT as Portia in *The Merchant of Venice*. Surreal composition, 1938.

Peggy Ashcroft appears as Portia in this surreal study, based on a production of *The Merchant of Venice* that appeared at the Queen's Theatre during John Gielgud's 1938 season there that also included Chekhov's *The Three Sisters*. This photograph was published in *The Sketch* on June 8, 1938.

Ashcroft made her stage debut in J. M. Barrie's play *Dear Brutus*, co-starring with Ralph Richardson, and was a fellow student of Laurence Olivier at the Central School of Speech and Drama.

Angus McBean was clearly influenced in this painting-like photograph by the artists Dalí and De Chirico. Referring to this image, and its exaggerated wood-grain door frame, McBean wrote, "My friend Roy Hobdel, himself a surreal painter, often helped me, and when the compositions called for drawing, he would do it for me. For instance, one which I greatly like was of Peggy Ashcroft as Portia. We had a door frame lying about, waiting for the builder. I wanted to use it. 'But you mustn't if not with natural wood in these pictures. I'll paint it into the wood for you,' which he proceeded to do, also painting the dream landscape behind on the wall."

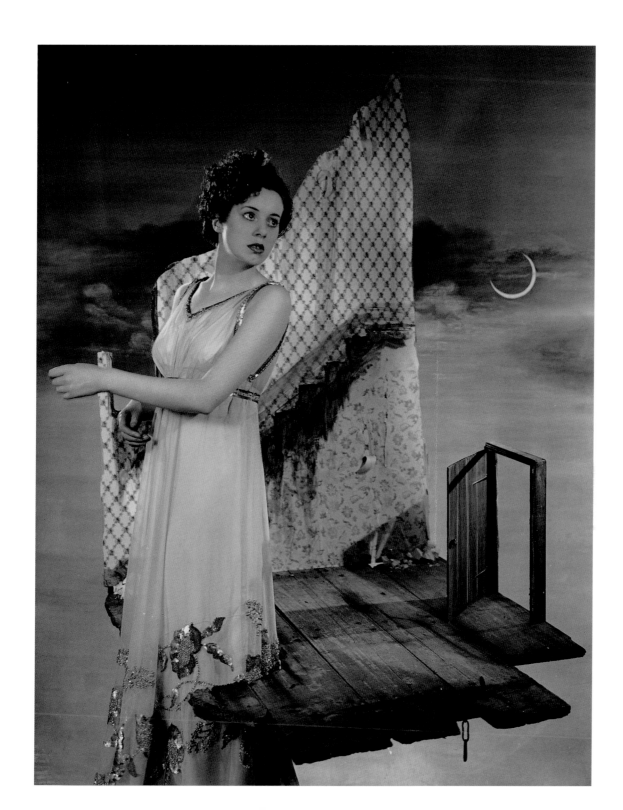

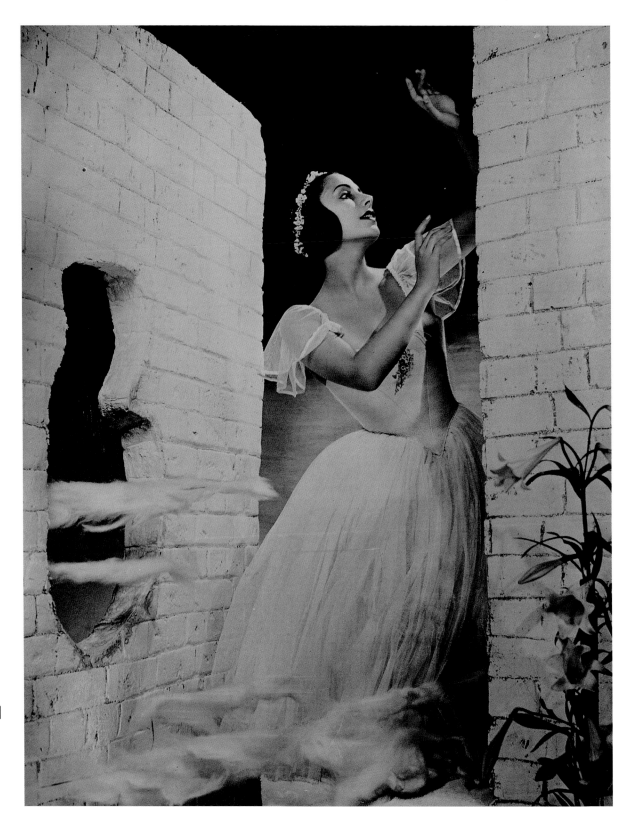

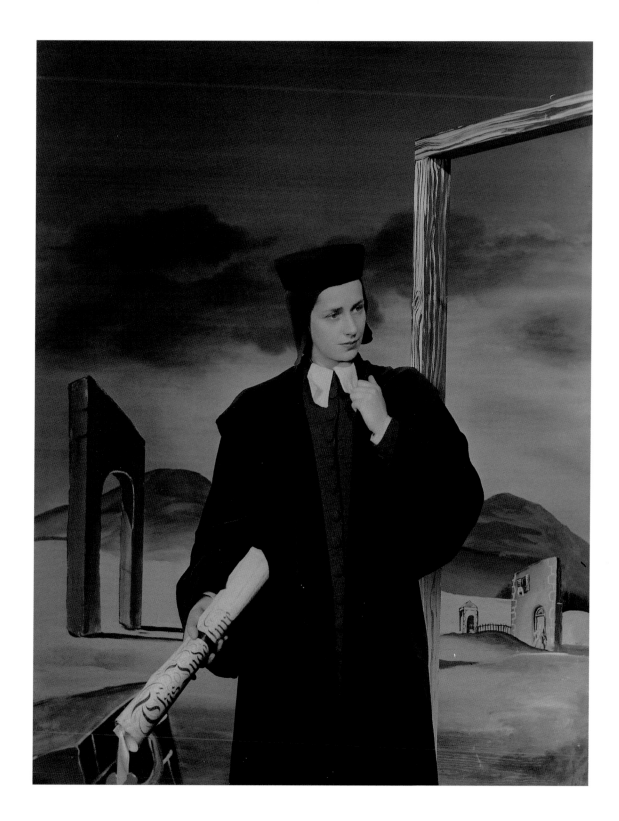

DOROTHY DICKSON. Surreal composition, 1938.

A dancer and singer in musical comedies, Dorothy Dickson (1893–1995) first appeared on Broadway in the late 1910s in Princess Theatre musicals (by Jerome Kern and P. G. Wodehouse) and in the Ziegfeld Follies. Transferring to London, she was in a string of West End musical hits (*Sally*, *The Cabaret Girl*, *Tip-Toes*) before she allied herself in the 1930s with Ivor Novello, for whom she appeared in the Drury Lane spectaculars *Careless Rapture* (1936) and *Crest of the Wave* (1937). She also appeared as the French princess opposite Novello in his production of Shakespeare's *Henry V* at the same theatre in 1938. She maintained a friendship with the Queen Mother dating from the 1920s until her death at age 102.

A similar photograph from this same session was published in the October 1938 issue of *The Sketch*, captioned "Dorothy in the Lily Pool." As McBean recalled the dialogue: "I'm getting very wet." "I told you to wear old clothes." "You didn't tell me to wear old undies!"

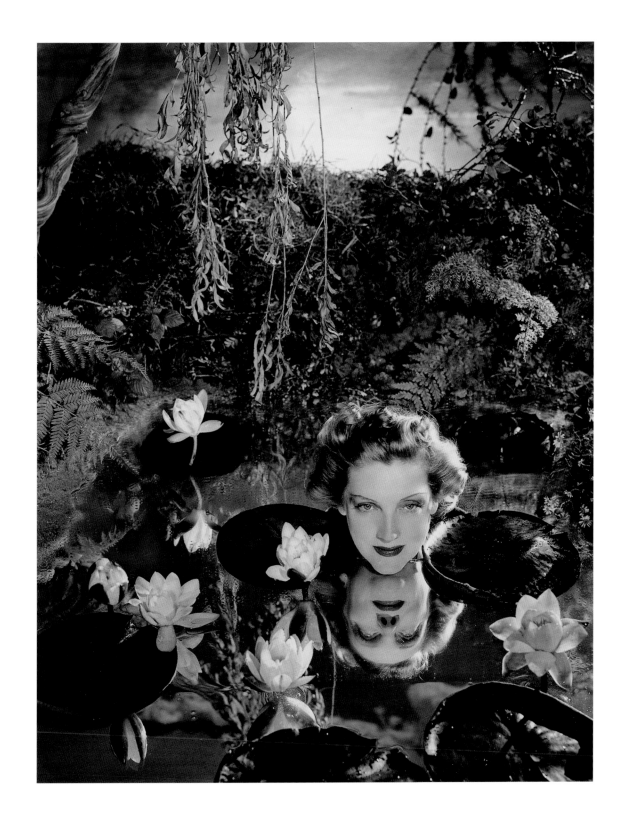

DIANA CHURCHILL. Surreal composition, 1940.

The actress Diana Churchill (1913–1994) was a British blonde who appeared frequently on the West End stage and somewhat less often in films, although she is remembered for her role as Kathleen Scott in *Scott of the Antarctic* (1948). When this surreal portrait was taken in 1940, she had recently appeared in two London plays and three films.

This photograph appeared on the cover of *The Picture Post*. McBean related the circumstances: "So the series [of surrealist photographs in *The Sketch*] went on. . . . Towards the end I began to run out of ideas. Also the amount of work demanded weekly to produce them, and the very little return in actual cash, made it clear that I must soon stop. . . . Still, the series must have kept their interest to the end, for *Picture Post* asked me to do a picture, especially for them, so that they could follow stage by stage with photographs. I chose Diana Churchill and made a picture of a very ordinary hall with a chair in it, against the wall. On it had been a broom, gloves, and bag, and on the floor beneath the chair had been dropped – Diana's head!"

This photograph was the cause of some diplomatic consternation when it fell into the hands of Nazi propagandists, who assumed the actress was Churchill's daughter. (She was not.)

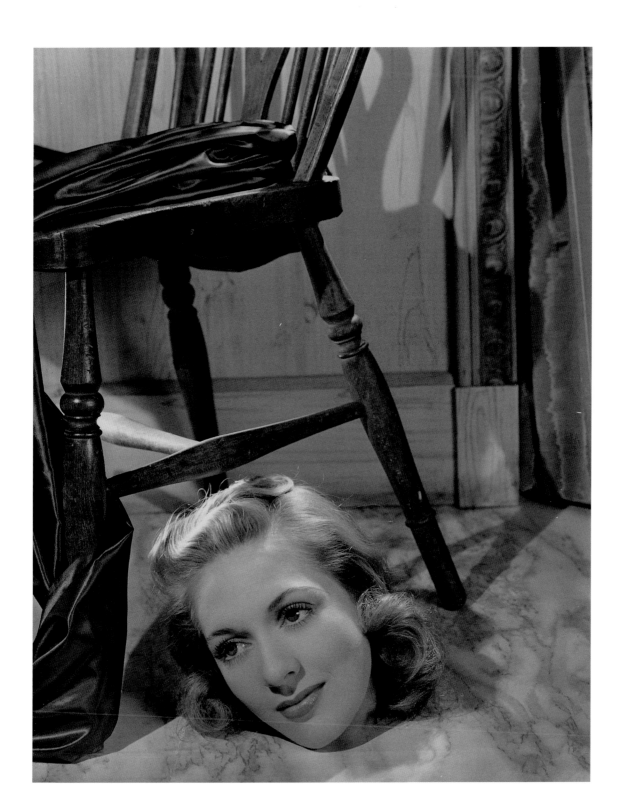

Edith Evans. Surreal composition, 1939.

Edith Evans was one of the finest actresses of her time, equally at home in comedy and drama. Her career spanned sixty years and included more than 150 roles, works by Shakespeare, Congreve, Ibsen, Wycherley, and Wilde, as well as contemporary playwrights including Shaw, Bagnold, Fry, and Coward.

Her first stage appearance was in the role of Viola in *Twelfth Night*, with Miss Massey's Streatham Shakespeare Players in October 1910. She made her professional stage debut in 1911 in Shakespeare's *Troilus and Cressida*. Beginning in 1925 she appeared at the Old Vic Theatre in a range of Shakespearean roles that included Portia, Cleopatra, Rosalind, Beatrice, and the Nurse in *Romeo and Juliet*.

She was also a frequent subject for Angus McBean. This photograph was published in *The Sketch*.

Vivien Leigh with Angus McBean. Preparation for a surreal pose, 1939.

In this accompanying photograph taken by McBean's assistant, John Vickers, we see McBean himself with the mechanics behind the plaster-of-Paris robes and the cotton clouds, the real behind the surreal. In the end Leigh's décolletage had to be covered somewhat with a floral sprig.

Vivien Leigh as Aurora. Surreal composition, 1939.

This photograph, captioned "Aurora, Goddess of Dawn," was published in *The Sketch* on April 6, 1938. Like a number of McBean's compositions, it was inspired by classical themes.

McBean related the process of making this photograph: "It involved making plaster clothes for her, so on the occasion of her first visit, we first of all stretched her as tightly as possible over a minimum of underclothes with a sheet of thin white rubber. She was put slightly reclining on a scaffold board. She had to have some support because the operation would be lengthy and the plaster drapery, when wet and very heavy. . . . When Vivien came, she slipped into the dress from behind. The front of the dress, it turned out, was a little too *plongé* for those days, so a spray of cherry blossoms was popped there, and at the last moment, I scattered more blossom on the clouds. The picture caused a lot of attention but it must have been due to Vivien, not myself, because as a photograph it does not rank very high amongst my other surrealist efforts, and a lot of enquiries were received by *The Sketch* which had published it. 'How was it done?' So the next week *The Sketch* published the picture John Vickers had taken of me making the dress on Vivien – the first picture ever to be published over his name."

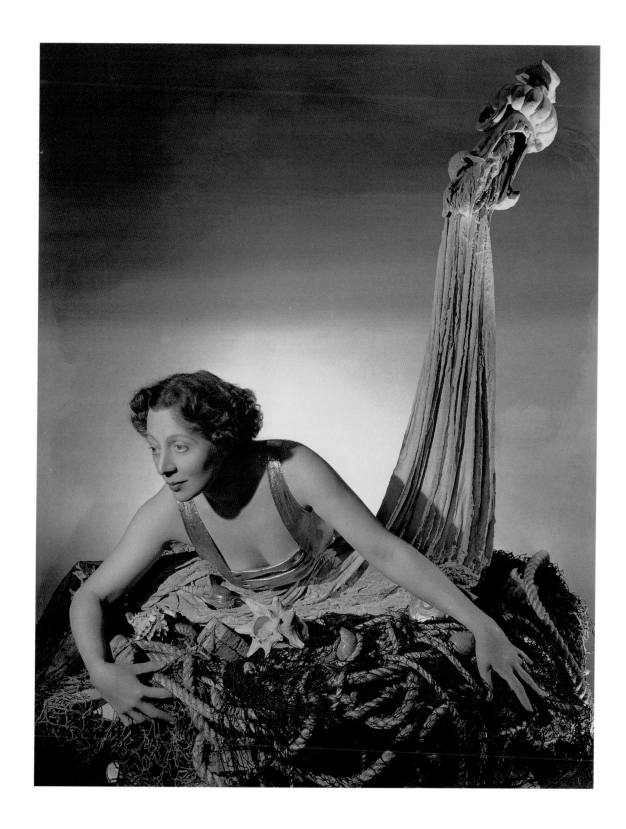

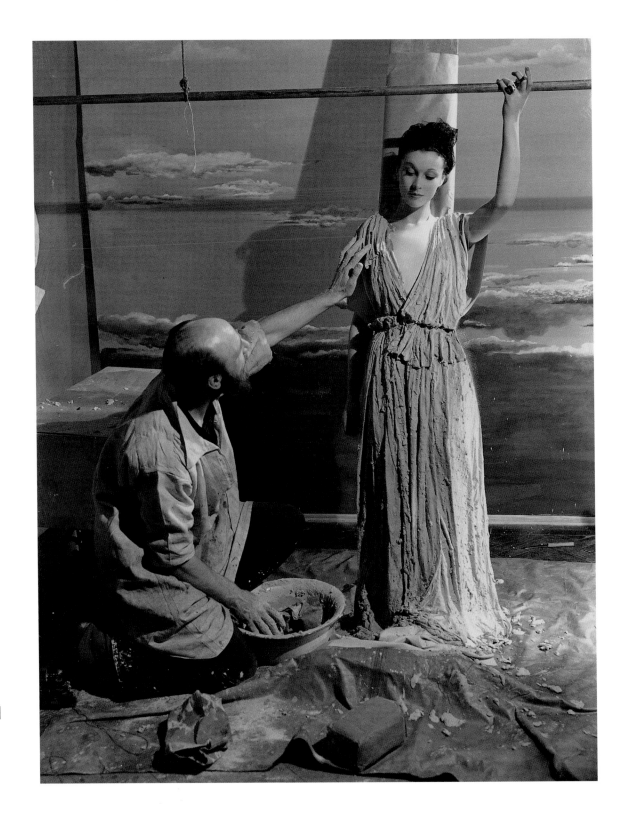

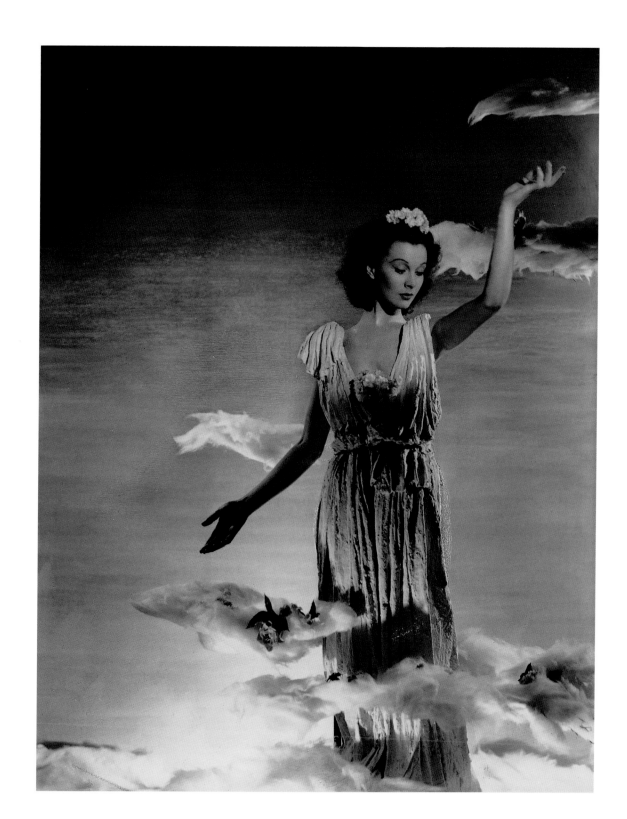

T

AMARA GEVA as Persephone. Surreal composition, 1939.

The beautiful ballerina Tamara Geva (1907–1997), born Gevergeyeva, attended ballet classes at the Imperial Theatre School in Leningrad shortly after the Revolution. She married her fellow student George Balanchine in 1921, after his graduation, and with him joined Diaghilev's Ballets Russes in 1924. After her divorce from Balanchine, and a falling out with Diaghilev, she came to America with Nikita Balieff's Chauve-Souris company. She remained on Broadway, appearing with success in such musicals as *Three's a Crowd* (1930), *Flying Colors* (1932), *Whoopee* (1934), and, most famously, Rodgers and Hart's *On Your Toes* (1936), choreographed by Balanchine. In 1935 she was engaged by the American Ballet, the company directed by Balanchine that would evolve into the New York City Ballet. Geva also had several film parts, including – most bizarrely – Oberon in a German silent version of *A Midsummer Night's Dream* (1924).

This photograph was published in a "beauty number" of *The Sketch*, paired with the portrait of Vivien Leigh shown previously. McBean recalled that *The Sketch* wanted two surrealist photographs for the same issue, "so I did one of Tamara Geva rising out of a tree trunk and entitled 'Persephone.'"

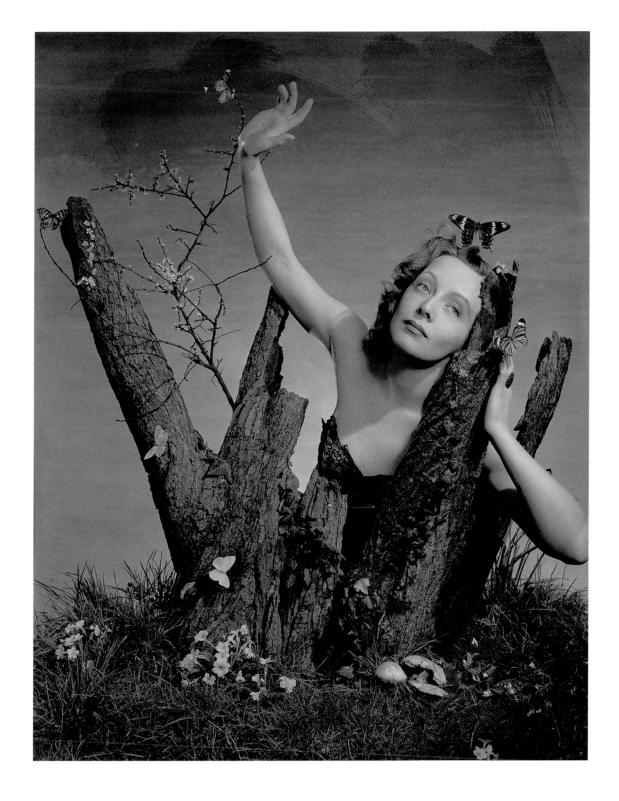

NANCY SPAIN. Montage composition, 1950.

Nancy Spain (1917–1964) was a popular British author, journalist, and radio and television personality, who at the time of this photograph was writing lurid crime thrillers. In this amusing montage from 1952, Spain seems to be lying on or against the blown-up corrected proofs of her latest tale, surrounded by all sorts of potential murder weapons. Spain later became particularly well known for her appearances on the Saturday night television show *Juke Box Jury*. She died, with her life partner Joan Werner Laurie, in the crash of a chartered plane en route from Luton Airport to the Grand National races.

This photograph was published in *The Tatler*.

AGATHA CHRISTIE. Montage composition, 1950.

Agatha Christie (1890–1976) was the author of many mystery novels and the deathless West End production *The Mousetrap*. She was not often photographed, and the few Angus McBean portraits from a single studio session, including this montage, are seen in connection with almost all of her books, plays, and films.

This image was published in *The Tatler*.

PETER BROOK. Montage composition, 1947.

This montage shows Peter Brook (b. 1925) bursting through a wall posted with reviews of productions he had directed at Stratford-upon-Avon. Among the plays represented is *Romeo and Juliet*, his first play at Stratford, for which the twenty-one-year-old director and the eighteen-year-old Juliet, Daphne Slater, both received immoderate praise.

The innovative theatrical director is best known for his work with the Royal Shakespeare Company, where he directed many productions with the likes of John Gielgud and Laurence Olivier. Brook later became director of productions at the Royal Opera House, Covent Garden. He was the director of the Royal National Theatre from 1973 to 1988, and he has directed many productions at Chichester Festival and the Arts Theatre, including *King Lear* with Paul Scofield, Peter Weiss's *Marat/Sade*, an epic mixed-race production of *The Mahabharata*, and a provocative quasi-operatic production of *Carmen*.

A photograph similar to this one was published in *The Tatler* in the July 23, 1947 issue.

silence seemed to have been chloroformed so... Honest...
...ghed so often with pleasure.) sat so still a...

"It's a divine performance, Miriam," went on Banjo. "Divin...

And he embraced her heartily. And Miriam did not recoil fr...
...im. She... up to her dressing-room dizzy and plastered w...
...pplause... excitement. And on the stage the music changed to...
...n Cinderella, alone by her fireside.

And Banjo went into *his* dressing-room and began to change
...is next entrance.

Peters, his dresser, found him half-changed when he came b...
...with his two glasses of Guinness from the Saracen's Head.
...Banjo was lying on the floor in a dreadful heap, like a bundle o...
...clothes. In the middle of his forehead there was a neat blue h...
He was quite dead.

THREE

POOR Banjo's dressin...
...had struck it. A...
...sticks of grease-...
...evidently grasped...
...had fallen... abo...
...Now he la...or...
...him. His righ... ha...

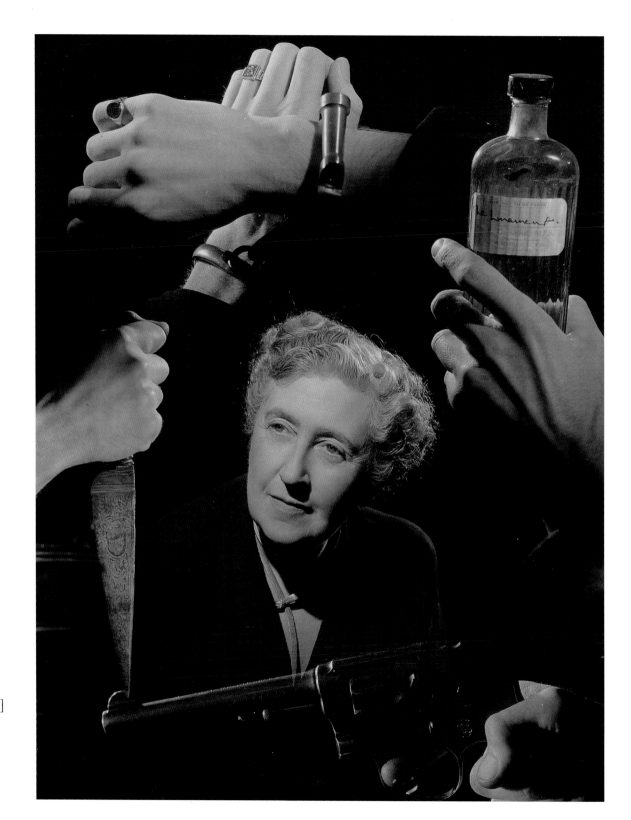

ANGUS McBean. Montage compositions created for Christmas cards.

Every year for several decades, McBean created a witty montage image and produced hundreds of original prints to send to his friends. Here and on p. viii are two famous and enthusiastically collected examples. At left, square-bearded McBean is seen as a disembodied head near a mop and pail on the back stairs. He explained that this absurd situation presented itself one day as workmen were repairing the stairs and created the hole in the course of their renovations.

In the montage on p. viii, McBean – with top hat, barefoot in pajamas, and seated in an old bathtub – floats in thin air with the help of an umbrella.

THE ANGUS MCBEAN ARCHIVE

THE HARVARD THEATRE COLLECTION acquired the photographic archive of Angus McBean in 1970, together with his comprehensive copyrights. There had been no previous connection between McBean and Harvard, and Harvard had not been McBean's first choice as the institution that would be entrusted to preserve his photographs. It was only after a long and unsuccessful effort to find an institutional purchaser in Britain that he made contact with Harvard University, an understandable initiative considering its large and well-known theater collection.

McBean had always retained possession of his own negatives. He preferred to control the density and cropping of the image by producing the prints. Another reason was practical: before circulating prints he carefully retouched them. He employed retouchers not only to finish his negatives, but to finish each print sent out from his studio; some of the more difficult work of this kind he did himself. In addition McBean received supplementary fees from reprints, either from his original clients or from the artists pictured in his photographs, and for their use in exhibitions and in books and on posters. In fact, the demand for re-use of his work still continues to increase year by year.

Unfortunately, the removal of the collection from Britain to the United States was anything but simple. McBean had arranged for the packing of the heavy and extremely fragile archive, which amounted to nearly forty thousand glass plates weighing eight tons, and several thousand of

the plates broke in transit. Even worse, the shipment arrived at the New York dockyard during a longshoremen's strike, and is believed to have stood out in the summer sun, heat, and damp weather for some weeks before being transported to Cambridge. As a result, other glass plates suffered damage of an equally drastic kind: the emulsions cracked or peeled. These, too, had to be regarded as a loss. This type of damage is sometimes revealed only with the passage of time, and unpleasant discoveries are still being made from time to time. And finally, some of the glassine wrappers that had originally enclosed the individual glass plates had adhered to the emulsion, causing further damage.

Fortunately, McBean's arrangement with Harvard University had resulted in an agreement through which he would provide a set of reference prints to accompany the negatives. So, luckily, in preparing for the transfer of the archive, and in anticipation of the time when the making of further prints would have to be entrusted to other hands, McBean produced contact prints of almost every negative in his archive. These were intended to provide a safe and convenient means of identification and reference for use within the library, and also a guide to the proper composition and exposure of each of the images.

Now arranged in archival binders, the index prints have served this purpose, and in the case of images whose negatives were damaged, they have been used as substitute sources. Now, every time a request is received to reproduce a photograph from this collection, the original

negative is examined to see if it can safely be handled and whether a satisfactory print can be made from it. Whenever the original glass plate does not survive, or for some reason cannot be used, recourse can often be made to a first-generation contact print that yields an excellent copy.

The archive was purchased inclusive of McBean's copyrights. The comprehensive agreement between McBean and Harvard University states:

> I, Angus McBean, of London, in consideration of the payment of $ —— to me by the President and Fellows of Harvard College . . . hereby give, grant, transfer and convey unto said President and Fellows of Harvard College all of my right, title and interest in and to my file of photographic negatives of theatrical productions and actors made prior to January 1, 1961, together with a set of prints for indexing and a run of printed programs of the productions the photographs represent, intending hereby to convey the entire property in these materials, including without limitation copyright and the right to publish and to charge for reproduction. Complete and exclusive ownership of the materials referred to above shall vest irrevocably in said President and Fellows of Harvard College immediately upon delivery of this instrument. . . . I further agree to cause Angus McBean, Ltd., a corporation of Great Britain of which I am a shareholder and director, to deliver to said President and Fellows of Harvard College not later than July 1, 1975 all the rest of the negatives of theatrical productions and actors taken by me and related materials, and to convey the entire property therein as fully as if they had been included in this conveyance, without any further or other payment by said President and Fellows of Harvard College. . . . Witness my hand and seal this 21st day of May, 1970.

> [Signed] Angus McBean, Flemings Hall, Suffolk.
> [Witness] David Ball, London.

INDEX OF SUBJECTS BY NAME

INDEX OF PRODUCTIONS BY TITLE

PHOTOGRAPHER'S NEGATIVE NUMBERS

Angus McBean at home. (No plate number.)

Angus McBean. Montage composition. (No plate number.)

Richard Burton as Henry. Stage photograph. Plate no. K 511-22.

Powys Thomas as Oberon and Muriel Pavlow as Titania. Stage photograph. Plate no. L 700-29.

Charles Laughton as Bottom. Stage photograph. Plate no. M 961-19.

A Midsummer Night's Dream. Stage photograph. Plate No. J 109-16.

Laurence Olivier in *Macbeth*. Stage photograph. Plate no. L 981-1.

Vivien Leigh in *Macbeth*. Stage photograph. Plate no. L 981-10.

Michael Denison, William Devlin, and Vivien Leigh in *Twelfth Night*. Stage photograph. Plate no. L 946-25.

Zoë Caldwell as Margaret and Michael Redgrave as Benedick. Stage photograph. Plate no. M 792-9.

Ian Bannen as Orlando and Vanessa Redgrave as Rosalind. Stage photograph. Plate no. P 540-7.

Paul Scofield as Lear and Diana Rigg as Cordelia. Stage photograph. Plate no. P 774-44.

Edith Evans as the Countess of Rossillion and Zoë Caldwell as Helena. Stage photograph. Plate no. M 911-10.

Doreen Aris as Miranda and John Gielgud as Prospero. Stage photograph. Plate no. M 595-39.

Fay Compton as Juno. Stage photograph. Plate no. L 719-18.

Alec Clunes as Caliban. Stage photograph. Plate no. M 595-18.

Diana Wynyard as Portia. Stage photograph. Plate no. H 206-16.

Emlyn Williams as Shylock (left). Studio photograph. Plate no. M 346-6.

Emlyn Williams as Shylock (right). Stage photograph. Plate no. M 290-9.

Robert Helpmann in *Hamlet*. Studio photograph. Plate no. H 148-9.

Laurence Olivier as Hamlet and Cherry Cottrell as Ophelia. Studio photograph. Plate no. 210-75.

Rosanna Seaborn as Cassandra, et al. Stage photograph. Plate no. C 116-2.

Ron Haddrick as Hubert de Burgh and Christopher Bond as Arthur, Duke of Bretagne. Stage photograph. Plate no. M 536-47.

The Merry Wives of Windsor. Stage photograph. Plate no. P 174-27.

Orson Welles as Othello and Gudrun Ure as Desdemona. Stage photograph. Plate no. K 687-1.

Laurence Olivier as Othello and Maggie Smith as Desdemona. Stage photograph. Plate no. P 922-24.

John Gielgud as Cassius. Stage photograph. Plate no. J 557-2.

Peggy Ashcroft as Cleopatra. Stage photograph. Session no. L 415-25.

Claire Luce as Cleopatra. Studio photograph. Session no. F 137-13.

Vivien Leigh as Cleopatra in *Antony and Cleopatra*. Stage photograph. Plate no. K 505-8.

Vivien Leigh as Cleopatra in *Cæsar and Cleopatra*. Stage photograph. Plate no. K 498-33.

Elizabeth Taylor as Helen. Stage photograph. Plate no. Q 258-2.

Pamela Brown, Richard Burton, and John Gielgud in *The Lady's Not for Burning*. Stage photograph. Plate no. H 566-3.

Paul Scofield as Treplef and Mai Zetterling as Nina. Stage photograph. Plate no. J 267-18.

Carol Goodner, Peggy Ashcroft, and Gwen Ffrangcon-Davies in *Three Sisters*. Surreal composition. Studio photograph. (No plate number.)

Robert Helpmann in *Nude with Violin*. Stage photograph. Plate no. M 654-4.

Ivor Novello as Nikki. Stage photograph. Plate no. J 236-62.

Noël Coward as Gary Essendine. Stage photograph. Plate no. G 260-17.

Michael Redgrave as Halvard Solness and Maggie Smith as Hilde Wangel. Stage photograph. Plate no. P 949-3.

Robrt Speaight in *Murder in the Cathedral* (actors?). Stage photograph. Plate no. D 256-11.

Dorothy Tutin as Joan and Richard Johnson as the Earl of Warwick. Stage photograph. Plate no. L 969-40.

Barbara Jefford as Joan. Stage photograph. Plate no. P 205-3.

Vivien Leigh as Jennifer Dubedat. Stage photograph. Plate no. E 217-8.

Vivien Leigh as Blanche Dubois. Stage photograph. Plate no. J 238-11.

Vivien Leigh as Paola and Claire Bloom as Lucile. Stage photograph. Plate no. M 697-28.

Alec Guiness as the Unidentified Guest. Stage photograph. Plate no. Q 437.

Edith Evans as Elizabeth Sawyer. Studio photograph. Session no. 197.

Peggy Ashcroft as the Duchess of Malfi and Sian Phillips as Julia. Stage photograph. Plate no. P 413-40.

Anton Walbrook, Diana Wynyard, and Rex Harrison in *Design for Living*. Montage composition. Publicity photograph. Session no. C 258.

Hermione Gingold as Jane Banbury and Hermione Baddeley as Julia Sterroll. Montage composition. Publicity photograph. Plate no. J 318-1.

Cyril Ritchard, Katharine Hepburn, and Robert Helpmann in *The Millionairess*. Montage composition. (No type designation.) Session no. K 905.

Katharine Hepburn as Epifania. Stage photograph. Plate no. K 905-43.

Emlyn Williams as Morgan Evans. Stage photograph. Plate no. C 129-63.

Opening scene of *My Fair Lady*. Stage photograph. Plate no. P 322-13.

Demot Walsh, Ruth Condomine, Kay Kendlall in *Blithe Spirit*. Composite. Stage photograph. Plate no. L 817-40-A.

Gwen Ffrangcon-Davies, John Gielgud, and Edith Evans in *The Importance of Being Earnest*. Stage photograph. Plate no. C 490-13.

Betty Felstead, Anna Halinka, and Ailsa Gamley in *After the Ball*. Stage photograph. Plate no. L 712-11.

Vivien Leigh and Charles Laughton as street performers in *St. Martin's Lane*. Publicity photograph. Plate no. C 108-15.

Elsa Lancaster as Peter Pan. Stage photograph. (No plate number.)

Margaret Rutherford as Miss Evelyn Whitchurch. (No type designation.) Plate no. H 375-9.

Margaret Rutherford as Mrs. Danvers and Celia Johnson as the Second Mrs. DeWinter. (No type designation.) Plate no. 291-30.

Robert Morley as the Prince Regent. Studio photograph. Plate no. F 194-1.

Norman Wisdom as Charley Wykeham. Stage photograph. Plate no. M 658-37.

Danny La Rue. Stage photograph. Plate no. Q 447-12.

Kathleen Ferrier as Orfeo. Stage photograph. Plate no. G 327-23.

Maria Callas. Studio photograph. Plate no. L 803-6.

Richard Bonynge and Joan Sutherland. Studio photograph. Plate no. P 935-4.

Blanche Thebom. Studio photograph. Plate no. K 167-13.

Jean Watson as Dalilah. Stage photograph. Plate no. L 247-8.

Benjamin Britten. Theater photograph. Plate no. H 241-1.

Peter Pears as Grimes (the storm). Stage photograph. Plate no. F 140-15. (with apprentice). Stage photograph. Plate no. F 140-117.

Peter Pears as Albert Herring. Stage photograph. Plate no. G 358-3.

Peter Pears as Captain Macheath. Stage photograph. Plate no. H 248-17.

Nancy Evans as Lucretia, et al. Stage photograph. Plate no. F 488-13.

Sir John in Love. Stage photograph. Plate no. F 403-9.

Andrew Downie as Ralph Rackstraw and Eric House as Sir Joseph Porter. Stage photograph. Plate no. P 644-18.

David Blair as Captain Belaye and Elaine Fifield as Pineapple Poll. Stage photograph. Plate no. K 560-12.

Martha Graham as Jocasta. Studio photograph. Plate no. L 698-7.

Ram Gopal. Studio photograph. Plate no. K 279-8.

Violetta Elvin in *Ballabile*. Studio photograph. Plate no. K 102-6.

Dolly Pick and Henri Barjac in *La Forêt Enchantée*. Stage photograph. Plate no. M 758-34.

Audrey Hepburn. Composite. Studio photograph. Plate no. K 295-1-a.

Richard Burton. Studio photograph. Plate no. L 491-4.

Ingrid Bergman. Studio photograph. Plate no. L 835-2.

Vivien Leigh in *Serena Blandish*. Studio photograph. Plate no. B 363-5.

Lupe Vélez. Studio photograph. (No plate number.)

Luise Rainer. Studio photograph. Plate no. C 343-10.

Jean Batten. Studio photograph. Plate no. B 188-4.

Jill Furse. Studio photograph. Plate no. C 145-14.

Penelope Dudley-Ward. Studio photograph. Plate no. C 130-5.

Bruce Ingram. Studio photograph. Plate no. J 476-1.

Mae West. Studio photograph. Plate no. H 175-3.

Cecil Beaton as Mephistopheles. Studio photograph. Plate no. J 205-8.

Hugh Beaumont. Montage composition. Studio photograph. Session no. G 243.

Audrey Hepburn. Surreal composition. Studio photograph. Plate no. K 266-7.

Zizi Jeanmaire. Surreal composition. Studio photograph. Plate no. J 124-1.

Beatrix Lehmann. Surreal composition. Studio photograph. Plate no. C 505-7. Session no. B 229.

Elsa Lanchester. Surreal composition. Studio photograph. (No plate number.)

Tamara Toumanova. Surreal composition. Studio photograph. (No plate number.)

Peggy Ashcroft as Portia. Surreal composition. Studio photograph. Plate no. C 505-22.

Dorothy Dickson. Surreal composition. Studio photograph. Session no. C 120.

Diana Churchill. Surreal composition. Studio photograph. Plate no. D 211-4.

Edith Evans. Surreal composition. Studio photograph. Session no. C 321.

Vivien Leigh with Angus McBean. Studio photograph. Session no. C 505.

Vivien Leigh as Aurora. Surreal composition. Studio photograph. Plate no. C 505-26.

Tamara Geva as Persephone. Surreal composition. Studio photograph. Plate no. C 505-20.

Nancy Spain. Montage composition. Studio photograph. Plate no. J 395-5.

Agatha Christie. Montage composition. Studio photograph. Plate no. J 585-2.

Peter Brook. Montage composition. Studio photograph. Plate no. G 341-5-x.

Angus McBean. Montage composition. (No plate number.)